TUDORS TO WINDSORS

TUDORS TO WINDSORS

EDITED BY TARNYA COOPER
CURATED BY LOUISE STEWART

INTRODUCTION BY DAVID CANNADINE

THE MUSEUM OF FINE ARTS, HOUSTON

CONTENTS

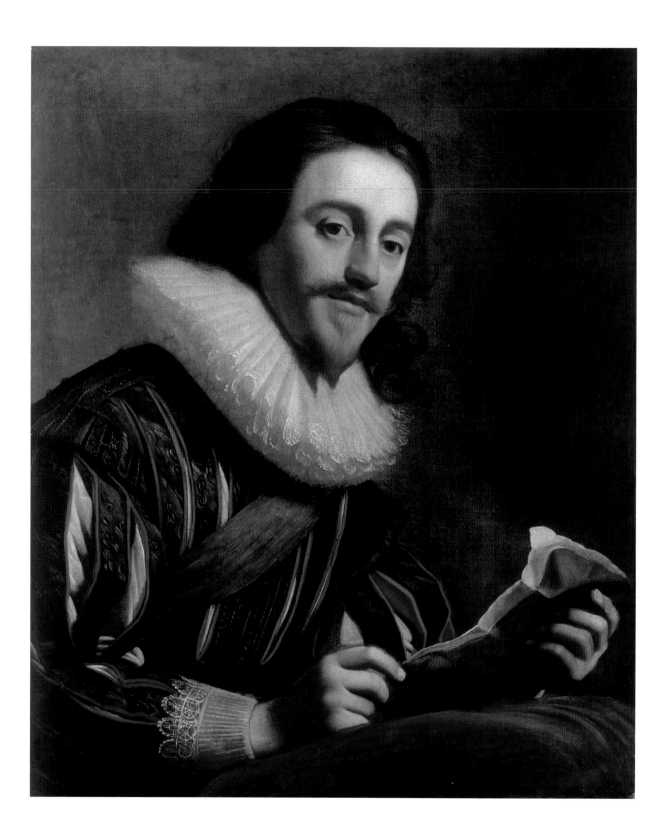

DIRECTOR'S FOREWORD

Royal portraits have held a special place in the Collection of the National Portrait Gallery, London, since its foundation in 1856. The Gallery has acquired numerous depictions of monarchs and their families, although until 1969 the reigning monarch and their spouse were the only living sitters permitted to hang on its walls. The royal portraits in the Collection span over 500 years of British history and include many of the finest works of art ever produced in Britain. The Gallery's earliest painted portrait is an image of Henry VII from 1505 (fig.65). Other highlights of the Collection include the famous 'Ditchley' portrait of Elizabeth I by Marcus Gheeraerts (fig.78) and Thomas Lawrence's striking depictions of George IV (fig.122). Today we continue to commission and collect portraits of royal sitters by leading British and international artists, from Annie Leibowitz to Thomas Struth.

This book serves as a guide and companion to the royal portraits in the Gallery's Collection. It sheds new light on changing ideas of monarchy and British nationhood and explores the role of royal patronage in the development of the portrait as an art form. As well as celebrating the formal portraiture of majesty, it documents the way in which portraits have given unique behind-the-scenes glimpses into the everyday lives of the royals.

This publication accompanies the Gallery's flagship international touring exhibition *Tudors to Windsors.* Drawn almost entirely from the Gallery's Collection,

this unprecedented exhibition provides visitors with the opportunity to encounter some of history's most fascinating personalities, as well as many of the most accomplished portraits produced in the last 500 years. I am delighted that this exhibition will tour internationally, bringing the Gallery's Collection to new audiences. The support of my fellow directors and staff at the host venues has been crucial in making both the exhibition and this book possible.

I am most grateful to Tarnya Cooper, former Curatorial Director at the Gallery, who has edited this book, to Louise Stewart, curator of the exhibition *Tudors to Windsors,* and to all the Gallery's curators for their contributions and expertise. I also wish to thank Professor Sir David Cannadine for his fascinating and insightful essay that highlights monarchy as a prism through which to view a changing nation.

Thanks also go to Melanie Pilbrow, Head of International Programmes at the National Portrait Gallery, and to the directors and staff of our partner museums, in particular Gary Tinterow at the Museum of Fine Arts in Houston and Karen Quinlan at Bendigo Art Gallery in Australia, both of whom it has been our pleasure to work with. Additionally, my thanks for her help and support go to Lucy Whittaker, Assistant Surveyor of the Queen's Pictures.

Nicholas Cullinan
Director, National Portrait Gallery, London

King Charles I
Gerrit van Honthorst, 1628

Oil on canvas
National Portrait Gallery, London (NPG 4444)

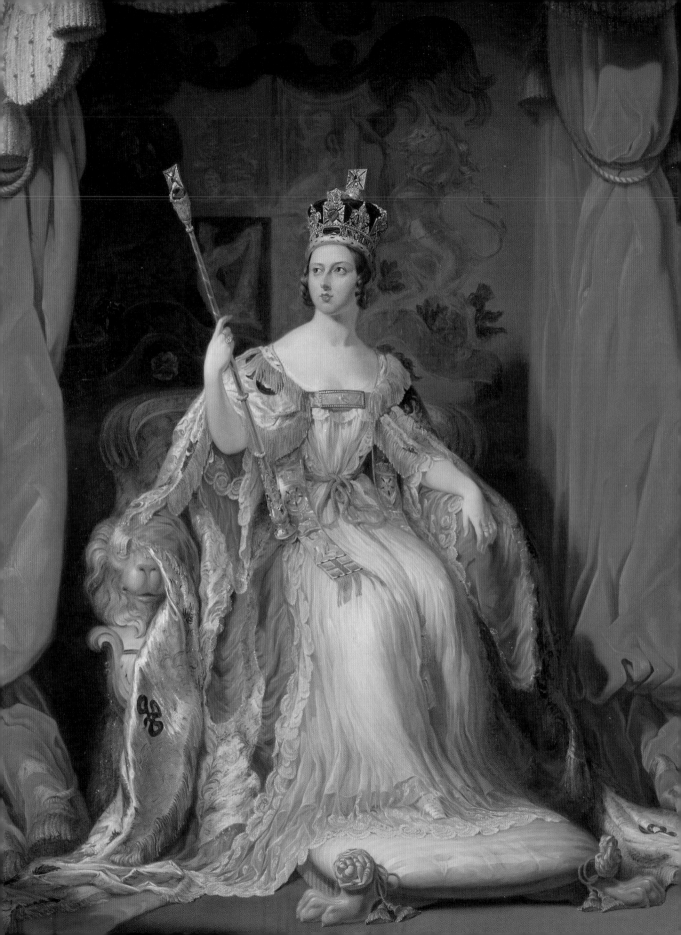

FOREWORD

Several generations have passed since American schoolchildren were obliged to memorise the succession of British monarchs, and soon more than 150 years will have passed since the descendants of German-speaking immigrants outnumbered Americans with British ancestry. But the special relationship between Great Britain and its former colony in North America persists and, some could argue, has recently grown stronger. The bicentennial of the Declaration of Independence of the United States of America can be seen in retrospect to have sparked a reappraisal of the relationship with our mother country, renewed appreciation and great admiration. Two factors in particular stand out: the respect engendered by the exemplary, record-setting reign of HM Queen Elizabeth II and the fascination generated by the glamorous, charismatic and untraditional role played by Diana, Princess of Wales, culminating in her tragic death, which unexpectedly cast a pall over our country as well as her own. Since 1976, the popularity in the United States of British historical dramas, from *Upstairs, Downstairs* and *Downton Abbey* to *The Queen*, *Victoria* and *The Crown*, not to mention the newfound interest in British artists on this side of the Atlantic, attest to the vibrant cultural dimension of this renewed relationship.

We thought, therefore, that Houston audiences would welcome an opportunity to acquaint themselves with British monarchs from Henry VII to Elizabeth II, and we are grateful to the National Portrait Gallery, London, for making this idea a reality. While focusing on the construct of a modern image of monarchical authority, one that, paradoxically, relied on Roman Catholic iconographic prototypes for (mainly) Protestant monarchs, this handsome exhibition also tells the story of British painting over the last 500 years. It was never a secret that the greatest portraits of modern British sovereigns were created by foreigners – Holbein, van Dyck, Rubens, Honthorst, Lely, Kneller, Sully, Winterhalter and Sargent – but today we can marvel at the strength of the British-born school of portraiture that emerged in the Georgian era, a tradition continued into our own times by Lucian Freud and David Hockney. It is thrilling to present these compelling portraits and distinguished works of art in our halls.

It has been a pleasure to work on this exhibition with Nicholas Cullinan, Director, and the entire team at the National Portrait Gallery, most especially Louise Stewart, Melanie Pilbrow and Tarnya Cooper. From the initial conception, David Bomford, Chairman of Conservation and the Audrey Jones Beck Curator of European Art at the Museum of Fine Arts, Houston, has been integral to the selection and presentation for Houston. He has been assisted throughout by Deborah L. Roldán, Assistant Director for Exhibitions, and Helga Aurisch, Curator. We all, in turn, are most grateful to the lenders to the exhibition, who include, in addition to the National Portrait Gallery: The National Gallery, London; the Museo Nacional del Prado, Madrid; The Metropolitan Museum of Art, New York; and the Galleria Nazionale d'Arte Antica, Palazzo Barberini, Rome; with thanks also to Patrick Demarchelier, and to the late Lord Snowdon and his children, David, Earl of Snowdon, and Frances von Hofmannsthal, and the Snowdon Archive.

Gary Tinterow
Director, The Museum of Fine Arts, Houston

Queen Victoria
Sir George Hayter, 1863,
based on a work of 1838

Oil on canvas
National Portrait Gallery, London (NPG 1250)

INTRODUCTION

Since the sixteenth century, royal sitters have patronised the leading portrait artists of their day, often enticing them from foreign courts to create images of wealth, power and glory. While royal patronage has often driven innovation in the field of portraiture, images of kings, queens and their heirs have been concerned with signalling not change, but continuity and tradition. These forces are very much in evidence in many of the royal portraits in the National Portrait Gallery's Collection, and particularly in the history of a full-length portrait of Henry, Prince of Wales (fig.1). The eldest son of James I, Henry died tragically in 1612, aged only eighteen. His death was a blow to the hopes of many in England who supported the extremely clever, cultured and Protestant prince, and prompted widespread mourning.

Originally thought to be an image of Henry's younger brother Charles I, technical analysis of the portrait carried out in the 1970s showed that much of the visible paint dated from the nineteenth century. When this was removed, the painting was revealed as a representation of Henry dating from around 1603 and painted by Marcus Gheeraerts the Younger, one of the leading artists working in England at the time. As is often the case in royal portraiture of this period, traditional symbols are used here to present monarchical power as unwavering and permanent. The robes and collar of the Garter signal Henry's membership of the ancient order of chivalry, and the sword is a conventional symbol of rule. As Henry was little known in later centuries, it is possible that the portrait was repainted to represent other known likenesses of Charles I to increase its importance and usefulness in a scheme of royal images. Henry's own story, with its journey from the nation's great hope to 'lost prince', reflects the unpredictable reality of royal succession, which is also charted in the many royal stories told within this book, with the themes of continuity and change recurring throughout.

Published to accompany the international touring exhibition *Tudors to Windsors*, this volume also serves as a companion and guide to the royal portraits in the Collection of the National Portrait Gallery in London. It represents a survey of royal portraiture in Britain from the Tudors to the present day. The book opens with three thematic essays that each reflect on a different aspect of royal power, history and portrait-making. David Cannadine's *Illusions of Majesty: Monarchy, Uncertainty and Image-Making* outlines the changing nature of kingship. He traces the transformation of concepts of monarchy,

1 Henry, Prince of Wales
Marcus Gheeraerts the Younger,
c.1603

Oil on canvas
National Portrait Gallery, London
(NPG 2562)

from the idea of the king as God's representative on earth and wielder of absolute power to the advent of a constitutional monarchy in the seventeenth century. The erosion of power that has led to the role of today's monarchs as national figureheads who reign, rather than rule, is outlined with reference to key examples. Cannadine explores some of the circumstances and strategies that resulted in the British monarchy surviving the period in the early twentieth century when so many of the royal houses of Europe fell. Finally, in considering royal patronage and image-making, he reveals the ways in which the British monarchy has existed historically in a constant state of flux and change, in spite of images that emphasise continuity.

Tarnya Cooper's essay, *Making Monarchy: The Changing Face of Power,* focuses on authorised royal portraiture. She considers the varied purposes of royal portraits, which have been exchanged as diplomatic gifts and displayed in civic institutions and domestic homes where they signalled loyalty, cemented the reputations of individual monarchs and led the way in terms of artistic innovation. She traces the evolution from early standardised likenesses, which functioned as generic ruler images, to the most successful, individualised royal portraits, which combine a sense of personal encounter with the portrayal of majesty. Cooper explores how patterns in representation created enduring traditions, and surveys the wide range of approaches artists from Hans Holbein the Younger to Annie Leibowitz have employed in creating definitive portraits of monarchs.

In her essay *Loyalty and Dissent: Royal Portraiture Beyond the Court,* Louise Stewart focuses on the ubiquity of royal portraits in everyday life, from the Middle Ages to the present day. Taking account of street signs, architectural ornament, wall paintings, ceramics, souvenirs, photographs and stamps, she explores the various ways in which royal images have been appropriated and reinterpreted by ordinary people. The royal portrait is revealed as endlessly adaptable, capable of expressing ideal notions of domestic order, being used as a marketing tool, expressing highly charged and, at times, subversive political statements or providing a sense of reassurance at times of change.

These essays are followed by a chronological survey of the English and British royal dynasties, from the Tudors to the Windsors. Each dynasty is introduced with a broad overview of the key events of its period of rule, the social and political context, and the achievements and reputation of each individual monarch. This is followed by a family tree, timeline and detailed consideration of several key royal portraits from each period written by the National Portrait Gallery's expert curators. These historical sections are interspersed with a series of brief thematic features exploring some of the key themes suggested by the portraits, including royal fashion, satire and royals at war. This book can be read as a chronological survey of the history of royal portraiture in Britain from the sixteenth century to the present day, or used as a reference work, providing in-depth information on individual portraits, reigns or dynasties.

In providing a much-needed comprehensive survey of the subject, this book charts the expansion of royal image-making and its varied audiences who took an active interest in collecting the royal likeness. Fuelled by a new interest in British history, the increased availability of images from the sixteenth century and the rise of nationalism and empire in the late eighteenth and nineteenth centuries, images of monarchs have become increasingly ubiquitous. Through this study, royal portraiture is revealed as inherently paradoxical; it strives to create illusions of permanence and stability even as it is radically adapted to changing historical contexts and ideas about monarchy. This also points to the political power of royal portraits, which do far more than reflect reality or the appearance of a ruler. Rather, in expressing the nature of power and cementing a monarch's reputation, or being used to articulate resistance to power, royal portraits have the ability to reflect, champion and contribute to political realities and the changing idea of British nationhood.

Louise Stewart and Tarnya Cooper

ILLUSIONS OF MAJESTY: MONARCHY, UNCERTAINTY AND IMAGE-MAKING

David Cannadine

The serene and sunset years of Queen Elizabeth II's unprecedentedly long reign help explain why the present-day British monarchy is a unique institution, hugely popular in its attraction and appeal, and global in its range and reach. Kings and queens in other nations come and go, abdicate and retire, most recently in Belgium, the Netherlands and Spain, and even Pope Benedict XVI resigned his office in 2013 on the grounds of age and infirmity. But unlike these fainter royal hearts and weaker sovereign spirits, the Queen has no intention of going away or of giving up. Having pledged herself at the tender age of twenty-one, when touring South Africa with her parents, King George VI and Queen Elizabeth, to the lifelong service of her subjects, and having reigned for more years than most of them have been living, she has no plans to retire. And this absolute devotion to her royal duty may help explain how and why she remains secure and confident in the affection of her peoples, as she consistently enjoys approval ratings in the opinion polls of which politicians and prime ministers can only dream. Moreover, Elizabeth II is not only queen regnant of the United Kingdom of Great Britain and Northern Ireland, she also remains the sovereign of many former British colonies and dominions, among them Canada, Australia and New Zealand. As Head of the Commonwealth, she is a reminder that many monarchs in many countries were once the focus and cynosure of global empires, sometimes land-based, sometimes transoceanic, but all of them now gone and, as Kipling put it in his poem *Recessional*, published to coincide with Queen Victoria's Diamond Jubilee in 1897, 'one with Ninevah and Tyre'.

For many Britons, and for many of the Queen's subjects around the world, this is a heartening narrative of self-congratulation, self-esteem and self-regard: Britain may no longer be the dominant industrial or maritime force it once was, and the 'Empire of power' may have morphed into the 'Commonwealth of sentiment', but its monarchy remains a uniquely strong and resonant global institution. Yet such a view fails to recognise just how extraordinary and remarkable the British monarchy is. These days, a crowned sovereign is a very unusual way to head up a nation, and such monarchs are largely confined to Scandinavia, the Low Countries and Spain in Europe,

2 *The Kings and Queens of England: From the Conquest to Queen Victoria*
Henry Hering, 1862

Albumen carte-de-visite photomontage
National Portrait Gallery, London
(NPG Ax131392, detail)

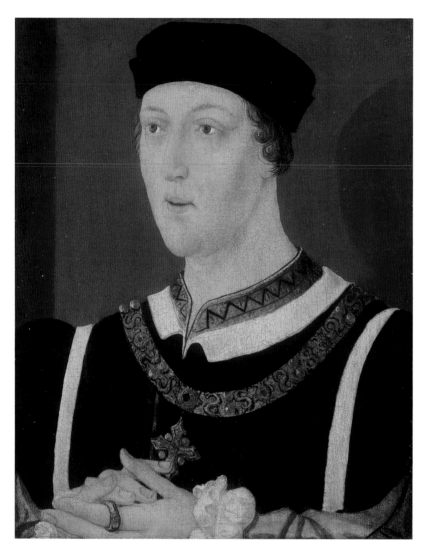

3 **King Henry VI**
Unknown English artist,
c.1540

Oil on panel
National Portrait Gallery, London
(NPG 2457)

to Jordan, Morocco and Saudi Arabia in the Middle East, to Swaziland and Lesotho in sub-Saharan Africa, and to Thailand, Brunei and Japan in the Far East (along with the papacy, which is, even more unusually in modern times, an elective monarchy). To be sure, there are other countries in which non-royal dynasties survive, of which North Korea is the most conspicuous example, but in the early twenty-first century, hereditary monarchy is the exception rather than the rule, and republics are much more common – whether democratic, authoritarian or something in between. Yet little more than one hundred years ago, the picture was very different. France, the United States and the nations of Latin America were already republics, albeit some more stable and successful than others; but elsewhere in Europe, across all of Asia and most of Africa, monarchical nations and royal empires were commonplace rather than exceptional. As late as 1900 there were emperors in Russia, Austria-Hungary, Germany, China, Anglo-India, Japan, Iran, Turkey and Abyssinia, which meant that the recently aggrandised British imperial monarchy was but one great-power throne among many.

STRENGTHS, WEAKNESSES AND TRANSFORMATIONS

It cannot be too strongly emphasised that, for most of European history, and indeed for most of world history, monarchs and sovereigns have been at the centre and at the summit of human affairs and events. Of course, the hereditary system of royal rulership has not always functioned smoothly or effectively. There have been varied and sometimes disputed laws of succession; problematic relations between princes and prelates, and between the Crown and the Church; dynastic rivalries, family squabbles and court intrigues; bad kings, foolish kings, evil kings and idle kings; long-lived dowagers, domineering wives, wicked uncles, faithless brothers and feckless cousins; usurpers, bastards, impostors and pretenders; and overmighty subjects, disloyal dukes and baronial rebels. Indeed, it is just such royal imbroglios and dynastic disputes that form the mainspring of so many of Shakespeare's plays, which constitute (among other things) the greatest sustained meditation on ancient, medieval and early modern monarchy ever undertaken by a single author. But, as Shakespeare so often makes plain – in *Julius Caesar* and *Antony and Cleopatra*, in *Hamlet* and *Macbeth*, in *Richard II* and *Richard III*, in *Henry V* and *Henry VI* (fig.3) – the battles and disagreements of the pre-modern period were about *who* should be king, about *how* the king should be chosen, and about *what* the king should be doing, rather than about whether there ought to be a king or not. Despite the alternative, republican tradition, extending from the city states of ancient Greece to those of Renaissance Italy, which offered a radically different and potentially subversive vision of how human affairs should be managed and organised, this was very much the minority view until the late eighteenth century – or even one hundred years after that.

For most of recorded history, then, monarchy has been the general rule, as peoples, tribes, nations and empires organised themselves, or were forcibly organised, on the basis of sovereign authority passed on by hereditary succession. Of course, there have been variations as well as exceptions. Elective monarchy, of which the papacy and (some have argued) the United States presidency are the last surviving examples, was once much more widespread than it is today. The Holy Roman Emperor was the most famous elected sovereign in Europe until Napoleon abolished the position in 1806, and at different times the same procedure for selecting a monarch was followed in Poland, Lithuania, Bohemia and Transylvania. As Shakespeare frequently records, there were also disputes as to who should inherit the crown, as was later the case with the War of Spanish Succession (1701–14) and the War of Austrian Succession (1740–8). And even where monarchy *was* hereditary, the normal rules of succession might be set aside when it was clear that the current occupant of the throne was not up to the job, or when the next in direct line was manifestly unfit to rule, as was the case in Habsburg Vienna in the aftermath of the revolution of 1848, when Emperor Ferdinand I abdicated and the throne passed, not to his (mentally unstable) brother, Francis, but to his nephew, Francis Joseph. Nevertheless, most monarchies have generally been hereditary and this has been deemed to carry certain advantages: the succession is known long in advance, heirs to the throne may be brought up and trained for their responsibilities, and there is an orderly transition from one generation to the next, as summed up in the phrase, 'The king is dead, long live the king!' Thus regarded, monarchy holds out the prospect of stability over time in a way that neither dictatorship nor democracy can necessarily guarantee.

Yet this was by no means the whole truth of things, for the strength of monarchy, namely the planned and prepared transfer of power and authority from one sovereign to the next, also carried with it just the sort of risks of which Shakespeare was so well aware. What would happen, for example, if the monarch produced no heir, either because they did not marry (as in the case of Queen Elizabeth I) or because all their children died young (as with Queen Anne)? And while it might be true that heirs to the throne who *did* survive could be trained up from their early years, this has not always worked out well. Among recent British monarchs, George IV and Edward VII had to wait so long to inherit that their reigns were disappointingly short, while Edward VIII had no wish to be king at all. By contrast, some of the most successful sovereigns of recent times, among them Victoria, George V, George VI and the present

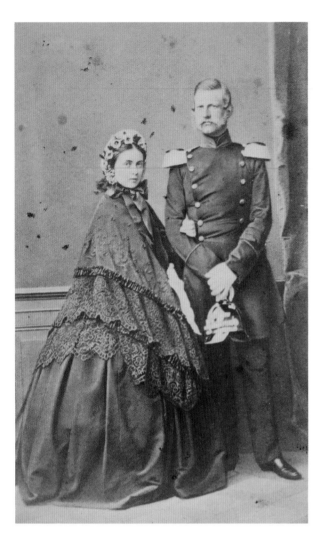

4 Victoria, Empress of
Germany and Queen of
Prussia, Frederick III,
Emperor of Germany and
King of Prussia
L. Haase & Co., early 1860s

Albumen carte-de-visite
National Portrait Gallery, London
(NPG x132094)

Queen, were neither born nor brought up expecting to inherit the throne. Moreover, direct hereditary succession, even if modified in this way, is something of a genetic lottery, and although under extreme circumstances it can be set aside, there are still potential pitfalls and problems. In the case of Britain and Germany, Victoria and Albert hoped that by marrying off their eldest daughter, another Victoria, to Crown Prince Frederick of Prussia (fig.4), they would ensure the perpetual friendship of the two Protestant nations on opposite sides of the North Sea. But, as the German Emperor, Frederick reigned for only one hundred days, having been mortally stricken with cancer of the throat and, with his death, Victoria and Albert's dreams of perpetual Anglo-German amity also expired, and they would go up in flames in 1914.

In its ideal form, monarchy is not only hereditary, but also patrilineal and patriarchal, as succession is supposed to be exclusively in the male line. This explains why, in 1837, Queen Victoria was unable to follow her male forebears, from George I to William IV, in becoming Elector of Hanover, as the Salic Law that prevailed there prevented women from inheriting. But, as the example of Victoria also shows us, in other countries females could inherit the throne, as Queen Elizabeth I and Queen Anne had done before her in England, and as Maria Theresa had done in Austria and Catherine the Great in Russia. Even so, Queen Victoria never fully reconciled her private role as wife and mother with her public persona as queen and empress, and these examples of regnant female sovereigns were the exceptions that proved the rule, for until recent changes in the succession laws, monarchy was generally believed to be generically male. The king of the jungle is a lion, not a lioness; at coronations, the new monarchs are presented with orbs and sceptres, phallic objects that are symbols of male potency; and most ruling sovereigns have fulfilled a range of traditionally masculine roles, as god, priest, lawgiver, judge, warrior, philosopher, patron and benefactor. And while the wife of a regnant king automatically becomes queen consort because that is deemed to be the natural order of things, as the subordinate woman takes the higher status of the man, the husband of a regnant queen does not become king consort because, according to the prevailing hierarchy of gender relations, he cannot take the superior

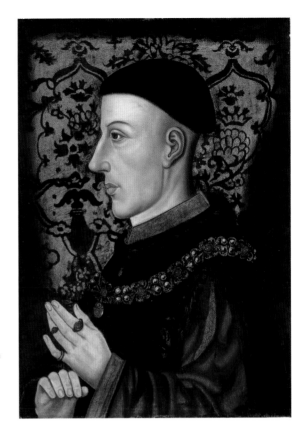

5 **King Henry V**
Unknown artist, late sixteenth
or early seventeenth century

Oil on panel
National Portrait Gallery, London
(NPG 545)

status of his wife – as Prince Philip and Prince Albert in
this country, and Prince Henrik in Denmark, husband of
Queen Margrethe II, all discovered to their annoyance.

Until the eighteenth century, and in some cases
beyond, most monarchs were expected to *rule*: to govern
the country, to command the armed forces, to be the
ultimate and vigorous source of all authority. Such were
the burdens of active and responsible kingship, summed
up well by these words Shakespeare puts into the mouth
of Henry V (fig.5):

Upon the king! Let us our lives, our souls, our debts, our
careful wives, our children, and our sins lay on the king!
We must bear all. O hard condition,
Twin-born with greatness, subject to the breath
Of every fool, whose sense no more can feel
But his own wringing. What infinite heart's ease
Must kings neglect that private men enjoy?
 Henry V, Act IV, Scene I

Some monarchs discharged these tasks well, as, in his
own way, did Henry V himself. But by the nineteenth
century, governing was becoming a much more difficult,
complex and demanding business. State bureaucracies
were ever more extensive and intrusive, elected
legislatures had to be managed and accommodated,
and international relations could no longer be conducted
on the basis of family connection. By 1914, three of the
great powers of Europe were ruled by men who were, in
different ways, not up to the job: Austria-Hungary, where
the Emperor Francis Joseph was too old and set in his ways
to exert decisive leadership as the crisis unfolded in the
aftermath of the assassination of his heir, the Archduke
Franz Ferdinand, at Sarajevo; Russia, where the Tsar
Nicholas II was ostensibly an autocrat, but was incapable
of directing either the civil government or the armed
forces; and Germany, where the increasingly unstable
Kaiser Wilhelm II failed to halt the slide towards a war
that he wanted – yet also did not want.

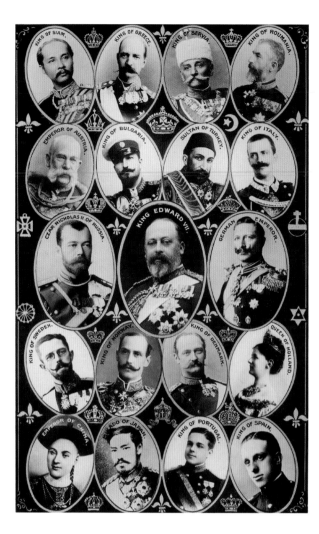

Part of the problem that these great European monarchs (fig.6) faced was that they were expected to do too many things, and while Francis Joseph, Nicholas II and Wilhelm II might have borne their burdens better had they been, respectively, more youthful and flexible, more able and energetic, and more mentally stable, the fact remains that, by then, they had too many demanding and contradictory roles to fill. Domestically, these sovereigns were supposed to be in charge of the civilian and military aspects of their national governments, as both the bureaucrat-in-chief and the commander-in-chief. They were also, in the increasingly democratic world of organised political parties, trade unions and a mass-circulation press, meant to be a focus of national loyalty and identity, holding together countries that were often very varied in their languages, religions and cultures, by participating in unprecedented displays of pomp and ceremony built around coronations, weddings, jubilees and funerals. But, in addition, they were expected to be the focus and symbolic centre of far-flung empires, extending, in the case of land-based Russia, from St Petersburg on the Baltic to Vladivostok on the Pacific and, in the case of the maritime British Empire, around the whole world. Yet, at the same time, these national icons and global super-sovereigns also belonged to a pan-European, transcontinental cousinhood of royalty that put dynastic ties and cosmopolitan connections above the petty constraints of national loyalties and imperial rivalries. Hence, by 1914, the complex interrelations of the British, Russian and German royal houses meant that King George V, Tsar Nicholas II and Kaiser Wilhelm II were all cousins. But, as the international crisis unfolded that summer, it proved impossible to maintain these varied, competing – and, in the end, conflicting – identities, and the First World War duly erupted as (among other things) a gigantic, right royal family row (fig.7).

Since the aftermath of the French Revolution, and even more so during and following the First World War, the monarchies that have been most successful at surviving have been those which, whether by accident or design, with enthusiasm or regret, have given up the many active and responsible tasks associated with ruling, and have relinquished them to the politicians, the civil

6 *Ruling Monarchs*
Published by Rotary
Photographic Co. Ltd, 1908

Gelatin silver postcard print
National Portrait Gallery, London
(NPG x196881)

7 *Royal Family of Europe Now at War. A Family Quarrel.*
Percy Lewis Pocock for
W. & D. Downey, published by
Underwood & Underwood,
1914, based on a photograph
of 1907

Colour half-tone postcard print
National Portrait Gallery, London
(NPG x200036)

service and the military. As a result, they have ceased to *rule* or to exert real power, or to bear the responsibilities that Shakespeare's Henry V so eloquently described, and have settled for the lesser role of *reigning* instead. Queen Victoria may have resented the fact that by the 1880s and 1890s she wielded far less political power than she had in earlier decades, and regretted that she was becoming the sovereign of a 'democratical monarchy'. But this also meant that George V would bear far less responsibility for the outbreak and conduct of the First World War than did the Tsar or the Kaiser, and, since he was also on the winning side, he kept his throne, whereas the German, the Habsburg and the Russian emperors, who were deemed to have been ultimately responsible for the humiliating military defeats of 1917 and 1918, did not. During the twentieth century, it has been easier to survive as a reigning, rather than as a ruling, monarch, and by being on the winning, rather than on the losing,

side in war. The one great exception is Japan, where the Emperor Hirohito was closely associated with the aggressive military policy pursued by his government before and during the Second World War, but who nevertheless survived the dropping of two atomic bombs and complete military defeat in 1945. Yet Hirohito paid a high price for keeping both his throne and his head: in future, the Japanese emperor would no longer rule as a quasi-divine and infallible being, but would reign as a national figurehead instead.

One of the names given to those kings and queens who reign rather than rule is 'constitutional monarchs', and it is widely believed that Britain pioneered this form of government sometime during the nineteenth century. As Walter Bagehot put it, perhaps more prescriptively than descriptively, in the pages of *The English Constitution* (1867), British sovereigns as constitutional monarchs possessed only three rights in dealing with

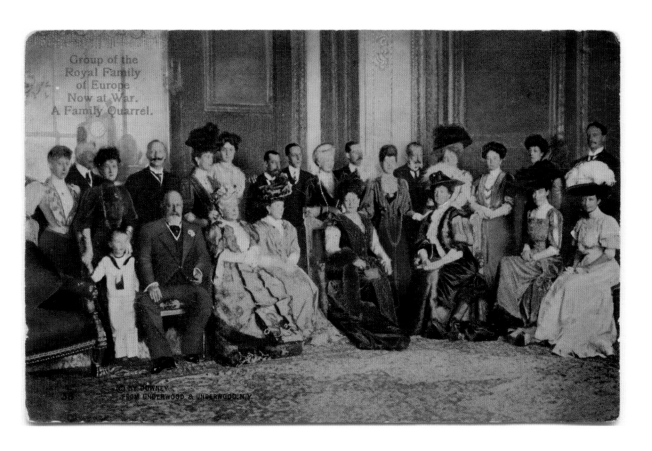

their governments and their prime ministers: to warn, to encourage and to be consulted. Queen Victoria never accepted such constraints, even as she had to endure them in the closing decades of her reign; but from the time of King Edward VII onwards, this was how things worked in practice, as a democratic franchise, a mass electorate and nationally based parties severely limited the scope for royal interference, which had still been significant at the beginning of Victoria's reign. This in turn meant that, from a gender perspective, constitutional monarchy was an emasculated monarchy, as all those generically male and assertively masculine attributes of active rulership were given up or taken away. Thus understood, constitutional monarchy was in essence a feminised monarchy, where the womanly virtues of hearth and home, nurturing and nourishing, morality and monogamy, superseded the male attributes of leadership and command – and sexual licence. It is, then, scarcely surprising that matriarchs rather than macho men have been among the most successful monarchs of recent times: Queen Victoria and Queen Elizabeth II in the United Kingdom; Queen Wilhelmina, Queen Juliana and Queen Beatrix in the Netherlands; and Queen Margrethe in Denmark.

As these general reflections suggest, monarchy has in practice always been an exceptionally protean and constantly changing phenomenon, not only in Europe but even more so in those many other parts of the globe where it flourished as the natural order of things until the first decade of the twentieth century; and that remains the case in those limited parts of the world where the institution has survived into the present day, the United Kingdom included. Some sovereigns have ruled or reigned over small or relatively compact kingdoms, such as Denmark or Greece. Some have ruled over what claimed to be unitary nation states, as in the case of France or Prussia. Some have been multiple monarchies, holding together extended and heterogeneous territorial agglomerations that were united only by their loyalty to the throne, such as Austria-Hungary, China, Russia or the Ottoman Empire. Some have been maritime imperia, as in the case of Spain, Portugal, the Netherlands, Belgium and Britain itself. Indeed, the geographical reach of the English monarchy and its later British embellishment

has gone through many different iterations: England, then England and Wales; then England, Wales and Scotland; then the United Kingdom of Great Britain and Ireland. And, in addition to becoming the focus of loyalty for the 'Greater Britain' that developed across the seas, and for the African, Asian and Caribbean colonies, successive British monarchs were Empress or Emperor of India from 1876 to 1947. Nowadays, by contrast, Queen Elizabeth II is no longer sovereign over most of Ireland, or Empress of India, or monarch of many former realms located elsewhere around the world. Even though the Commonwealth (fig.8) still gives the Queen a residual global role, the British monarchy has significantly downsized across the half-century between Indian independence and the Hong Kong handover in 1997.

ARTIFICE AND THE CONSTRUCTION OF CONTINUITY

Monarchies have not only evolved, changed, expanded and contracted in many ways across the centuries, they have also functioned in what often seem paradoxical and contradictory ways. The essence of monarchy is supposed to be continuity, stability and permanence, yet many royal dynasties and regimes have been discontinuous, or unstable or toppled by revolutions. Although monarchy holds out the prospect of an orderly succession from one generation to the next, the relations between many kings and their heirs have been selfishly hostile, resentful and antagonistic, as in the case of the Hanoverians in Britain. Monarchy is supposed to be at the apex of a traditional, time-hallowed, religiously sanctioned, hierarchical and unequal society. Yet the sovereigns that have successfully survived in western Europe reign over nations that see themselves as democratic, secular, egalitarian and meritocratic. Some kings have wielded enormous power, both politically and militarily, and have been rulers to whom the epithet 'the Great' has been deservedly and appropriately applied; others, especially, but not exclusively, in recent times, have been little more than decorative figureheads. Although monarchy has generally been a system strongly rigged in favour of men, there

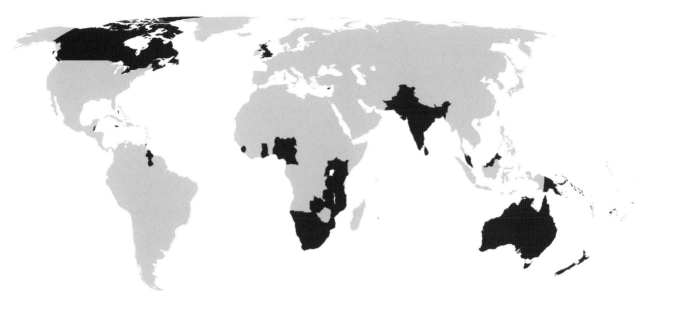

8 **Map of the Commonwealth, 2016**

Image courtesy of the Commonwealth Secretariat

are many examples of regnant queens, not only in their modern, maternal guise as constitutional monarchs, but also in earlier times as commanding rulers or even as warrior queens. It is only necessary to compare the very different backgrounds, upbringings and education of the first and second Queen Elizabeths, along with the equally different circumstances in which the first of them ruled, whereas the second has reigned, to get a sense of just how varied monarchs and monarchies have been and can be.

These broader considerations also help explain why representation and image-making – in architecture and in art, in ceremonials and in coinage, and in all kinds

of media – have been so important in the past history and current practices of royal regimes. For much of what might, with defensible anachronism, be termed the public relations of all royal houses, has been – and still is – concerned with denying or concealing the fragilities by which, in reality, many dynasties and monarchs have been threatened or weakened. The construction of great palaces, such as the Louvre in Paris, the Hermitage in St Petersburg or Whitehall in London, all of them filled with outstanding works of art, were intended to give an overwhelming impression of unrivalled royal power, permanence, stability, wealth, status and taste. Grandiose

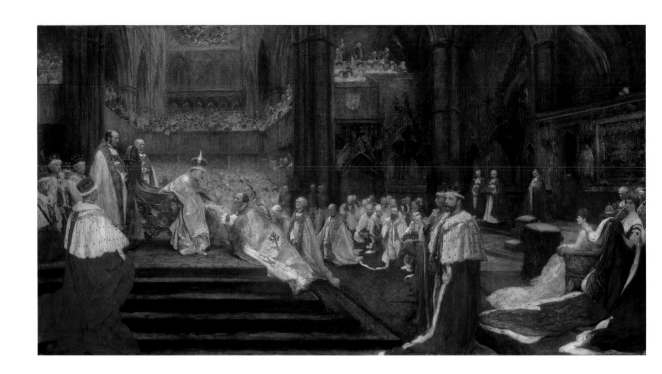

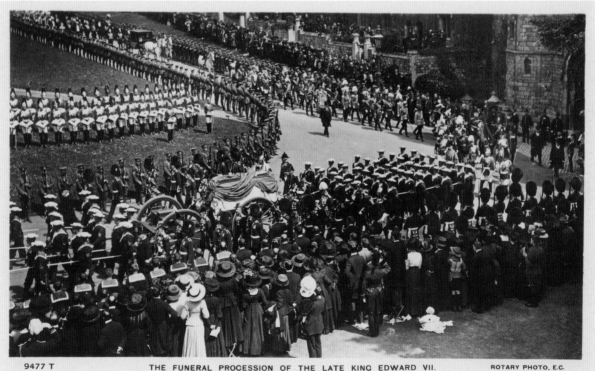

9477 T THE FUNERAL PROCESSION OF THE LATE KING EDWARD VII. ROTARY PHOTO, E.C.
IN WINDSOR CASTLE.

public pageants and ornamental spectacles, focusing on the rites of passage of monarchs and their children, and subsequently made available to large audiences thanks to the invention of photography, were supposed to bring and to bind the monarch's subjects together in a shared sense of national veneration and imperial homage (figs.9, 10). Portraits of individual sovereigns, or of a king and queen posing together with their children, might convey an image of royal authority, distance and command or, alternatively, of a happy, homely, companionate, loving, exemplary family (fig.11). The projection of royal images, on coinage and latterly on stamps, and the installation of royal coats of arms on or in official buildings, brought the monarchy into the daily lives of many people and at many levels. And in more recent times, the advent of the mass-circulation press, of the newsreels, the wireless, television and, in our own day, of social media, means that images of monarchs, their consorts and their families are now instantly and globally available – as, also, are many of the most intimate details of their private lives.

But even in earlier eras, there was what we would now term a credibility gap that existed between the intended aim of regal projection and monarchical enhancement, and the actual outcome – although the width of that gap, and the anxieties thereby engendered, has varied considerably over time according to (among other things) the skills of the sovereigns' spin doctors, the standing of the royal individuals in question and the broader climate of public opinion. Moreover, the creative arts, especially architecture, music and portraiture, have not only supported, embellished and aggrandised royal regimes across the centuries and around the world, but have also been driven by their own internal aesthetic dynamics, which have not always been helpful to monarchy. In particular, the advent of modern architecture, abstract art and atonal music, which reject historical resonance, accurate visual representation and rousing marches or patriotic melodies, means that relations between royal courts and the creative arts have become far less close than once they were. Is it just coincidence that the twentieth

9 *The Homage-Giving: Westminster Abbey, 9th August, 1902*
John Henry Frederick Bacon, 1903

Oil on canvas
National Portrait Gallery, London
(NPG 6058)

10 *The Funeral Procession of the Late King Edward VII in Windsor Castle*
Published by Rotary Photographic Co. Ltd, 20 May 1910

Gelatin silver postcard print
National Portrait Gallery, London
(NPG x38524)

11 *Princess Anne, Prince Charles, Queen Elizabeth II, Prince Philip, Duke of Edinburgh*
Lord Snowdon, 10 October 1957

Gelatin silver print
National Portrait Gallery, London
(NPG x32733)

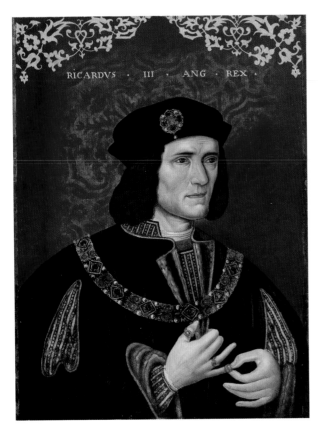

12 **King Richard III**
Unknown artist, late sixteenth century

Oil on panel
National Portrait Gallery, London
(NPG 148)

century witnessed both the rise in popularity of modes and forms of architecture, painting and composition less favourable to royal purposes and less amenable to royal uses, and the overthrow of so many crowns and dynasties? And in today's world of mass media and instant information, it is far more difficult for palace officials to control royal image-making than it was in earlier times. Walter Bagehot believed that mystery was essential for monarchy and that too much 'daylight' should not be let in on the 'magic'; but now the daylight pours in to an extent and in ways that he could never have imagined, and that development is surely irreversible.

Ever since Henry VII succeeded Richard III (fig.12) after his victory at the Battle of Bosworth Field in 1485, the English monarchy has been, like most crowns and thrones, in a constant state of flux, even as its image-makers and propagandists have sought to deny this – sometimes successfully, sometimes not. Although ostensibly an English then a British monarchy, the royal line has more

often than not been sustained by the recruitment of outsiders from other lands. The Tudors were Welsh not English, and the Stuarts were Scottish, while William of Orange was a Dutchman. The Hanoverians were German and the 'British' monarchy remained essentially Teutonic in its personnel until the early twentieth century. Two of Henry VIII's wives were foreign: Katherine of Aragon and Anne of Cleves. Queen Mary married King Philip II of Spain. (Elizabeth I did not marry, but she was fluent in French and German, and read Latin and Greek for pleasure.) The spouses of James I, Charles I, Charles II and James II were, respectively, Anne of Denmark, Henrietta Maria of France, Catherine of Braganza and Mary of Modena. All the Hanoverian monarchs, from George I to William IV, were married to German princesses. Queen Victoria wed another German, from the minor princely house of Saxe-Coburg-Gotha, the future Edward VII took Princess Alexandra of Denmark for his wife and the future King George V was betrothed to Princess Mary of Teck (as celebrated in the marriage souvenir of 1893, fig.13). One of the few attributes that Queen Victoria shared with her eldest son was that both were fluent in French and German. Only during the First World War did the British monarchy cut loose from its continental connections, but even then it did not do so entirely. One of the sons of King George V, the Duke of Kent, married Princess Marina of Greece; while Prince Philip, so often regarded as a bluff, no-nonsense Englishman, is in fact descended from the Greek, Scandinavian and German royal houses.

But it is not just that the English and British monarchs and their spouses have so often been cosmopolitan and continental, rather than English or British, in their backgrounds; there have also been many domestic

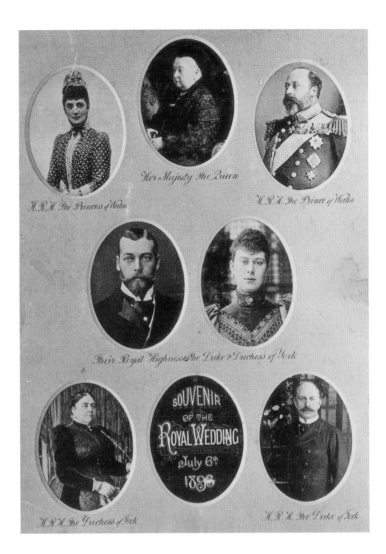

13 *Souvenir of the Royal Wedding, July 6th, 1893*
Unknown photographer, 1893

Half-tone reproduction
National Portrait Gallery, London
(NPG P1700(1c))

discontinuities and disruptions. King Henry VII won the throne by defeating Richard III, the last of the Plantagenets, on the battlefield, and so began the rule of the Tudors. On the death of the unmarried Queen Elizabeth I in 1603, the English crown passed to King James VI of Scotland, the first of the Stuarts, whose mother, Mary Queen of Scots, had been executed on Elizabeth's instructions. In 1688, Parliament deposed King James II and invited William of Orange to take his place. Anticipating the death of the childless future Queen Anne, and determined to keep the (by then) Catholic Stuarts from the throne, Parliament passed the Act of Settlement in 1701, which bestowed the

British throne on the Electors of Hanover, minor German princelings and only distant relatives of the reigning monarch. These dynastic discontinuities, often artfully concealed by the production of elaborate genealogies (fig.14), were not the only form of royal instability. All Tudor monarchs faced significant revolts: Henry VII in the late 1480s and 1490s, Henry VIII with the Pilgrimage of Grace in 1536, Edward VI with Kett's Rebellion in 1549, Mary Tudor with Wyatt's Rebellion in 1554, and Elizabeth with the Rising of the North in 1569 and rebellions in Oxford and Essex during the closing years of her reign. But these were as nothing compared to the Civil War (1642–51),

THE ROIAIL PROGENEI OF OUR MOST SACRED KING IAMES BY THE

grace of God King of E.S.F & I. &c. Decended from ÿ victorius King Hÿ 7 & Elizabeth his wife wherin ÿ 2. deuided famis ware vnited together

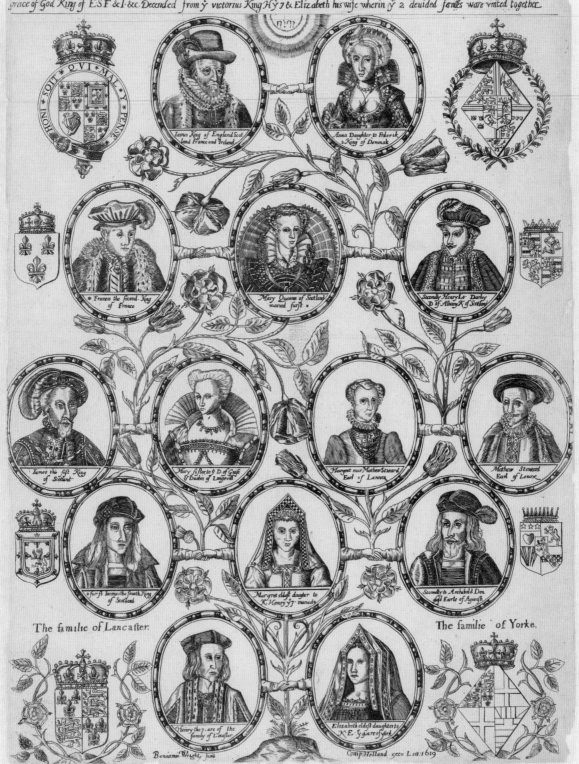

The familie of Lancaster.

The familie of Yorke.

Beniamin Wright fecit

Comp: Holland excu Lon: 1619

as a result of which King Charles I lost both his throne and his head, more than a century before the American colonists rejected George III and the French revolutionaries executed Louis XVI, which meant that between 1649 and 1660 England was a republic. By comparison, the peaceful ejection of James II in the Glorious Revolution of 1688 was a relatively modest and pacific affair, although no less significant in the constantly disrupted history of England's royal dynasties; and the Jacobite Rebellions of 1715 and 1745 were a sign that, during their early decades on the English throne, the Hanoverians were far from being secure.

Abrupt changes of dynasties, along with revolts, rebellions and revolutions, were not the only ways in which the monarchies of England and Britain, like those existing elsewhere in Europe and far beyond, were subject to uncertainty and risk. For even as the Tudors, Stuarts and Hanoverians survived for more than one hundred years, the succession within each dynasty often took unexpected turns. Henry VIII would never have been king had his elder brother, Prince Arthur, not died in 1502. With both an elder sister (the future Queen Mary) and a younger brother (the future Edward VI), it was highly unlikely that Elizabeth would accede to the throne, let alone reign for as long as she did. Like Henry VIII, Charles I would never have become king had his elder brother, Henry Frederick, Prince of Wales, not predeceased him in 1612. George III, although undoubtedly in the direct line of Hanoverian succession, would not have become king as early as 1760 had his father, Prince Frederick, eldest son and heir of George II, not died at the age of forty-four in 1751. And it bears repeating that when Victoria, the future George V, the future George VI and the present Queen were born, not one of them was first in line of succession to the throne. To those unforeseen royal successions must also be added one example of deliberate

and calculated discontinuity, which took place in 1917 when George V, worried that Saxe-Coburg-Gotha, which had been the royal family's patronymic since Albert had married Victoria, seemed insufficiently British, changed the name to Windsor. And, in deliberately distancing his royal dynasty from his German cousins across the North Sea, he allegedly provoked the Kaiser to make a rare joke, when he observed that he eagerly looked forward to the first production of that well-known comic opera *The Merry Wives of Saxe-Coburg-Gotha*.

Thus understood, the continuation and survival across the centuries of the English, and subsequently the British, monarchy looks far more certain in retrospect than it often did during the many crises of individual or dynastic succession that have taken place since 1485. Nor has the twentieth-century monarchy been free of such crises, as the name change of 1917 and the abdication of Edward VIII in 1936 make plain – and it was fortunate for George VI and for the present Queen that Edward sired no heir, who might have set up an alternative court and provided a focus for opposition and popular disaffection. Yet the greatest threats that the British monarchy has faced in modern times have not come from their own dynastic problems, but from the two world wars. In 1917, and again in 1941, it seemed as though Britain might be defeated and, had it been forced to surrender to Germany, the monarchy might have been swept away, even though George V and George VI were much less involved in military matters than the Tsar or the Kaiser or the Emperor Hirohito. It is, then, one of the ironies of history that the two British Georges owed their thrones to the interventions of the Americans late in the First World War, and to the involvement of the Americans and the Russians during the Second – two republican nations that had come into being by rejecting the monarchies and hierarchies of 'Old Europe' as a result of revolutions that were much more permanent and transformative in their impact than the English revolt of the mid seventeenth century. So, while the position of the present Queen may seem serene and secure, it is in no sense the inevitable outcome of an inexorably organic pattern of evolution, even though many royal images, created across the centuries, may seek to proclaim to the contrary.

14 *The Roiail Progenei of our Most Sacred King James*
Benjamin Wright, after unknown artist, published 1619

Line engraving
National Portrait Gallery, London
(NPG D1370)

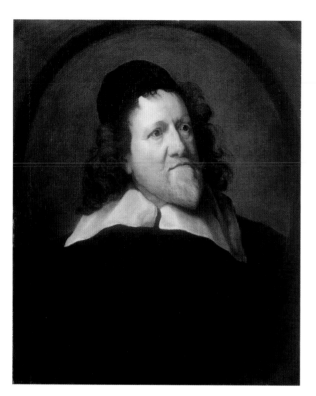

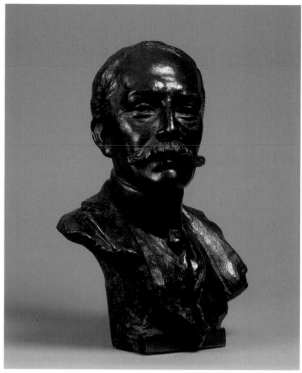

ART AND CULTURE IN SERVICE OF THE CROWN

As can be seen throughout this volume, one of the prime purposes of royal art and artifice has always been to convey what is often only the illusion of firm and secure patriotic identity, of reassuring dynastic continuity and of consequent political stability. Nor is this the only paradox, for many of the most resonant images of the English/British monarchy, rooted deeply in the national psyche, have been created by artists of foreign origin, most famously Hans Holbein, Peter Paul Rubens, Anthony van Dyck, Johan Joseph Zoffany and Franz Xaver Winterhalter. These men were of German or Flemish ancestry and, with the exception of Holbein, they all painted other royal families in other European courts. When Inigo Jones (fig.15) designed the Banqueting House for James I as part of Whitehall Palace, he introduced neo-classical architecture into England, which he had learned as a result of studying with Andrea Palladio in Italy. Britain's most famous court composer, George Frideric Handel

15 **Inigo Jones**
After Sir Anthony van Dyck,
c.1632

Oil on canvas, feigned oval
National Portrait Gallery, London
(NPG 603)

16 **Sir Edward Elgar, Bt**
Percival Hedley, 1905

Bronze bust
National Portrait Gallery, London
(NPG 2219)

17 **George Frideric Handel**
Thomas Hudson, 1756

Oil on canvas
National Portrait Gallery, London
(NPG 3970)

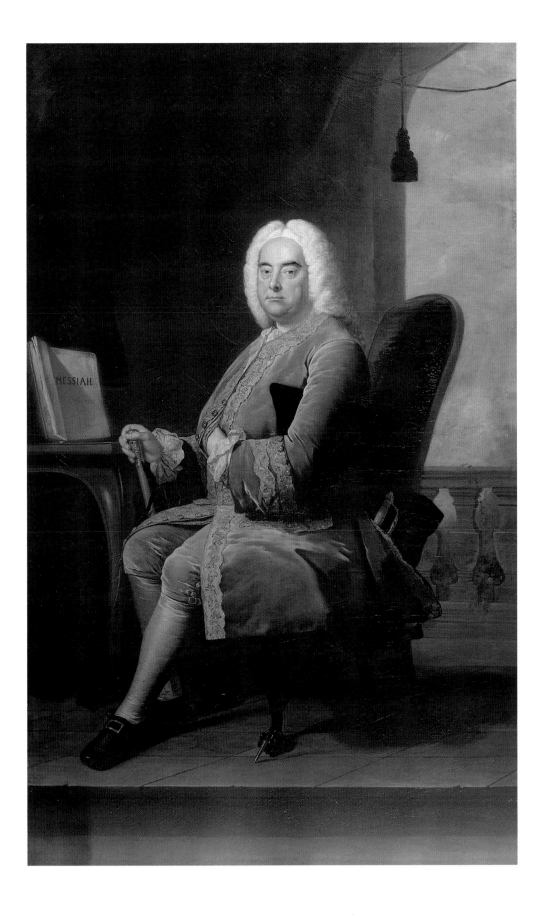

18 **The Family of Henry VIII**
British School, c.1545

Oil on canvas
Royal Collection, London

(fig.17), was born at Halle, and worked in Germany and Italy before arriving in Britain in 1712, where he produced such ostensibly 'English' works as his *Water Music*, *Music for the Royal Fireworks* and the coronation anthem *Zadok the Priest*. And while Sir Edward Elgar (fig.16) is often regarded as epitomising the very spirit of England, expressed in his *Pomp and Circumstance* marches and his two symphonies, his inspirations were in fact such middle-European composers as Johannes Brahms, Antonín Dvořák and Richard Wagner. Like their royal masters, these were cosmopolitan men in cosmopolitan professions, drawing on a wide range of European traditions and cultural allusions in their work.

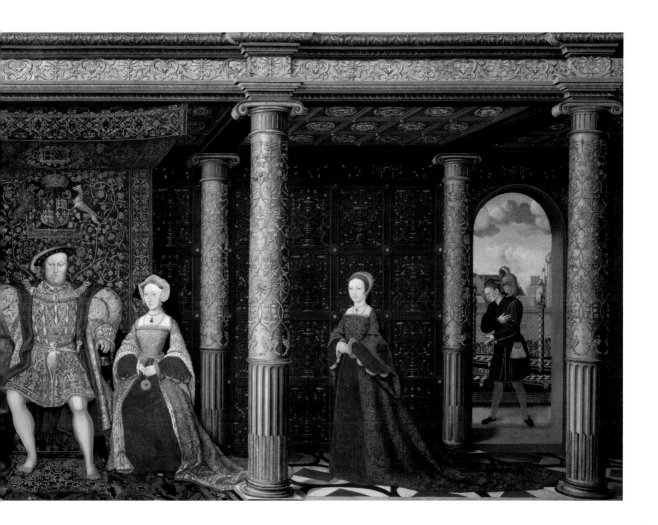

It is one of the many ironies and paradoxes of royal image-making that creative figures with broad outlooks and wide-ranging perspectives have often been employed to bolster the images of kings and queens as icons of national identity or imperial cohesion. And those responsible for producing portraits or photographs of monarchy have often been urged to establish, or seen their task as enabling, comforting and confirming, links with earlier royal pasts that were, in reality, often illusory. Zoffany's paintings of King George III and his family contained many allusions to earlier royal portraits by van Dyck, as if insisting that the execution of King Charles I and the Glorious Revolution of 1688 had never in fact

happened. In the same way, but in even more exaggerated form, Cecil Beaton's photographs of Queen Elizabeth, the consort of George VI, taken in 1939, depicted her as a romantic 'fairy queen', wearing spangled crinolines of lace and tulle, and adorned with diamond tiaras, necklaces and stars, who might have stepped straight from a Winterhalter painting. But between Winterhalter and Beaton, the royal family had changed its name, King Edward VIII had been forced to abdicate, and Elizabeth herself was the first queen consort who did not come from a royal house since Henry VIII had married Anne Boleyn, Jane Seymour, Katherine Howard and Katherine Parr. As such, the Beaton images were almost pure

make-believe, projecting a fantasy world of escapist royal nostalgia and illusory royal continuity – and, on his part, deliberately so.

Such fanciful image-making also carried the risk that portraiture might collide (rather than collude) with political realities. Holbein's famous depictions of the Tudor dynasty, centred on Henry VIII (fig.18), proclaimed that it was much more united and securely established than in fact it was. Van Dyck's magnificent equestrian portraits of Charles I became distinctly unconvincing in the light of the king's subsequent trial and execution. Allan Ramsay's rendering of a very regal George III at the time of his accession (fig.36) appears equally unpersuasive given the later loss of the American colonies. Depictions of kings and queens and their children, embodying what Walter Bagehot termed 'a family on the throne', have also often backfired, as with the pictures of domestic royal harmony and amity painted by Zoffany (George III and Queen Charlotte), Winterhalter (Victoria and Albert) and Lavery (George V and Queen Mary) – see figs.37, 38, 20. For these sentimental tableaux all belied the less wholesome, less *gemütlich* reality: without exception, George III's sons turned out badly; Victoria disliked childbirth and was far from being a doting mother; and while George V was in many ways an exemplary father of his people, he was far from being a good father to his children. In the same way, the television documentary *Royal Family* (1969) depicted the Queen, Prince Philip and their children as happy, contented and empathetic in what seemed a recognisably middle-class way. But the subsequent unravelling of the marriages of Princess Anne, the Duke of York and (especially) the Prince of Wales, again suggested that this was something of an illusion.

Those who seek to manage and manipulate royal images have never been assured of success, and in today's world of 24/7 news, where very little is confidential, their task is harder than ever.

19 **Prince George of Cambridge, Prince William, Duke of Cambridge, Queen Elizabeth II, Prince Charles**
Jason Bell, 23 October 2013

Inkjet print
National Portrait Gallery, London
(NPG x138989)

20 *The Royal Family at Buckingham Palace, 1913*
Sir John Lavery, 1913

Oil on canvas
National Portrait Gallery, London
(NPG 1745)

GVLIELMAS. CONQISTER.

MAKING MONARCHY: THE CHANGING FACE OF POWER

Tarnya Cooper

Up until the twentieth century, representing the features of striking grandeur and stable authority were the two components most critical to a royal artist. In the eyes of the monarch's subjects, royal portraits promoted esteem of their ruler's personal qualities, as well as respect and even veneration. The royal artist's task usually required the depiction of extraordinary splendour in dress and setting, often in works of substantial scale, with the standard emblems of rule, such as the crown, orb and sceptre. But the secret of outstandingly successful royal portraits was to combine two contradictory concepts: wonderment at the awe-inspiring majesty of their person and the tantalising impression of real insight into the monarch's appearance and character. Throughout the long period from the first Tudor reign to the present day, artists have achieved this in very different ways, and surprisingly few set formulas have prevailed in British royal portraiture over this 500-year period. Dependent on the characteristics of the monarch, the political contexts and the style of the age, royal images at their best could reflect raw brutish power, as with Henry VIII, serene and icy authority, as with Elizabeth I, suave and fashionable prowess, as with

Charles I and Charles II, grand and effortless elegance, as with George III, sweet maternal charm, as with the young Victoria, or calm respectable formality, as in portraits of George V and George VI.

This essay explores the production, the contexts and the varied purposes of the British royal image over the long history from the Tudors to the Windsors, examining along the way some of the most important and remarkable royal portraits, as well as less well-known images, often produced in multiple form to champion the visualisation of state power through monarchy. From the Tudor period onward, painted, sculpted, drawn and printed images of the monarch were made to serve an increasing range of different functions for a widening market. The purpose of an image determines its scale, the materials used, its composition and iconography, cost and often the meanings its first audience placed upon it.

Alongside the need for personal insight and the inspiration of awe, royal images had to create the illusion of permanence and stability. Portrait painters achieved this in a variety of ways, from the prominent display of royal heirs and wider family to the use of architectural devices, emblems and the repetition of individual motifs borrowed from earlier royal portraiture. For example, carved statues of the kings of the realm had long appeared on funerary monuments in the cathedrals where they were buried, but

William I
Detail of fig.22

a set of sculpture kings from Edward the Confessor onward was also installed in the interior of Westminster Hall during the reign of Richard II, providing an early precedent championing the continuity of unified monarchy.[1] Royal portraiture appeared in stained-glass windows in cathedrals, abbeys, private chapels and parish churches, as well as university chapels, throughout the medieval period and into the Tudor period, as seen, for example, in the extensive Royal Window, depicting Edward IV and family, at Canterbury Cathedral, the scheme of several monarchs, including Edward II, Henry V and John of Gaunt, at All Souls College, Oxford, or Henry VIII and Elizabeth of York at the parish church of St Nicholas, Stanford-on-Avon, Northamptonshire.[2]

This essay also explores some of the ways visual images were used to make statements of power through a likeness of the monarch that was usually first established in drawings, paintings or miniatures. The function and reach of royal portraits was considerable, and images have appeared on many different kinds of objects, including coinage, manuscripts, medals, woodcuts, engravings and items of jewellery, as well as painted surfaces of every type, all serving very different purposes. This visibility ensured – long before the invention of the national media – that the identity of the monarch as head of state infused national public consciousness. Images upon coins provided every subject with the opportunity to recognise an image of their ruler, imposed or otherwise. Coinage was widely used in Roman Britain, with examples showing the head of the emperor and, during the Anglo-Saxon period, rulers of smaller kingdoms within the realm appeared on some of the earliest coins minted in Britain with a resident ruler. One example is a silver penny (fig.21) showing Offa, King of Mercia from 757 to his death in 796, who is shown with a strong profile and distinctive headdress, providing an emblem of kingship rather than a portrait of a person.

From the medieval period onward, small-scale, more detailed images routinely appear within illuminated letters at the start of official documents on parchment, such as plea rolls, charters, grants and patents, ensuring the business of government was overseen and endorsed by a royal emblem. Realistically conceived painted portraits – using the technique of pigments mixed with a drying oil discovered in the early 1400s – took rather longer to become an established medium of representation in Britain and painted portraits of monarchs were only regularly commissioned from the early Tudor period. These were made for the monarch or their families to display in palaces, or to be exchanged in marriage negotiations, given as gifts to loyal courtiers, or sent abroad to foreign rulers as tokens of mutual regard. Portraits of monarchs were also commissioned by the nobility and gentry for display in their own houses to demonstrate their unerring loyalty to the Crown. Both loyal servants and distinguished soldiers would receive decorative medals, usually cast in silver, bronze or occasionally gold or copper, depicting an image of the ruler's head, either to wear or simply to keep as a souvenir. Fom the Tudor period onward, royal portraits were also made for public consumption in multiple copies (as prints and painted versions), allowing citizens of more modest means without royal connections to own and display a simple likeness of their king or queen within their home.

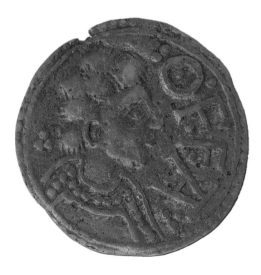

21 | **Offa, King of Mercia**
Unknown artist, c.796

Silver penny
National Portrait Gallery, London
(NPG 4152)

THE DEFINITIVE ROYAL IMAGE

In the early history of royal portraiture, images frequently settled into a largely standardised form of representation during the course of a ruler's reign, and these definitive images were then adapted and reworked by other artists. This process helped with recognisability and, looking back on the reigns of individual monarchs, it is possible to see how particular images emerged as influential examples, helping to define a reign and establish the reputation of the ruler. Taking the long view from Richard II to Elizabeth II allows us to see how the evolution of the monarch from an agent of divine power, to a figurehead of nationhood and empire, to a kind of moral exemplar came to be expressed in visual representation. The journey takes us through some lessons in the representation of power and popularity that stands as a testament to the invention of royal artists and shows that the crafted manipulation of appearances in the service of the state existed long before public relations and the idea of political spin came to be defined.

The design, content and symbolism of an authorised royal portrait was usually a collaborative process between monarch and artist, and the relationship between the two was vital in determining a monarch's reputation, within their lifetime, in the wider national and European sphere, and for posterity. The creation of the portrait would have been guided by the views of the monarch (either directly or as filtered through a court official) and influenced by their impressions of the portraits of their ancestors and predecessors, which were readily on display in royal residences, including Whitehall Palace, St James's Palace, Windsor Castle and, from the 1760s, Buckingham House, which was enlarged into a palace under Queen Victoria from 1837. Flattery was a prerequisite but, to be effective, the royal portrait had to be based within the bounds of reality, presenting enough of the true character to capture the viewer's imagination. The prevailing style and fashion of the age would also usually influence the monarch's taste. The monarchy have often been patrons of some of the most prodigious artistic talent, enticing the most highly skilled European artists to work for the court, as with Hans Holbein the Younger (c.1497–1543) for Henry VIII, Anthony van Dyck (1599–1641) for Charles I, and Frans Xaver Winterhalter (1805–73) for Victoria and Albert, but the discovery of painters or sculptors who could not only capture, but also perfect the period style or aesthetic, while simultaneously setting a dynamic and recognisable model of likeness, was not to be the lot of every reigning monarch. There were certainly monarchs, such as Queen Anne, George I and George II, who took little interest in the visual arts or who, for personal, religious or political reasons, eschewed the prevailing European style. This was the case with Elizabeth I, who had no interest in the kind of illusionistic painting where the skill of the artist could make sitters appear lifelike, a mode of representation that was popular across the whole of continental Europe. Instead, Elizabeth I preferred a more linear or diagrammatic painting technique without naturalistic shadows, following Reformation concerns regarding the role of images and their potential to deceive.[3]

Once a perfected royal portrait was established, it could be copied and adapted. Copies and versions of established portraits were often made by the artists' studio assistants as demand for a successful image grew. Yet in the early period, other experienced artists would be influenced by an original portrait and utilise the design, making similar versions, following drawn and painted face patterns that appear to have circulated between artists' studios.[4] The phenomenon of royal portrait sets encouraged the production of multiple portraits of monarchs, and these became particularly fashionable in the sixteenth and early seventeenth centuries. The earliest surviving set appears to have been devised for Henry VIII and dates from 1509–20; it includes Henry V, Henry VI, Edward IV, Elizabeth Woodville and Richard III.[5] Another later surviving example, known as the Hornby Castle set (fig.22), now only partially intact, dates from around 1597–1618 and depicts sixteen monarchs, from William I to Mary I. Such sets were designed principally to provide a lively visual narrative to British history at a time when audiences could already visit the theatre to see depictions of the lives of monarchs acted out on stage in history plays by William Shakespeare (1564–1616) and John Fletcher (1579–1625).[6] The sets could be made to order in different sizes and with coloured backgrounds as specified by the patron. Research has shown that the Hornby Castle set is

a product of a number of different workshops and it is likely that the commissions for individual kings and queens might have been placed with different studios in order to fulfil a large order to a deadline. In fact, for many of the early monarchs depicted in this set no lifetime portrait existed, so the likenesses are imagined, thereby indicating the emblematic nature of the idea of 'likeness'. In the seventeenth and eighteenth centuries, the widescale increase in the production of (and market for) printed images meant that the act of acquiring images of consecutive rulers became incorporated into print-collecting practices, and woodcut and engraved portraits of British royals were available from the early seventeenth century.[7]

Over one hundred years before the beginning of the Tudor dynasty, two remarkable portraits were painted of

Richard II, who ruled England from 1377 to 1399, providing powerful exemplars for later monarchs, while setting a tone of grandeur and authority as a standard feature for painted royal portraiture. These were images designed not simply to impress King Richard's subjects, but also to feed and promote his own personal narrative, a feature that remained pertinent in many later royal portraits. The image known as the Wilton Diptych (fig.23) depicts Richard II kneeling alongside his patron saint, John the Baptist, and the English saints Edward and Edmund. It was made in the last five years of his reign and appears to show him as a young boy of eleven, his age at the time of his coronation. This small diptych folded in half and was therefore portable; it was probably commissioned by Richard II himself for his private

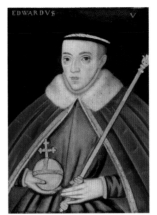
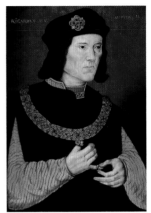
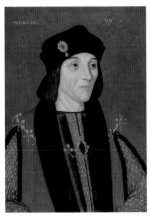
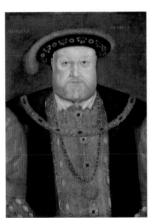
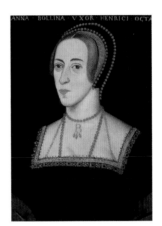
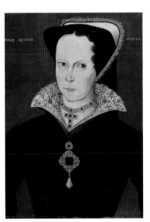

devotional use. On the opposite side of the diptych, the Virgin Mary stands holding the Christ child surrounded by eleven angels, who wear Richard's personal badge of a white hart. No other royal image harnesses the sacred so brilliantly. Richard's strong belief in the sacred nature of his own kingship appears to have been the motivation for this commission, as it visualises his idea of monarchy being ordained by the Virgin and by Christ. That the picture also includes a tiny image of England, painted on the orb of the cross of St George and held by an angel who offers it to Christ, must have enhanced its religious meaning for Richard. This seems to indicate that Richard's supplication to the Virgin was not simply for her to be his own protector, but that of the whole realm.[8] At around the same time, a large-scale image of Richard II was created

22 **Hornby Castle set of kings and queens from William I to Mary I**
Unknown artist, 1597–1618

Oil on panel
National Portrait Gallery, London
(NPG 4980 (1–16))

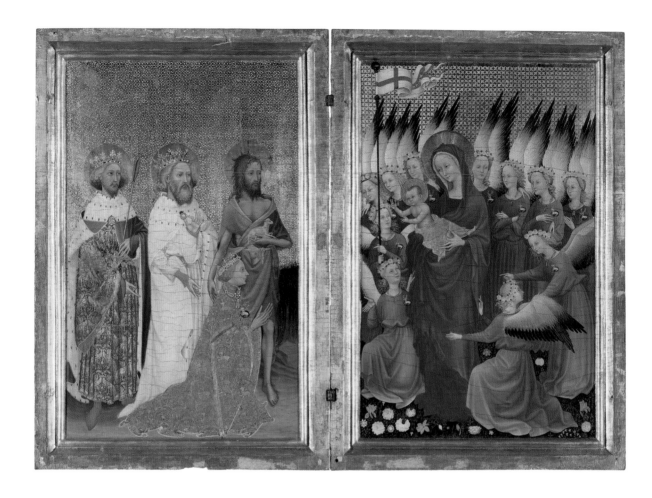

for display in the choir of Westminster Abbey (fig.24). This serene, impressive full-length portrait shows the king in a sober and contemplative pose, seated and directly facing the viewer as he would have appeared at his coronation, with robes, orb and sceptre. While it hung, this clever conceit would have made King Richard appear perpetually present within the Abbey, glorious in his acceptance of his royal duty. These images, as powerful as they are, did not ultimately help Richard to hold on to his throne and he was deposed just a few years later, in 1399, by the forces of Henry IV. Richard's large-scale image only survived by being fastened to the back of a door in the Abbey and was rediscovered in the Elizabethan period, when it appears to have influenced the portrait of Elizabeth I in her coronation robes (fig.71), likewise made towards the end of her reign.[9]

23 *King Richard II presented to the Virgin and Child by his Patron Saint John the Baptist and Saints Edward and Edmund (The Wilton Diptych)*
Unknown French or English artist, c.1395

Egg tempera on oak
National Gallery, London

24 **King Richard II's coronation portrait**
Unknown artist, possibly Andrew Beauneveu, c.1390

Oil on panel
Westminster Abbey, London

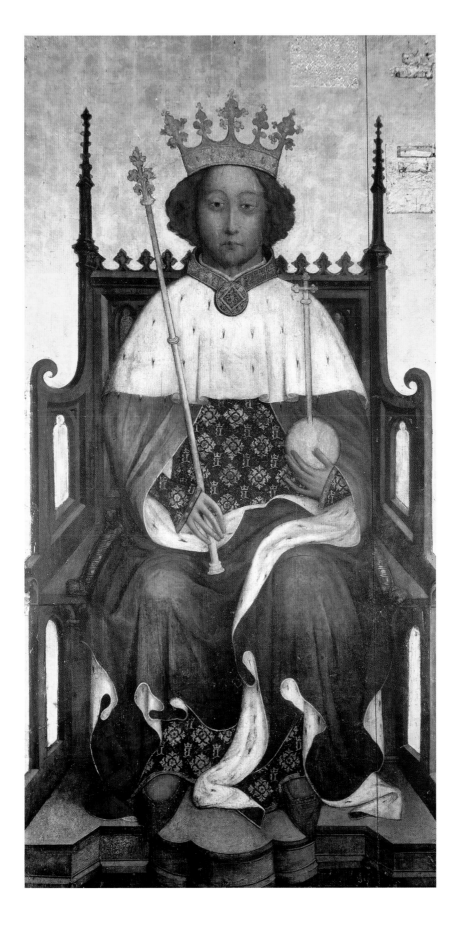

PERSONIFICATIONS OF POWER

During the reign of Henry VIII, painted portraiture flourished, developing from small head-and-shoulder images with simple backgrounds to large-scale depictions of the sitter in more richly decorative, realistic settings. Several portraits of Henry VIII were produced in the first twenty years of his reign before the arrival of the German artist Hans Holbein the Younger. None, however, convincingly captured Henry's authoritarian personality and brooding presence in the way so brilliantly crafted by Holbein around 1536–7. Henry commissioned Holbein to create a large-scale wall painting for the king's Privy Chamber at Whitehall Palace (now destroyed), depicting him with his recently deceased wife Jane Seymour, his father Henry VII and his mother Elizabeth of York behind. An arresting full-length drawing (known as a cartoon) of Henry VIII for part of this wall painting survives (fig.26) and provides a vivid portrait of the king's thick-necked features and massive bulk – made even wider by an elaborate, padded, fur-lined cloak – presenting him with the features of a charismatic, immovable saviour. His body stands defiant to his foes, his physical form cleverly turned into an emblem of heroic masculinity, strength and permanence. This was exactly the art needed to illustrate the raw and ruthless power exercised at the Henrician court. An inscription accompanying the lost wall painting celebrated the king's decisive action dismissing his 'worthless ministers' and triumphantly declared 'None greater was ever portrayed'.[10] Another painting by Holbein, possibly made the same year, using an expensive rich blue pigment and precious metals, shows a very similar composition, half-length (fig.25), and may have been made as a diplomatic gift.

Holbein's composition came to be adopted as the definitive image of the king, copied by other artists' workshops to create multiple versions both throughout his reign and across the sixteenth century.[11] Once established as successful, this full-length, wide-legged pose was also replicated for portraits of Henry's son Prince Edward, later Edward VI, whose portrait (fig.27), despite his very young age, was purposefully modelled on Holbein's commanding image of his father.

In 1554, the year of her coronation and marriage to Philip II of Spain, Mary I commissioned the émigré artist Hans Eworth (1520–74) to make her portrait, an image that may have been slightly idealised. Later that year, her father-in-law, Emperor Charles V, also commissioned the leading continental artist Antonis Mor (1516–c.76/7) to take her likeness. Years later, in the reign of Elizabeth I, it was recorded that Philip had cursed the portrait painters when he finally met Mary following their marriage.[12] This melancholy and cautionary tale may have made the young Elizabeth I wary of the false expectations portraiture could provoke, and her most important royal portraits were not the result of direct patronage but were apparently commissioned, or in some way orchestrated, by courtiers, admirers and even institutions hoping to gain royal favour. By the second and third decades of her reign, Elizabeth I had been well served by courtiers and statesmen

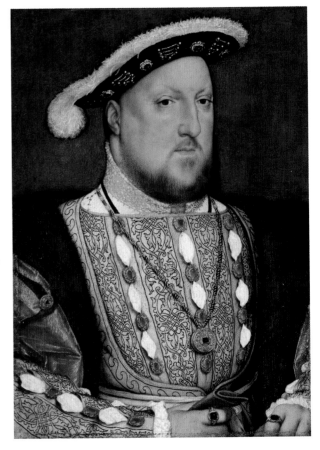

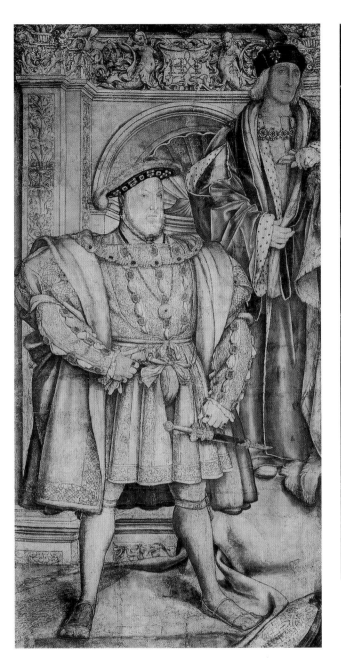

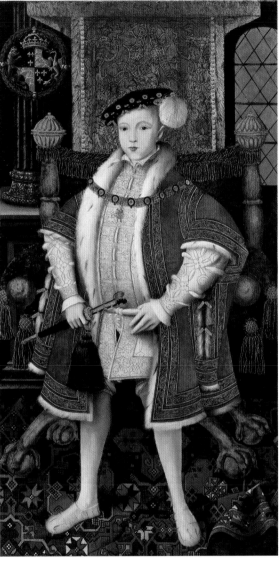

25 **King Henry VIII**
Hans Holbein the Younger,
*c.*1537

Oil on panel
Museo Nacional Thyssen-Bornemisza,
Madrid

26 **King Henry VIII,**
King Henry VII
Hans Holbein the Younger,
*c.*1536–7

Ink and watercolour
National Portrait Gallery, London
(NPG 4027)

27 **King Edward VI**
By a workshop associated
with 'Master John', *c.*1547

Oil on panel
National Portrait Gallery, London
(NPG 5511)

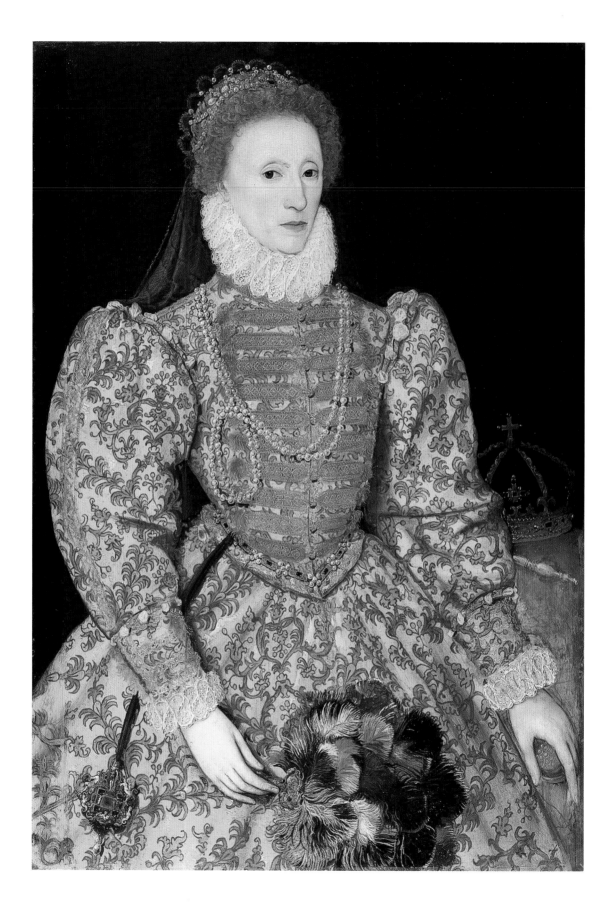

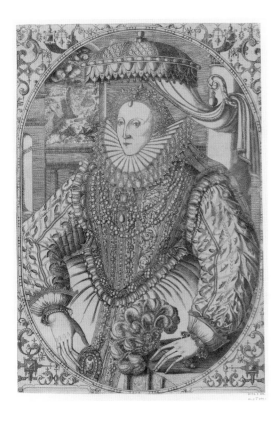

who authorised the production of portraits of increasing allegorical complexity, celebrating her unique nature as a virgin queen. One of the most important surviving images of Elizabeth I, painted from life, was also one of the most copied and adapted in her own lifetime. The portrait, known as the 'Darnley' portrait (fig.28), showing her in an embroidered dress and holding a brightly coloured feather fan, dates from *c*.1575. Curiously, the crown and sceptre on the table in the background have been painted by a less accomplished artist, and were probably added at the final stages at the request of a patron to ensure there was no ambiguity about the regal identity of the sitter. The success of this portrait relies upon the clever marriage of feminine elegance and steely authority, as found in the queen's cool stare out to the viewer, the formality of her upright pose, the sense of the impregnability of her military-style bodice, and the beauty of her complexion and curling golden locks. Little is known about the artist or the circumstances of its production, but it must have been created by a continental painter and, almost certainly, would have been sanctioned by the queen. The facial likeness perfected in this portrait came to be repeated in many later portraits (most with different costumes) over the next twenty years and allowed the queen to keep – at least pictorially – her youthful looks, while her clothes were updated, thereby maintaining the impression of an unchanging goddess, secure in her command of the realm.

Numerous printed images of Elizabeth I were produced in her lifetime, although few received royal approval. Most were made during the later part of her reign by émigré artists working in England in response to both local and continental demand. One example, where the queen's face is a schematised version of the 'Darnley' face pattern (fig.29), was probably engraved before 1590 and is signed by Jan Rutlinger, an artist from Germany working in England from *c*.1588 until his death in 1609 and who was employed by the Royal Mint. The costume and composition have been updated and it draws upon other painted and adapted versions of the 'Darnley' portrait.[13] However, the Rutlinger print exists in only two surviving impressions, indicating how ephemeral prints were at this early date, as they were regularly pasted directly onto walls in domestic interiors and consequently have rarely survived.

28 **Queen Elizabeth I (The 'Darnley' portrait)**
Unknown continental artist, *c*.1575

Oil on panel
National Portrait Gallery, London
(NPG 2082)

29 **Queen Elizabeth I**
Jan Rutlinger, *c*.1590

Engraving
British Museum, London

COURTLY STYLE AND MILITARY HEROISM

Perhaps more than any other monarch before or since, King Charles I had the most enduring interest in the representation of his own person and that of his family. He also had one of Europe's most talented artists at his disposal – the Antwerp-trained painter Anthony van Dyck. Van Dyck came to England for a second visit in 1632 and he went on to paint more than forty images of members of the royal family. His vivid and seemingly effortlessly realistic yet grand style was influenced by both Italian painting and his Antwerp master Peter Paul Rubens (1577–1640), who had painted an *Apotheosis of James I* for the ceiling of the Banqueting House at Whitehall Palace in 1632–4. Van Dyck's style had a dramatic effect on artists working in Britain for centuries to come, due to the sheer number of impressive and technically accomplished portraits he painted of English royalty and nobility, which remained within British collections. Among his portraits of King Charles I, perhaps the most impressive and impactful are the several very large-scale, full-length portraits of the monarch on horseback, painted for various palace locations between 1633 and 1640, now in the Royal Collection, the National Gallery in London, and the Louvre in Paris.[14] Yet it is in the portrait of *Charles I in Three Positions* (1635), that van Dyck shows his unsurpassed talent for capturing a strong likeness, while also endowing the monarch with a powerful sense of dignity, sober intensity and restrained elegance (fig.30). The king visited van Dyck at his own house on the river Thames at Blackfriars in June and July 1635, when several studies from the life appear to have been made. The portrait depicts the king from the front and from both sides, wearing a different costume in each pose. The painting was made as a model to be sent to the

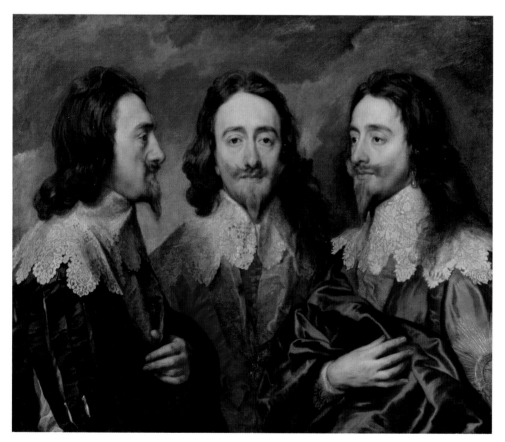

30 *Charles I in Three Positions*
Sir Anthony van Dyck, c.1635–6

Oil on canvas
Royal Collection, London

Italian sculptor Gian Lorenzo Bernini (1598–1680) to make a life-sized sculpture commissioned by Queen Henrietta Maria. By this date, van Dyck had painted the king many times, but he would have known that this portrait was destined to become the object of scrutiny by Italian artists and connoisseurs, and consequently may have taken particular care with the characterisation and all details of the handling.

Bernini's bust was made with a special licence granted by Pope Urban VIII as a gift for the king. The pope harboured the desire that Charles I would bring Britain back to the Roman Catholic fold, providing one example among many of how, by the seventeenth century, high-status art objects might be employed as ambassadors in the cause of international diplomacy. The completed marble bust was sent from Rome in April 1637 and presented to the king and queen, where it was greatly admired for the 'exquisiteness of the worke' and for the 'nere resemblance' it had to the king. [15] How Bernini had realised van Dyck's likeness in three dimensions can no longer be judged, however, as the bust was destroyed in a fire at Whitehall in 1698, along with many other precious royal images, including Holbein's wall painting of Henry VIII. Over twelve years after the triple portrait was painted, during the very different times of the Civil War, a cheaply produced woodcut print loosely utilised a version of van Dyck's likeness, with the addition of a military breastplate (fig.31). The propaganda print appears to have been made to celebrate the king's meeting with Parliament, 'to the great comfort and joy of all true hearted subjects', when Charles was a prisoner, and may have been circulated to rally support for the Royalist cause.

Once the powerfully appealing painting style of van Dyck had become established in the minds of patrons and in the admiration of artists as a perfected form of representation, it became hard to surpass. Decades and even centuries after the artist's death, admirers routinely 'quoted' from his poses and plagiarised his compositions in paint. It might perhaps be seen as curious that Parliamentarian commanders during the civil wars, and even Oliver Cromwell himself, employed artists who drew on a style created to promote autocratic royal power. Yet, to invent an entirely new style, suitable for the challenging purposes of the Commonwealth, seemed both unnecessary and largely beyond the powers of native artists in 1650, except, perhaps, for a miniaturist by the name of Samuel Cooper (1609–72). A small, unfinished sketch by Cooper, depicting the head of Oliver Cromwell (fig.32), undoubtedly from the life, became the model for several other finished miniatures by the artist. [16] Samuel Cooper was working for Cromwell from around 1650 and this sketch may have been made around 1653 – it is here that we catch a glimpse of how this determined, tenacious and charismatic leader may have wanted to be seen. The carefully observed likeness shows

King CHARLES his Royall welcom_

at his happy and gracious return towards his Parliament; Who came on Munday Feb. 15. to Holmby in Northhamptonshire in Peace. To the great joy and comfort of all true hearted Subjects.

London, Printed for G. R. 1647.

31 **King Charles I**
Published by G.R. London,
1647

Woodcut
Royal Collection, London

32 Oliver Cromwell
Samuel Cooper, c.1653

Watercolour on vellum
Collection of the Duke of Buccleuch

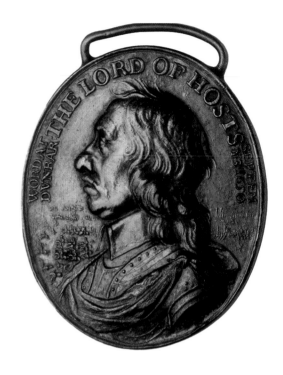

**33 Oliver Cromwell
(The Dunbar Medal)**
Thomas Simon, 1650

Silver medal
National Portrait Gallery, London
(NPG 4365)

a man in studied contemplation, with slightly unruly hair falling towards his shoulders and thinning on the crown of his head, with warts upon his chin and forehead, wearing a simple, unpretentious falling collar. According to later accounts, Cromwell famously wished to be depicted without flattery, including 'pimples warts & everything as you see me'.[17] If accurate, it may well be that Cooper took him exactly at his word. The likeness appears to have been employed in a later, slightly more idealised, finished oil painting by Peter Lely (now in the City Museum and Art Gallery, Birmingham).

Another image of Cromwell, employed this time for more popular consumption, was a medal issued to officers and men after Cromwell's victory at the Battle of Dunbar on 3 September 1650. Created by the talented medallist Thomas Simon (1618–65), it shows him in profile, bareheaded and wearing armour (fig.33). The likeness was taken from the life when Cromwell was in Scotland and depicts him in the midst of battle, while on the reverse is an image of Parliament shown in session. Although most of the design was suggested by Cromwell, he had requested that his own head should not be included. In the final

design, however, his request was not followed. The medal was designed to be worn and must have been produced in reasonable numbers (some cheaper copper examples still survive).[18] It would have provided a public face for the new Commonwealth following the death of Charles I the year before.

After the great schism of the civil wars, the execution of Charles I and the dissolution of the Protectorate Parliament, the Restoration of the monarchy in 1660 needed the appropriate visual trappings, emblems and sense of grandeur to reclaim the magic of authority owing to a hereditary head of state. A number of medals were commissioned in celebration of the Restoration, including one depicting Charles II's departure from exile in Holland (*The Embarkation at Scheveningen, 1660*), and another

the same year by the émigré John Roettier (1631–1703), showing him wearing the classical robes of a Roman hero and a military breastplate (fig.34), with the words *Felicitas Britanniae* (Britain's happiness) to commemorate his entry into London.[19] Such official tokens were important for marking both loyalty and forgiveness to those whose allegiance was essential, and many different medals continued to be made by a range of artists throughout Charles II's reign. One of the most impactful and definitive painted portraits of the restored king was a large-scale canvas by John Michael Wright (*c.*1617–1700), showing Charles II wearing his garter robes while seated beneath a canopy of state (fig.35).[20] Wright was a Roman Catholic and may have had contact with the exiled court during the Commonwealth rule, and was therefore a natural choice

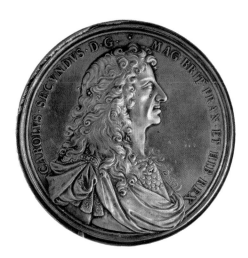

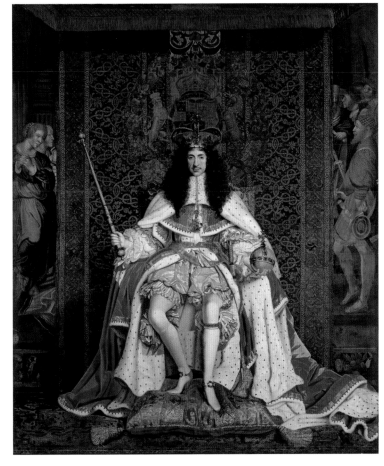

34 **King Charles II**
John Roettier, 1660

Silver medal
National Portrait Gallery,
London (NPG 6076)

35 **King Charles II**
John Michael Wright,
c.1676

Oil on canvas
Royal Collection, London

for royal portraits in the first years of the Restoration. The king is shown holding an orb and sceptre in each hand – the original regalia had been destroyed during Parliamentary rule, so the objects depicted here, including the crown of state, were made anew for the coronation.[21] The composition, with the king facing the viewer, owes something to the coronation portrait of Elizabeth I (fig.71), which in turn was influenced by the portrait of Richard II (fig.24), and shows the king proudly in command, grasping the sceptre in the way a military commander might grip a baton. The coronation took place in April 1661, but it is likely that this portrait dates from some years later, perhaps as late as 1676, when Wright mentioned in a letter that the 'King will sit to my great picture for the Citty this next month', indicating that the painting was already in existence and probably nearly completed.[22] The inclusion of tapestry in the background, depicting part of the Old Testament story of the Judgement of Solomon, is designed to allude to the king's good judgement, wisdom, experience and rightful sense of justice.

By the late seventeenth century, with portraits of succeeding monarchs James II and William and Mary, royal portraiture became both increasingly grandiose but also formulaic. Portraits in the short reigns of these monarchs depict them in a heroic style, full length, in armour, with swirling fabric creating a sense of showmanship and theatricality. In turn, from a contemporary perspective, Queen Anne, an invalid for much of her reign, seems poorly served by royal artists, who appeared inadequate to the task of capturing her sober Protestantism and loyal tenacious character alongside her royal status; the style of portraiture of the early 1700s was based on a formula perhaps better suited to flamboyant beauty than stable queenship. With the accession of the Hanoverian monarchs, who reigned from 1714 to 1837, portraiture gradually gave way to a more elegant, refined style, but also to a kind of studied naturalism not seen since van Dyck. Neither George I nor George II were particularly interested in the visual arts and both disliked sitting for portraits. With the exception of the artist Godfrey Kneller (1646–1723), it was not until the mid eighteenth century that artists emerged who could do justice to the character of monarchy and express the elegant grandeur, ambition and idealism of the age.

IDEALISM AND ROYAL CONTINUITY

One of the most successful royal portraits of the whole eighteenth century was painted by the Scottish artist Allan Ramsay (1713–84), who was one of the principal painters to George III, having been introduced by his tutor and favourite John Stuart, 3rd Earl of Bute. An impressive full-length portrait of the king, painted shortly after his coronation, shows him standing in his coronation robes, while also fashionably dressed in a gold coat and breeches (fig.36). The image was created with a pendant of Queen Charlotte, also full length in coronation robes, and the pair of portraits were painted to hang at St James's Palace. Unlike almost any monarch since Charles I, George III presents an impression of remarkable grace and elegance. He affects an attitude of studied insouciance, looking into the distance with one hand on his hip and the other resting on the table. The classical pillar, a device well known in Renaissance and Baroque portraiture, provides a sense of permanence and solidity appropriate to kingship, while the billowing drapes of fabric contribute an other-worldly effect that seems to present the visual equivalent of the sound of a heralding trumpet. This remarkable grand-manner portrait became the most copied image of its time, and Ramsay and his studio worked for the remainder of his career creating versions for the nobility at home, but, more predominantly to be shipped abroad, where they were displayed in the official residences of ambassadors and governors across Britain's colonial territories. It is estimated that Ramsay's studio produced perhaps as many as 200 images (including around 153 pairs) and, in this context, far from the shores of Britain, the portraits became emblems of state power, intended to elicit a new sense of patriotism, inspire a feeling of awe at royal presence and grandeur, and also convey a sense of the elegant and orderly rule that Britain hoped to bring to the colonies.[23] The fate of many of these portraits is unknown, but some, perhaps most,

36 **King George III**
Allan Ramsay, c.1761–2

Oil on canvas
Royal Collection, London

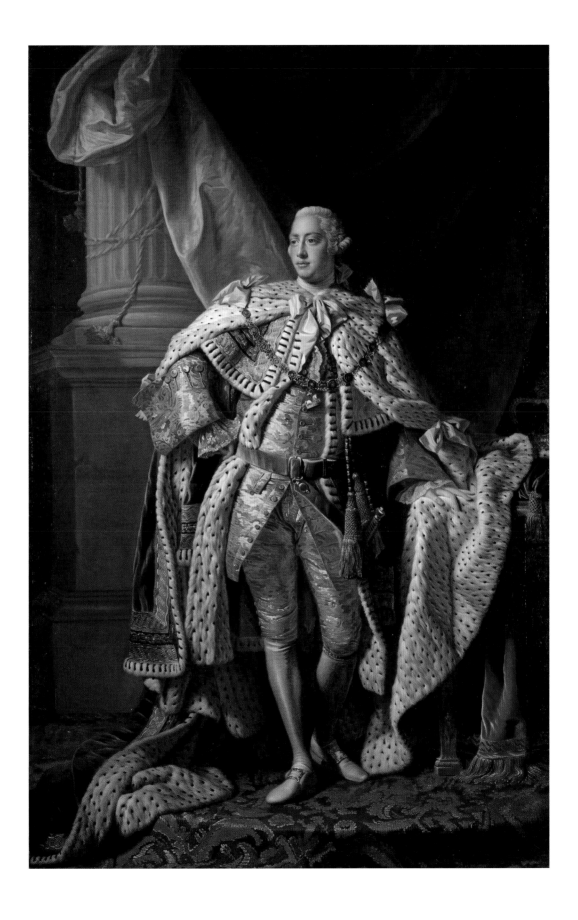

may have been symbolically destroyed or discarded when countries gained their independence from Britain.

A portrait of Queen Charlotte seated with her two eldest sons, the two-year-old Prince of Wales (the future George IV) and one-year-old Prince Frederick, was painted by the German artist Johan Zoffany (1733–1810) around 1765 (fig.37). The spacious and playful composition creates a dynamic impression of domestic harmony not previously seen in royal portraiture. Zoffany became known for informal 'conversation pieces' – portraits in domestic settings providing a lively impression of a particular moment in time, while simultaneously demonstrating the taste and characters of the sitters. This particular scene takes place in a room at Buckingham House and the composition is cleverly constructed to provide a sense of expectation, through the use of doorways, reflections in mirrors and the significant placing of objects, almost turning the image into a scene from a stage play. The children both wear the equivalent of today's fancy dress outfits, costumes that were recorded as ordered by the royal household very shortly before the portrait was painted. George wears the costume of the warrior Telemachus, the son of Odysseus (an exemplar for princes across Europe), while Frederick is dressed as a Turk. The portrait of the young queen, who was described in 1761 as 'pale and very thin', but also 'sensible and genteel', accords well with other miniatures from around the same date. George III and Charlotte went on to have thirteen surviving children, categorically securing the royal succession, and such images set a new tone in royal portraiture, celebrating the familial harmony particular to the Georgians after the infertility of the latter Stuarts.

With the accession of Queen Victoria in 1837, her marriage to Prince Albert and the arrival of a stream of royal children, the opportunities for royal family portraits in the

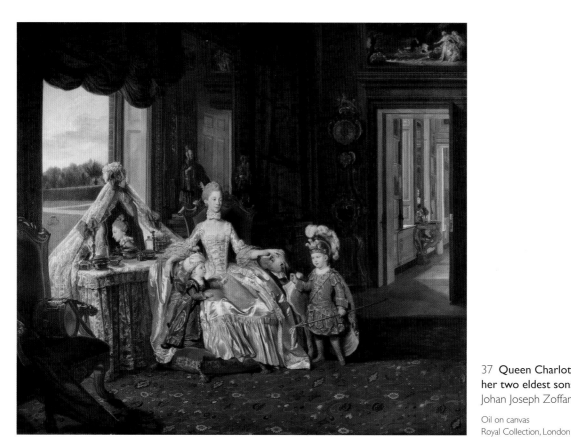

37 **Queen Charlotte with her two eldest sons**
Johan Joseph Zoffany, c.1765

Oil on canvas
Royal Collection, London

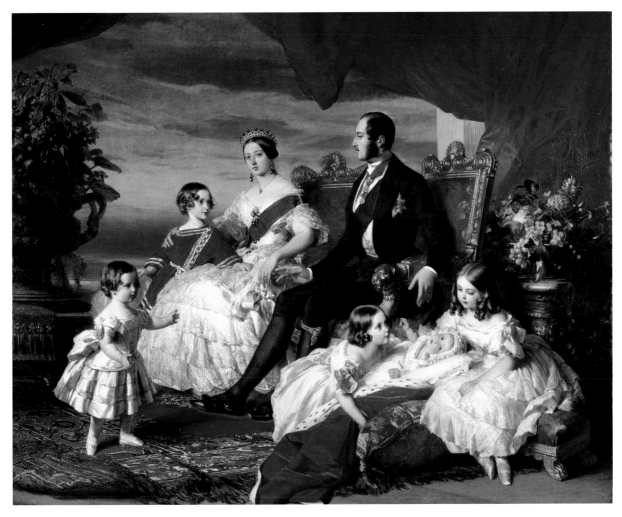

38 The Royal Family in 1846
Franz Xaver Winterhalter, 1846

Oil on canvas
Royal Collection, London

39 The Royal Family in 1846
Samuel Cousins, after Franz
Xaver Winterhalter, first
published 20 March 1850,
republished 1853

Mixed-method engraving
National Portrait Gallery, London
(NPG D48098)

1840s and 1850s were manifold. One of the most successful and best-loved images was painted by the German artist Franz Xaver Winterhalter in 1846 and depicted Queen Victoria, Prince Albert and five of the royal children (fig.38). In contrast to preceding images of the family, it captured a mood of bright and tender felicity that also upheld Victoria's distinction as monarch. The queen is shown seated, with one arm around Edward, Prince of Wales (later Edward VII), signalling a sense of royal continuity. Victoria wears evening dress, while Albert is in court dress, but both also display the Order of the Garter, providing a clear sense of their unerring devotion to their duty to the realm, even in the midst of family life. The portraits are elegantly idealised, while the female royal children, Princesses Victoria and Alice to the left, already display the virtues of maternal care with their sister Princess Helena. The oblique angle of the two chairs, placing the queen both at the centre of the image, but also set back further from the viewer than Albert, creates a sense of distance and orderly decorum. Like the portrait of Queen Charlotte and her sons, the movement within the picture provides an active sense of a moment in time, with the infant Prince Alfred tottering across the carpet towards his sisters. It was this almost photographic quality that appeared to give viewers a privileged insight into the domestic life of the royals. On its completion, the painting was displayed to the public at St James's Palace in 1847, where it is estimated to have been seen by over 100,000 people, and thereafter was hung at Osborne House, the family's private residence on the Isle of Wight. Victoria expressed her delight at the painting, complimenting the likenesses and comparing it with the work of the Italian Renaissance artist Paolo Veronese in its 'beautiful, brilliant fresh colouring'.[24] Not all critics agreed with the queen, however, and some voiced anxiety that a foreign artist should have gained such royal approval, yet Winterhalter went on to paint at least one hundred oil portraits of the royal family, returning to England each year to paint at Buckingham Palace or Windsor Castle. The success of the image in the popular imagination was secured by the production of an impressive large-scale engraving in 1850 (fig.39) by Samuel Cousins (1801–87) – nearly 1,000 copies were produced at a price within the reach of the patriotic middle classes.[25]

DUTY AND DIGNITY

In 1913, the year before the outbreak of the First World War, the society artist Sir John Lavery (1856–1941) began to paint a large-scale portrait of George V and his family, which was presented to the National Portrait Gallery the same year (fig.20). The idea was that the picture would be inspired by Winterhalter's 1846 painting of Victoria and her family. The resulting image, however, shown at the Royal Academy that summer, provides a much more imposing, formal and less sentimental impression of monarchy. The decision to include King George, Queen Mary and only two of the royal children, the Prince of Wales (later Edward VIII), aged nineteen, and the Princess Mary, just on the cusp of adulthood, ensured the mood of the picture was one of correct orderly elegance rather than family intimacy. The setting is the White Drawing Room at Buckingham Palace, where Lavery set up a temporary studio to undertake the initial oil sketches (now in the Royal Collection and Ulster Museum, Belfast) to establish the overall composition, which was approved by the queen. The resulting picture is impressive in scale and appears to us today as much a portrait of the grandeur of the environs of monarchy as it is of individuals, and provides a sense of constitutional monarchy as an established institution. In the process of painting the portrait, Lavery made a number of changes, in particular moving the figure of the young Prince of Wales from the right of his mother and sister to their left, ensuring the group became more unified and the prince himself less distant. Both the king and queen took a great interest in the progress of the picture and visited Lavery in his London studio as the work was being finished, even requesting to paint the finishing touches to the blue of the garter ribbons themselves. In the year 2000, the picture inspired the artist John Wonnacott (b.1940) to paint another very large-scale royal portrait of the Queen, the Queen Mother, Prince Philip, Prince Charles, and Princes William and Harry, in the same White Drawing Room (fig.167).

Like the Lavery group, many highly significant royal portraits in more recent years were not commissioned by the royal family for their own interiors, but for public view or the offices of organisations where they served as patrons.

One example is a remarkable portrait of Prince Albert, Duke of York (later King George VI), by the painter Meredith Frampton (1894–1984), which was commissioned for the charity Barnardo's Homes, of which the sitter was president (fig.40). It was painted in 1929, seven years before the abdication of his brother King Edward VIII. Sittings for the portrait took place in the artist's studio in St John's Wood in London. The Duke wears the full dress uniform of a Royal Navy captain and the artist has taken great care to copy exactly the details of his uniform, which was left in the studio for that purpose. The cool and subdued tone of the painting, with a marble pillar and a green-blue tablecloth, and with Prince Edward's head framed against a pinkish-grey background, sets a mood of serene and orderly elegance. Following the sitter's accession to the crown and his subsequent coronation, the portrait was shown at the Royal Academy's Summer Exhibition in May 1937. While there, the picture was discussed by the royal family and was considered by the king to be the best portrait ever painted of him. Frampton's starkly lit, exacting and meticulous style was influenced by the French artist Jean-Auguste-Dominique Ingres (1780–1867), but

40 Prince Albert, Duke of
York (later King George VI)
Meredith Frampton, 1929

Oil on canvas
National Portrait Gallery, London
(NPG L214)

also by seventeenth-century masters, such as the Spanish artist Francisco de Zurbarán (1598–1664). His portrait of the prince is imbued with the dignity of the office, while allowing the humanity and character of the person to speak on equal terms, creating a sense of psychological insight – a characteristic relatively rare in royal portraiture.[26]

The demand for the likeness of Her Majesty Queen Elizabeth II has been a constant feature of her long reign since 1952. Indeed, she is one of the most, if not *the* most, painted and photographed people in the world. Artists as varied as Pietro Annigoni (1910–88), Cecil Beaton (1904–80), Andy Warhol (1928–87) and Lucian Freud (1922–2011), as well as a vast number of others, have responded to the challenge of depicting a well-known face and creating an image of a modern monarchy in different and sometimes provocative ways. These images often tell us as much about the culture of the time and changing attitudes to monarchy as they do about the subject. The photographer Annie Leibovitz (b.1949) became the first American artist to make official portraits of the Queen in 2007. Her photographs were commissioned by the Royal Household to commemorate the 400th anniversary of the founding of Jamestown, Virginia, and the Queen's visit to the USA that year. In a publication of her work, Leibovitz described the careful planning involved, including helping to select clothes, the room and lighting, as well as having to undertake the shoot in only twenty-five minutes.[27] Several different photographs, in varying poses and outfits, emerged from the sitting and the setting chosen in the image shown here (fig.41) is again the White Drawing Room at Buckingham Palace, selected for the large window that emits good natural light and a view out to the gardens. The Queen is presented in a formal pose reminiscent of earlier royal portraiture and Leibovitz has commented that, as an American, she had an advantage as it was 'OK for me to be reverent'. The artist has produced a clever and highly constructed image designed to project a picture of regal majesty while reflecting the Queen's strong and determined character. Elizabeth II sits in formal evening clothes with a fur stole and tiara, looking out to the gardens, composed, as if lost in thought or in calm contemplation of her long reign. The image seems to celebrate the Queen's constancy, sense of purpose and endurance, but the clothes and

41 Queen Elizabeth II
Annie Leibovitz, 2007

Colour coupler print
National Portrait Gallery, London
(NPG P1314)

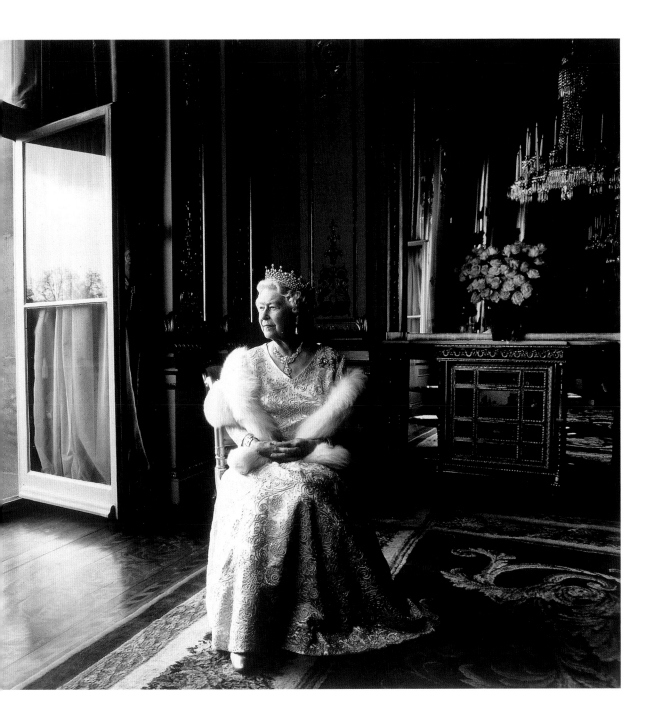

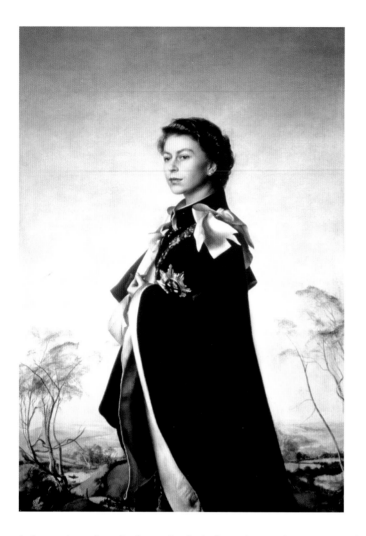

42 **Queen Elizabeth II**
Pietro Annigoni, c.1954

Tempera, oil and ink on paper on canvas
Collection of Fishmongers' Hall, London

lighting also reflect the fairy-tale ideal of grandeur and elegance traditionally due to a female monarch. Leibovitz was inspired by both Cecil Beaton's earlier romanticised images as well as Annigoni's first portrait of 1954–5 (fig.42).

As we have seen, one of the most enduring features of over 500 years of British royal portraiture has been the organic evolution of poses and formats, both in 'quotation' of, and in reaction to, images from the past. The precedents of royal pictorial history have sometimes weighed heavily on monarchs and artists. Royals themselves were only too aware of the images of their forebears displayed in royal palaces, and artists both reworked poses and adapted from earlier compositions, often in homage to famous painters. The best artists also regularly invented new approaches

specific to the age, the individual character of the rulers and the political and social demands of the moment in time. The definitive royal portrait, which could inspire the necessary sense of awe and majesty, as well as provide the illusion of dynastic permanence, only emerged when royals or other patrons sought out artists with the vision and requisite diplomatic and artistic skill. Yet by the nineteenth century, with the advent of photography and more opportunities for a large range of different types of image, increasingly for popular consumption, control over the royal image – while always problematic – became even more difficult, and for today's royal family, the idea of one definitive image has perhaps become less achievable and gradually less relevant.

Endnotes

For full bibliographic references, see page 230.

1 Marks and Williamson, eds., *Gothic; Art for England 1400–1547*, p.176, cat.36 (Henry VI); Henry VI, Sitter boxes, National Portrait Gallery Archive, London.

2 Marks and Williamson, *Gothic; Art for England*, pp.40, 176–8, cats 37, 38.

3 Hamling and Williams, eds., *Art Reformed: Re-Assessing the Impact of the Reformation on the Visual Arts*. See also Hilliard, *The Arte of Limning*, p.67 – for Hilliard's description of the Queen's views on painting.

4 Several possible patterns survive: for example, head depicting Elizabeth I, black chalk and watercolour (NPG 2825), which does not appear to have been turned into a surviving portrait, and Sir Henry Sidney, oil on paper (NPG 2823), two examples from a set of several heads, probably from an Elizabethan artist's studio. See Strong, *National Portrait Gallery: Tudor and Jacobean Portraits*, vol.1, pp.107–8, 119–20, 289.

5 Scott, *The Royal Portrait: Image and Impact*, pp.26–34.

6 Daunt, 'Heroes and Worthies: Emerging Antiquarianism and the Taste for Portrait Sets in England'; Daunt, 'Portrait Sets in Tudor and Jacobean England'; Cooper, 'The Enchantment of the Familiar Face: Portraits as Domestic Objects in Elizabethan and Jacobean England', pp.157–77; Gibson, 'The National Portrait Gallery's Set of Kings and Queens at Montacute House', pp.81–7.

7 See, for example, Talbot, *A Booke Containing the True Portraiture of the Kings of England* (London, 1597); Holland, *Baziliologia, a Booke of kings: being the true and lively effigies of all our English kings ...*

8 Gordon, *The Wilton Diptych*.

9 Alexander and Binski, *The Age of Chivalry: Art in Plantagenet England 1200–1400*, pp.517–8.

10 Bolland and Cooper, *The Real Tudors*, pp.50–3.

11 Versions include: i) Galleria Nazionale d'Arte Antica, Rome; ii) The Walker Art Gallery, Liverpool; iii) Petworth House, West Sussex (The Egremont Collection/National Trust); iv) The Devonshire Collection, Chatsworth House, Derbyshire; v) Trinity College Cambridge. See Brooke and Crombie, *Henry VIII Revealed: Holbein's Portrait and Its Legacy*.

12 Von Klarwill, ed., *Queen Elizabeth and Some Foreigners*, trans. T.H. Nash, p.218.

13 Strong, *Gloriana: The Portraits of Queen Elizabeth I*, pp.88–9.

14 *Charles I on Horseback with M. de St Antoine*, 1633, Royal Collection; *Charles I in the Hunting-Field (Le Roi à la chasse)*, c.1635, Louvre, Paris; *Equestrian Portrait of Charles I*, c.1637, National Gallery, London.

15 Brown, *Van Dyck* (1982), p.176. See also Brown, *Van Dyck* (1999), cat.86, pp.292–3; Barnes, de Poorter, Millar and Vey, *Van Dyck: A Complete Catalogue of the Paintings*, cat.iv, 48, pp.464–6; Alsteens and Eaker, *Van Dyck: The Anatomy of Portraiture*, cat.69, p.198.

16 See: Samuel Cooper, *Oliver Cromwell*, 1656, watercolour on vellum (NPG 3065); Samuel Cooper, *Oliver Cromwell*, 1657, watercolour on vellum (the Viscounts of Harcourt); after Samuel Cooper, *Oliver Cromwell*, oil on canvas, c.1656 (NPG 588).

17 Piper, 'The Contemporary Portraits of Oliver Cromwell', pp.27–41.

18 Hawkins, *Medallic Illustrations of the History of Great Britain and Ireland to the Reign of George II*, p.391.

19 Ibid., p.460.

20 Millar, *The Tudor, Stuart and Early Georgian Pictures in the Collection of Her Majesty the Queen*, p.22 and cat.285, p.129; Gibson, 'The Iconography of Charles II', Courtauld Institute of Art, London, 1997 (unpublished PhD thesis); Brooke, ed., *The Age of Charles I*, pp.17–18.

21 Clark, 'Charles II by John Michael Wright', no.49, pp.114–17; Blair, ed., *The Crown Jewels: The History of the Coronation Regalia in the Jewel House in the Tower of London*, vol.II, pp.7, 31–3.

22 Millar, *The Tudor, Stuart and Early Georgian Pictures in the Collection of Her Majesty the Queen*, p.129, quoting W.J. Smith, 'Letters from Michael Wright', *Burlington Magazine*, vol. XCV, 1953, p.234.

23 Smart, *Allan Ramsay: A Complete Catalogue of His Paintings*, cat.192, pp.111–15.

24 Ormond and Blackett-Ord, *Franz Xaver Winterhalter and the Courts of Europe 1830–70*, p.41. See also Marsden, *Victoria and Albert: Art and Love*, cat.25, pp.78–9.

25 Engravings of different states were offered at between 15 and 5 guineas. *Plates declared 1847–1891*, p.325.

26 Morphet, *Meredith Frampton Retrospective Exhibition*, p.50, cat.13.

27 DeLano, ed., *Annie Leibovitz at Work*, p.180–9.

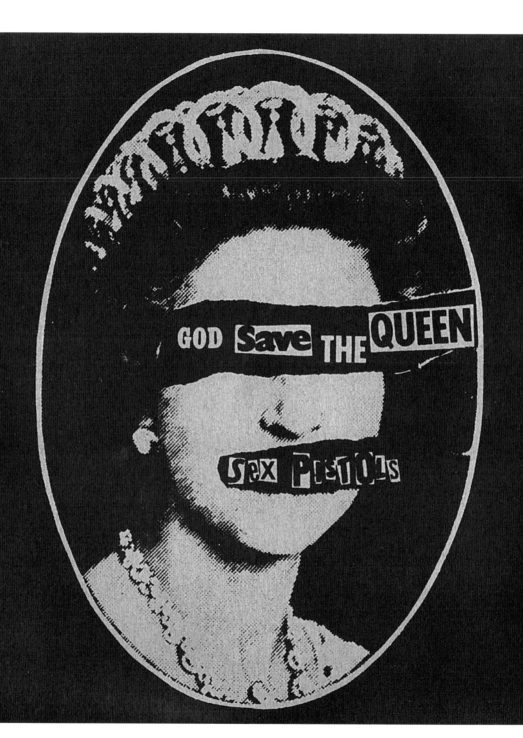

LOYALTY AND DISSENT: ROYAL PORTRAITURE BEYOND THE COURT

Louise Stewart

In 1839, a competition was launched to design pre-paid stationery and postage stamps for the new Penny Post, which would go on sale to the public the following year. Of the forty-nine designs submitted for the pre-paid postage stamps, most focused on complex geometric patterns that were thought difficult to forge. Two entries, however, from designers William Wyon and Benjamin Cheverton, suggested that stamps should bear a detailed image of the sovereign's head. Cheverton argued that this would make forgery difficult, due to the familiarity of the queen's likeness – the idea being that Queen Victoria's image was sufficiently recognisable to the general public to make fakes easy to spot. The result was the first postage stamp – the Penny Black (fig.44). Launched to the public in 1840, this stamp bore a classicising profile image of Queen Victoria based on drawings made by Wyon when she was a fifteen-year-old princess, and was to become the model for all subsequent British stamps and many colonial

ones too. To this day, Britain is the only nation with stamps that use the monarch's image without the country's name alongside.[1]

The image of the queen, as well as deterring forgery, lent royal authority to the fledgling Penny Post. During the remainder of Victoria's long reign, and despite the widespread availability from the 1860s of photographic images of the ageing queen, her youthful image never aged on British stamps, thereby providing a comforting sense of continuity in an era of unprecedented change. By 1898, the penny postage rate was in use across the empire, and the humble stamp brought the sovereign's portrait, and her authority, into the hands and homes of British subjects around the world. Unsurprisingly, upon becoming independent, many former colonies chose to remove the British monarch's image from their stamps as a sign of regained autonomy.[2] The likeness of the monarch on the postage stamp is just one example of the myriad ways in which royal portraiture has made its way into the everyday lives of ordinary people in Britain, the empire and beyond, in both public and private contexts.

Since the Middle Ages, images of monarchs have pervaded the public realm. Ordinary people have encountered royal figures as sculptures on town crosses and gates, on civic buildings and free-standing in squares. In churches and cathedrals they could view

43 **The Sex Pistols:
God Save the Queen**

Artwork for 7-inch single sleeve designed in collaboration with Jamie Reid, 1977

Ink on card
Private collection

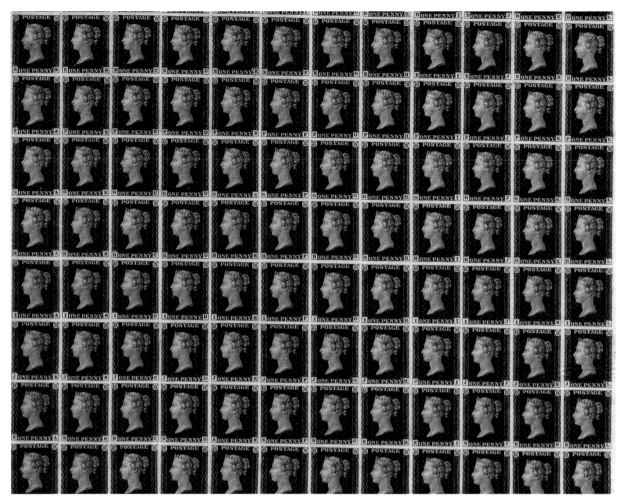

44 The Penny Black stamp,
featuring Queen Victoria
Engraved by Charles and
Frederick Heath, 1840

Ink on paper
The Postal Museum, London

sculpted tomb and funeral effigies, and royal portraits in stained glass. After the Reformation, the royal arms were established in all English churches, and from the Tudor period onward royal portraits could commonly be found in town halls. Anyone navigating the city streets of Tudor, Stuart or Georgian Britain would have passed numerous signs featuring kings, queens, crowns and the royal arms. Sculptures of monarchs kept company with saints on the west fronts of cathedrals, and the royal visage was handled by the masses in the form of coins and later banknotes and stamps.[3] Under the Tudors and early Stuarts, royal occasions such as ceremonial entries, coronations and weddings were cause for processions and street pageants, with images of historical and contemporary royal figures contributing to the decoration of public spaces. This practice was revived under Victoria, and

45 **Queen Elizabeth II**
Commissioned by the Flower
Council of Holland for
Old Street, London, 2012

Lily stems and petals
Image by Nigel Davies

46 **Queen Elizabeth II**
Peter Grugeon,
for Camera Press, 1975

Gelatin silver print
National Portrait Gallery, London
(NPG x134731)

was particularly evident for her two jubilees in 1887 and 1897, when London shops utilised the queen's image in their celebratory decorations, while jubilee plaques featuring the queen's profile were manufactured to adorn buildings erected during the jubilee years. Similarly, in 1977, Elizabeth II's Silver Jubilee was widely celebrated with street parties and parades, commemorative coins were struck and special leather bookmarks, mugs and celebratory sweet tins were distributed to schoolchildren. For the Diamond Jubilee in 2012, the Queen's image was recreated using everything from jelly sweets and Cheddar cheese to flower petals, as shown in fig.45, commissioned by the Flower Council of Holland and displayed at a London florist's shop during the jubilee celebrations. Based on an official photographic portrait produced to mark the 1977 Silver Jubilee (fig.46), it demonstrates the continuity of images of the monarch and the way in which, in jubilee celebrations, portraits from throughout the reign can be used to commemorate the king or queen's longevity.

The ubiquity of royal imagery in the lives of ordinary people, in the street, institutional settings and in the circulation of currency, raises a number of questions.

47 *The Arch of the Dutchmen*
William Kip, after Stephen
Harrison, published 1604

Line engraving
National Portrait Gallery, London
(NPG D18325)

What is the purpose of royal imagery as utilised by civic and commercial bodies in different parts of the UK and beyond? How does this 'everyday' royal portraiture reflect changing ideas of monarchy? And why does royal imagery continue to be so commercially successful in public settings?

48 *The Arch of the Italians*
William Kip, after Stephen
Harrison, published 1604

Line engraving
Folger Shakespeare Library, Washington DC

ROYAL PORTRAITS IN THE PUBLIC DOMAIN

During the sixteenth and seventeenth centuries, royal progresses, processions and ceremonial entries provided ordinary people with opportunities to encounter the monarch, either by catching a glimpse of them in the flesh or by viewing specially created likenesses. One such event was James I's official entry into London on 15 March 1604, which involved a procession from the Tower of London to Temple Bar. This passed through a series of spectacular wooden triumphal arches, funded by groups of merchants, each of which represented a different region. Spectators lined the streets, hoping for a glimpse of the king, who was entertained at each arch with allegorical shows written by playwrights including Ben Jonson and Thomas Dekker.[4] The arches erected by the Italian and Dutch merchants bore likenesses of the king, and in this way royal portraiture contributed to the transformation of the ordinary city streets into festive spaces for this celebratory occasion. The Italian merchants' triumphal arch featured an image of Henry VII (James's great-grandfather) in imperial robes, passing the sceptre to a mounted James I (fig.48). The message here was unambiguous – James was the rightful inheritor of the crown through his descent from the founder of the Tudor dynasty. Similarly, the Dutch arch (fig.47) was, according to its designer, intended to 'honour the king and show [the Dutch merchants'] gratitude to God and the City'.[5] However, the merchants also wanted to press their own cause; the image of the king on their arch was surmounted by another of Divine Providence, signifying God's intervention in the world. In a pointed plea for armed assistance, the oration delivered at the arch reminded the king of Elizabeth I's military support for the Dutch Protestant cause and that he was subject to God's will. James, who believed in the divine right of kings and was reluctant to involve himself militarily in the affairs of the Low Countries, was apparently unimpressed, passing on 'in stony silence'. One contemporary account even suggests that the king walked off before the oration had finished.[6]

Although triumphal arches were ephemeral and usually taken down after ceremonial occasions, royal images permeated the urban environment in more everyday and

49 George I wall painting at the George and Dragon (formerly the George Inn), Chesham, Buckinghamshire
Unknown artist, c.1714

Wall painting

50 King's Statue, Weymouth, Dorset
Designed by James Hamilton, executed by Coade & Sealy, 1809–10

Coade stone (statue) and Portland stone (pedestal)

lasting ways, and were frequently to be found in and around inns and taverns. In this period, towns and cities bristled with pictorial trade signs hung outside shops and businesses to identify and differentiate them. Accounts of sixteenth- and seventeenth-century London indicate that the most popular trade sign by far was the King's Head, although the Royal Arms, the Crown and the Queen's Head were also widespread.[7] There is also evidence that these royal signs were particularly associated with public houses.

Writing in 1598, Richard Haydock railed against the poor quality of ale-house painted signs and their workmen's 'grosse ignorance, for Signes at Innes & Ale-houses (the toleration wherof I have ever wondered at) putting no difference between the renowned Scepter of K: Henry the 8 and Tattletons pipe. If this bee not to prophane the sacred Maiestie of Princes and disgrace Nobility, surely I cannot iudge.'[8] Haydock is clearly disturbed by the irreverence shown to the royal image. By contrast, during the Commonwealth period, royal iconography in signs was used expressly to convey loyalty to the monarchy. The

royalist poet John Taylor, who kept an alehouse in London, carried out a survey of London signs prior to the civil wars, finding that the King's Head was the most popular. There is evidence, however, that signs bearing royal iconography were being defaced and taken down during the Commonwealth, and in 1649, when Taylor changed his alehouse's name and sign from the Crown to the Mourning Crown as a symbolic act of resistance, he was forced to take it down.[9]

The iconography of royalty was also present inside inns and taverns, many of which provided customers with drinking vessels decorated with royal images.[10] For example, at Ann Baker's inn in Ipswich, early seventeenth-century patrons had the opportunity of sleeping in the Queen's Head Chamber, a room that must have been decorated with an image or images of past queens.[11] Cheap prints featuring royal portraits were often pasted to tavern walls, and the image of the monarch could appear in wall paintings, as in fig.49 from the George and Dragon (formerly the George Inn) at Chesham in Buckinghamshire, thought to be an image of George I painted to celebrate his accession in 1714.

The concentration of royal imagery in inns, taverns and alehouses is interesting given that these semi-public spaces are widely acknowledged as having been sites for political discussions that sometimes aroused the suspicions of the authorities.[12] The prominent display of royal imagery might have been intended to allay any suspicions of subversive behaviour. It is likely, however, that it was also being utilised as a marketing tool; the associations between royalty, luxury and hospitality, as well as the appeal of recognisable images attached to familiar narratives, likewise account for the popularity of images of monarchs in and around public houses.

Royal imagery also pervaded the public realm in the form of free-standing sculptures erected in town and city squares. Intended to demonstrate loyalty, as well as to mark the Crown's territories, these were often set up by civic or colonial authorities. In 1809, for example, many British towns and cities erected statues of George III to celebrate his fifty years on the throne, including one example that still survives in the seaside town of Weymouth, Dorset, and is today known as King's Statue (fig.50).

When the statue was erected, George III was at the height of his popularity, partly due to the declining political power of the monarchy, a growing sense of British national identity and as a reaction against the revolutions in France and America.[13] The king had become a symbol of Britishness and stability. This statue is also likely to have been intended as a reminder of his many visits to Weymouth, a town renowned for its health-giving properties. This is an example, then, of an image of the monarch as an expression of popular civic loyalty and a celebration of national identity that also allowed Weymouth to capitalise on the royal patronage from which the town benefited.

Other statues, however, particularly in British colonial territories, are associated with turbulent histories and contested meanings. In 1770, the New York General Assembly dedicated a statue of George III by Joseph Wilton in the city's Bowling Green Park. Rather than a sign of true loyalty, however, this statue was something of an afterthought. The General Assembly had originally wanted only a statue of William Pitt to commemorate his role in the repeal of the Stamp Act, but it was thought inappropriate to erect a statue of an adviser to the king without one of the monarch himself. The statue of George III was larger than life-size, made of gilded lead, and stood on a pedestal almost 5.5 metres in height. However, no visual record survives, and the story of its destruction is arguably more significant than its creation.

On 9 July 1776, the text of the Declaration of Independence, which characterised George III as a ruthless tyrant, reached New York. In other cities the king was burnt in effigy, but in New York it was George's statue that became a target. Under cover of night, it was attacked by a mob who used ropes to pull it down, then they removed the head, stripped it of its laurel crown and drove a musket ball into it. Although the head was eventually rescued and sent to London by loyalists, the rest of the lead was melted down and made into bullets for use against the British.[14] Like more recent attacks on statues, such as the pulling down of Sadam Hussein's effigy in Firdos Square, Baghdad, in 2003, and its subsequent decapitation by Iraqi citizens, this was a form of public catharsis, indicative of the rejection of British rule.[15] The mob who took part in the destruction of George's statue may well have lacked access to political or legal redress. Such acts were, therefore, a way for the people, who were no longer British subjects, to have their collective voice heard.[16]

The destruction of the statue of George III became an important narrative feature in the national histories of America issued during the nineteenth century and has been regularly depicted in the succeeding years, including in an 1854 painting by William Walcutt (fig.51). The artist, a supporter of republicanism, intended the image as a call to arms against Napoleon III.[17] To this end, although the original statue had been neoclassical in style, he has here portrayed the king as a medieval ruler, evoking ideas of feudal society and the abuse of serfs. In 2017, Walcutt's image became embroiled in debates about the removal of statues of confederate figures across America. The addition of modern captions to the image in online memes has turned the destruction of the statue into a precedent, used to undermine the argument that such removals constitute the erasure of history. Thus, a statue destroyed over 240 years ago continues to generate new meanings, albeit little related to the original intentions behind its erection.

The appropriation and defacement of royal imagery has remained a potent form of protest well into the

51 *Pulling Down the Statue
of George III at Bowling Green,
New York, 9 July 1776*
William Walcutt, 1857

Oil on canvas
Lafayette College of Art, Easton, PA

twentieth century. This is best exemplified by the outrage that greeted the single *God Save the Queen* by punk band the Sex Pistols. Released in 1977 to coincide with Elizabeth II's Silver Jubilee celebrations, the song railed against the 'fascist regime' and a lack of opportunities for young people, and heralded the arrival of punk on the mainstream music scene. Despite a ban by the BBC and the refusal of major high-street shops Woolworths and WHSmith to stock the record, it reached number two in the singles chart.[18] The promotional posters and record sleeve created for the single subvert the conventional use of royal imagery. They intentionally utilise the official colours (blue and silver) of the jubilee celebrations, but feature a defaced version of Peter Grugeon's official Silver Jubilee portrait of the Queen; the sovereign is blinded and gagged by the track title and band's name (fig.43).

Central to the punk movement was a rejection of authority, mainstream culture and inequality, and the promotion or glorification of anarchy and nihilism. The Sex Pistols' decision to appropriate and disfigure the Queen's official portrait reveals the fault lines within society at a time when a seemingly disenfranchised youth clashed with the establishment, represented here by the royal image. Although the monarch no longer claimed to rule by divine right, the Queen's portrait was a quasi-sacred image, associated with traditional values, national identity and continuity with the past. In aiming to shock, and to generate publicity, the Sex Pistols couldn't have selected a better target.

Today, images of the monarch continue to pervade the public realm. Royal imagery is frequently used as a marketing device, an important means both of encouraging tourists to visit Britain and of fostering a sense of national pride.[19] As such, it has largely lost any direct political function, having been co-opted into the mechanics of international capitalism. However, in loyalist contexts, and particularly in Northern Ireland, images of British monarchs continue to be utilised in explicitly political ways. Here the annual 'marching season' occurs from Easter to the end of August, featuring various events, the most important of which are the bonfires and marches commemorating the Battle of the Boyne, the Glorious Revolution and the restoration of a Protestant monarchy in 1690, which take place on 11 and 12 July. Parades are organised by the Grand

52 **Orange Arch**
Lurgan, Co. Armagh
Paul Allen, 2012

Digital photograph

53 **Banner depicting Queen Elizabeth II**
Bushmills, Co. Antrim
Louise Stewart, July 2017

Digital photograph

Orange Lodge, a Protestant fraternity named in honour of William III, which advocates for Northern Ireland to remain a part of the union with Great Britain. Today during the marching season predominantly loyalist urban areas are decorated in red, white and blue, the colours of the UK's union flag, with kerbstones and other street furniture painted, and bunting and flags strung up. The dominant form of visual display in small towns in Ulster during the marching season is the Orange Arch, a structure based on the triumphal arches of earlier centuries and often erected across main thoroughfares. The arches are decorated with symbols relating to Protestantism and the Orange Lodge, such as images of William III on horseback, the gates of Derry, the Red Hand of Ulster and the crown (fig.52). The arches are historically associated with military triumphalism and fraternity, and are interpreted by some members of the Protestant community as symbols of welcome, unity and belonging to the loyalist community. As is widely acknowledged, however, such decorations transform public spaces and mark certain towns as loyalist territory. To those with a different political viewpoint, then, they can be interpreted as hostile, threatening or intimidating.[20]

Recently, as Northern Ireland's economy has recovered from the stultifying effects of the Troubles, and with a burgeoning tourism industry, the Orange Order has attempted to promote the marching season as a cultural experience – 'Northern Ireland's biggest festival' – capable of attracting visitors to the province and encouraging them to engage with the area's Protestant heritage.[21] This attempt to create a touristic experience is now mirrored in the choice of loyal imagery in the decorations at visitor destinations. In the town of Bushmills, for example, site of the famous whiskey distillery and located on the north coast a few minutes' drive from the UNESCO World Heritage site the Giant's Causeway, the unionist imagery on the main street tends to be far less overtly political than that displayed elsewhere. Instead, in 2017, banners concentrated on the vintage glamour of a 1957 photograph of the Queen by Lord Snowdon (fig.53) and provided information on the history of the Orange Order, while the Orange Arch did not span the main street, but was located less prominently outside the Orange Hall. Given the province's past, however, the display of royal imagery on Northern Ireland's streets, whether it be triumphalist images of King William III or elegant photographs of the Queen, remains highly politically charged.

ROYAL IMAGERY IN THE HOME

For much of the sixteenth, seventeenth and eighteenth centuries, the idea of the household was conceived as a powerful metaphor for the state, with the relationship between ruling sovereign and subject echoing the terms of a marriage contract. In this 'contract', people gave consent to their subjection and practised obedience, like the wife in a successful marriage, whilst the husband/monarch respected the subject's rights and practised good government. Both relationships were underpinned by love and loyalty, and thus domestic order could give rise to national political order. This relationship meant that it was natural for householders to display royal images within their homes.[22] From the sixteenth century onwards, in doing so, they could choose from a wide range of objects in a variety of different media. As textual sources are often silent on this type of popular imagery, the surviving objects themselves provide the most comprehensive body of evidence regarding the meanings and practices associated with royal imagery in the home.[23] What do the particular places and spaces in which people chose to display these images tell us about the ways they interpreted them? And were these objects acquired as straightforward expressions of loyalty or do they signify different intentions and narratives?

Householders in the Tudor and Stuart periods might choose to paste a relatively cheap print of the royal line of succession or an image of a monarch, accompanied by a ballad, on the wall or chimney breast. Royal figures also appeared in domestic relief sculpture in wood, metal and plaster from the sixteenth century, and in wall paintings and painted cloths. The civil wars, Commonwealth period and Restoration saw an explosion of material objects intended to demonstrate loyalty to the Stuart dynasty. A well-to-do lady might choose to work the figures of King Charles I and Queen Henrietta Maria discreetly into her needlework or to wear a locket embossed with the late king's head to signify her continuing allegiance to the monarchy.

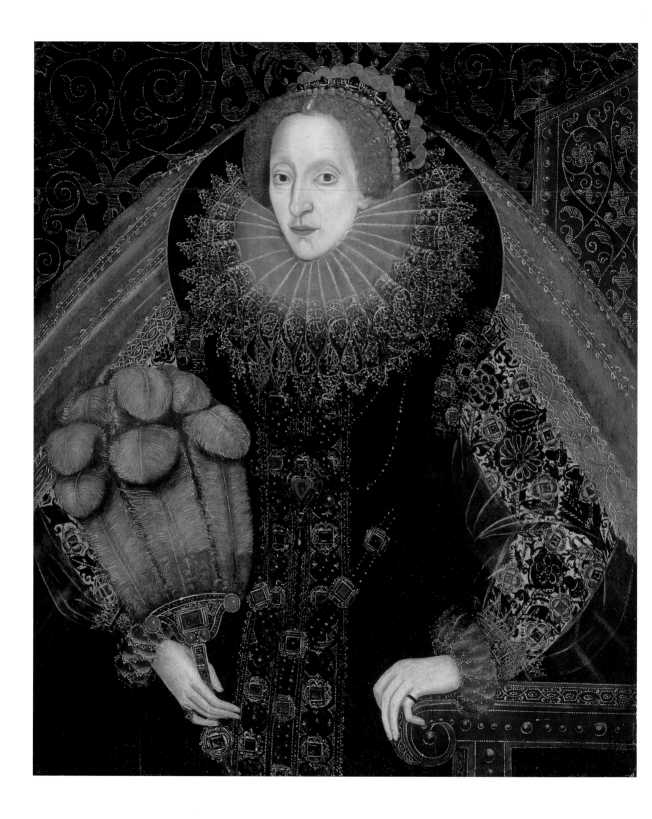

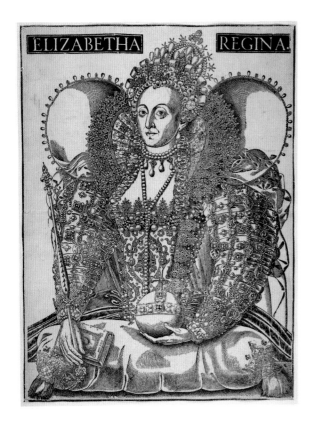

54 Queen Elizabeth I
Unknown artist, 1585–90

Oil on panel
National Portrait Gallery, London
(NPG 2471)

55 Queen Elizabeth I
Unknown artist,
late sixteenth century

Woodcut
Ashmolean Museum, Oxford

56 Fireback
Unknown maker,
mid seventeenth century

Cast iron and brass
Private collection

Commemorative ceramic and pewter tableware celebrated the Restoration and subsequent royal marriages. During the eighteenth century, ceramic objects bearing transfer-printed portraits of royal and political figures might enhance the decoration of the home or a child's plate mourn the death of a monarch. By the Victorian period, genteel ladies took to creating photographic albums of celebrities, routinely framed with the royal family, while Victoria's Golden and Diamond Jubilees provided opportunities to acquire myriad souvenirs from ceramics and glassware to biscuit tins, postcards and printed textiles. This souvenir trade thrived throughout the twentieth century and continues today,

with Royal Doulton figurines, prints and photographs, commemorative china and even collectable *Barbie* doll figures representing various members of the royal family.

Perhaps the most effective medium by which the royal image was originally disseminated into the homes of the masses in the early modern period was that of the print. Woodcuts could be purchased from booksellers for as little as one penny, making them widely accessible. Whereas prior to the Reformation devotional images were common, portraits were the most popular form of print during the sixteenth and seventeenth centuries and these focused predominantly on royalty and nobility.[24] They could be based on painted

57 **Dish depicting Charles II and Catherine of Braganza**
Brislington Pottery, c.1662

Tin-glazed earthenware with painted decoration
Private collection

58 **Dish depicting Charles II**
London or Brislington, 1672

Tin-glazed earthenware
Private collection

portraits produced in court circles, as in a late sixteenth-century woodcut showing Elizabeth I (fig.55), which closely resembles the 'Ditchley' portrait of the queen (fig.78). There is evidence that such prints were pasted on domestic walls, particularly on chimney breasts and over fireplaces.[25] In 1890, a portrait of Queen Elizabeth I by an unknown artist (fig.54) was discovered built into the panelling of a wall immediately over the fireplace in a seventeenth-century cottage in Sussex. The relatively humble setting in which this portrait was discovered led to the assumption that it had originated elsewhere, perhaps from the collection of the Viscounts Montague at nearby Cowdray House.[26] It is now clear, however, that the ownership of portraits of royalty was much broader than originally thought and included those outside the nobility and gentry as early as the 1530s.[27]

It was also common practice to place the royal arms above the fireplace, as in the parlour at Plas Mawr, a townhouse built in Conwy, Wales, for the merchant Robert Wynn in the 1570s–80s. Cast-iron firebacks often included royal imagery such as the royal arms or the royal oak, as seen in fig.56, here accompanied by the initials CR (for *Carolus Rex* – King Charles). This is likely to refer to the celebrated oak tree in Boscobel Wood where Charles II hid from Parliamentary troops prior to his escape in 1650. This object may have been made in the period during Cromwell's Republic or immediately after the Restoration, when the country witnessed a huge increase in the display of objects symbolising loyalty within the home.[28] That the fireplace was a location for the display of royal images is particularly significant, as its status and function within the

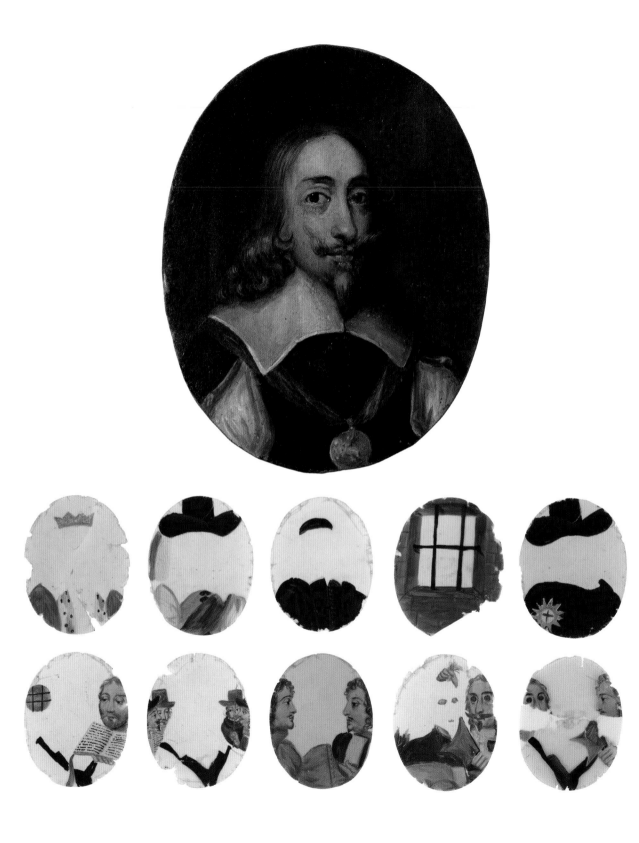

home places it at the centre of domestic life. This gives an indication of the importance householders ascribed to the idea of monarchy and its relevance for family relationships. The fireplace has long been seen as the spiritual centre of the home, the place from which all warmth and hospitality emanated and the focus of protective ritual practices intended to ward off bad luck.[29] Objects bearing royal imagery that were specifically designed to ornament the fireplace, such as the royal oak fireback, suggest that this imagery was being utilised by householders in ways that may be difficult to trace, given the nature of the images' environment. These might include signalling specific allegiances, affording protection to the household, or instructing family members on their role and correct behaviour.

Objects of loyalty could also commemorate specific personal events within the reign, including marriages. The symmetry between the marriage contract and the political contract between ruler and subject is neatly encapsulated in the delftware and pewter chargers produced to commemorate royal and other marriages. These were highly popular and, being relatively cheap, could be acquired by people of the 'middling sort'.[30] Some examples display conventional marriage portraits, as seen in the delftware charger with portraits of Charles II and Catherine of Braganza (fig.57), along with the tokens of sovereignty – crown, orb and sceptre. These images are related to the numerous engravings of Charles and Catherine that circulated at the time of their marriage, and Catherine's depiction may ultimately derive from an official portrait by the Dutch artist Dirk Stoop.[31]

Other objects commemorated the marriages of 'ordinary' people, combining the initials of the couple with patriotic imagery, as with the dish dated 1672 featuring an image of Charles II (fig.58).[32] These objects express the ways in which early modern households engaged with the idea of monarchy. Chargers were intended for display within the home and

many of them were kept as heirlooms; they were objects for contemplation rather than use, which may have encouraged reflection on the analogy between State and household.[33]

THE POSSIBILITY OF DISSENT

The conception of the household as the State in microcosm reflected changing ideas of kingship in the wake of the Restoration, with the monarch now ruling only with the consent of the people, just as the husband required the consent of his wife, according to the marriage contract.[34] Whilst possessing objects showing royal images may have encouraged consent to a political contract, they also implied the possibility of dissent and attempts to undermine those in power. This is demonstrated through the survival of numerous objects produced during the Commonwealth period and apparently intended to express loyalty to the Stuart dynasty. Charles I as a martyr was a favourite subject and can be found in prints, embroidered pictures, medals, jewels and miniatures. One relatively common miniature type is accompanied by a series of transparent overlays made from a translucent, shell-like material called mica (fig.59). They allow the viewer to modify the miniature image to show scenes from the king's life before the civil wars, his imprisonment, trial, execution and apotheosis. The series appears to have been produced during the Commonwealth period, probably in Holland. It may have been intended to express opposition to the Parliamentary government because the small scale of these images and other royalist objects created at the time meant that they could be easily concealed in the home or on the person. With their changeable overlays, the miniatures encourage the viewer to engage actively with the narrative of Charles's execution. Possibly used to tell the story within the home, they would have facilitated the memorialisation of the events that they depicted.

Just as objects of domestic culture may well have been created to encourage the veneration of the king at the expense of the government, other items could be used to criticise the reigning monarch. This is evident in the production of ceramic ware in connection with the Queen Caroline Affair. After George IV's accession to the throne

59 **Charles I**
Unknown artist, late seventeenth century

Oil on copper with seventeen mica overlays
National Portrait Gallery, London
(NPG 6357)

in 1820, he was determined to arrange a divorce from his estranged wife, Caroline of Brunswick. His attempts to force the government to grant an annulment led to a public campaign in support of the queen, which was capitalised on by both Whig and radical politicians. George IV, dissolute and deeply unpopular, was widely vilified as a profligate, neglectful husband and a symbol of aristocratic corruption, whereas Caroline was seen as a virtuous, wronged wife. Their acrimonious relationship and her ill treatment by the king were viewed as symbols of the perceived breakdown of relations between people, government and monarchy, as well as George's neglect of the sovereign's responsibility to act in the interests of his subjects. This was a period of widespread dissatisfaction at corrupt political processes, and that discord was expressed in public unrest. This included the Peterloo Massacre of 1819, during which a peaceful crowd demanding enhanced political representation was charged by cavalry, resulting in perhaps as many as twenty deaths and hundreds of injuries. Caroline was also in contact with radical politicians who utilised the analogy between household, marriage and State to inflame public opinion and agitate for

60 **Jug depicting Queen Caroline**
Unidentified factory production, probably Staffordshire, c.1820

Earthenware and lustreware
Fitzwilliam Museum, Cambridge

61 **Loewentheil Album, 1860s–70s**

Hand-decorated album with albumen prints
National Portrait Gallery, London
(NPG Album 262)

political reform, leading to demonstrations, confrontations and an outpouring of popular material in support of the queen, including ballads, caricatures and painted and printed ceramics.[35] Fig.60 is typical of the ceramics produced to champion her cause, with her bust on either side and the slogan 'Success to Queen Caroline'.

The Queen Caroline Affair is particularly interesting because of the involvement of women in protests against the actions of the king and Parliament. They wrote ballads and pamphlets, signed petitions and predominated in the crowds that greeted the queen's arrival at Gravesend and lined the streets during her trial. When she was acquitted, female villagers and townswomen across the country held

celebratory tea parties and paraded with effigies of the queen.[36] Indeed, historians have shown that Caroline's plight came to be seen as representative of the situation of all married women and that her case was used in demands for revisions to family law, including recognition of a wife's right to respect and protection, and of women's dominion over the domestic sphere.[37] Thus, women were urged:

> Attend ye virtuous British Wives,
> Support your injur'd Queen;
> Assert her rights; they are your own,
> As plainly could be seen.[38]

Owning and displaying a jug or plate depicting Caroline in 1820 would have implied clear disapproval of the actions of the king and Parliament. Within the context of widespread female support of Caroline, however, and when located within the feminine sphere of the household, such objects may not have implied an outright rejection of monarchy. Rather they represented an appeal to the king and, given the links between State and household, to all men to carry out their responsibilities with regards to matrimony.

THE PUBLIC CONSUMPTION OF ROYALTY

George IV died in 1830 and was succeeded by his younger brother, William IV. William's death without an heir in 1837 cleared the way for Princess Victoria of Kent, daughter of George III's fourth son, to become Queen Victoria. Public disillusionment with the monarchy in the wake of the excesses of the late Georgians meant that Victoria was not a popular public figure at the outset of her reign. The development of the new technology of photography, the emergence of a mass consumer market as a result of the Industrial Revolution and a renewed emphasis on royal ceremony from the 1870s meant, however, that by the end of her reign Victoria's was one of the most recognisable and popular faces in the world.[39] Royal portraiture was once again incorporated into the domestic interior, this time more fully than ever before, and played an important part in fashioning the image of the ideal middle-class family, as well as fostering a sense of pride in belonging to the British national family.

Whilst engravings from the early part of Victoria's reign testify to interest in the royal family's domestic life, the development of the carte-de-visite was particularly significant in facilitating ordinary peoples' creative engagement with royal and celebrity imagery. Small and cheap, cartes-de-visite were exchanged among friends and acquaintances and were especially popular in Britain in the 1860s. Women in particular collected them and pasted them into albums, which were arranged thematically and embellished by hand. These albums have been interpreted as both generating and reflecting cultural norms, as well as playing an important role in constructing genteel feminine identities.[40]

A typical photographic souvenir album, probably compiled between the 1860s and 70s, has the cartes arranged into different categories of celebrity sitter, including singers, explorers, writers and statesmen. The opening leaves are concerned with images of the royal family, with the first page showing portraits of Victoria and Albert along with images of the principal royal residences (fig.61). The page is hand-decorated with scrolls, roses, thistles and shamrocks, and the union flag, Red Ensign and royal arms. Photographs of other members of the royal family and a hand-drawn genealogy, setting out their descent from William the Conqueror, appear on the following pages. Royal portraiture is here used as a framing device for the album's narrative of national achievement, the royal family being positioned as the guardians of national identity. At the same time, photographs like these contrasted markedly with the engraved images of Victoria from earlier in her reign, which focused on her youth and beauty. These much less flattering photographs have been interpreted as conveying an image of middle-class respectability and giving the viewer who handled the cartes, pasted them into an album or turned its pages, the impression of an intimate encounter, and even a relationship with the queen and her family.[41] In the album, the sequence of Victoria, Albert and the royal residences, followed by their children and spouses, presents the queen as the ultimate middle-class matriarch and associates her with domestic virtues.

The latter part of Victoria's reign saw a shift away from the image of the monarch as an ordinary woman, the simultaneous development of increasingly elaborate

royal ceremony with a decline in the monarch's political power, and a change in role for the queen towards that of national figurehead.[42] The Golden Jubilee of 1887 and the Diamond Jubilee of 1897 provided unprecedented opportunities for ordinary people to purchase souvenirs to suit all budgets, whilst civic and ecclesiastical authorities gave items such as commemorative mugs and portraits of the queen to schoolchildren. The queen's portrait was used in advertising numerous products, from soap and cocoa to tyres and paint, while newspapers reporting on preparations for celebrating each jubilee focused on Victoria's 'record reign', characterised by unprecedented progress and prosperity. Many of the souvenirs produced at the time communicate this narrative of national achievement, in which the expansion of empire figured prominently.[43] One plate, made in Staffordshire in 1887 and probably for sale in Britain and abroad, clearly celebrates the wealth and extent of the empire (fig.62). Portraits of Queen Victoria and the Prince of Wales flank Britannia, surrounded by figures representing the colonies. A world map shows British territories in red, and a clock face with the time difference in each colony is surrounded by the inscription 'THE EMPIRE ON WHICH THE SUN NEVER SETS'. At the bottom are the total values of imports and exports, the population and extent of the empire in square metres. During the 1880s, educationalists and politicians were actively promoting

a sense of national identity defined by pride in Britain's achievements and loyalty to the empire, and consciously used the queen's image as a symbol of empire, permanence and Englishness.[44] Aimed at working-class consumers, this jubilee plate represents an attempt to capitalise on these patriotic sentiments, inevitably heightened by the celebrations of Victoria's fifty years on the throne.

As well as promoting a sense of national identity, such objects gave consumers a sense of ownership of royal events. For the Diamond Jubilee, photographs of the queen were distributed throughout the empire and Victoria's image was appropriated by other artistic traditions; in Lagos, Nigeria, for example, Yoruba artists produced sculptures based on the jubilee photographs. The example seen in fig.63 was presented to the queen by the governor of the British

62 **Queen Victoria Jubilee Plate**
Wallis Gimson & Co., 1887

Earthenware, transfer print and hand colouring
Private collection

63 **Queen Victoria**
Unknown artist, 1892–7

Wood and paint
Royal Collection, London

64 **Coronation Loving Cup**
Royal Doulton, 1953

Coloured and glazed earthenware
National Portrait Gallery, London
(NPG D48090)

Lagos Colony in 1897 and was incorporated into the royal children's 'museum' of curious objects in the Swiss Cottage in the grounds of Osborne House on the Isle of Wight.

Like the Victorian jubilee souvenirs, later commemorative objects including, for example, a Royal Doulton loving cup produced to mark the coronation of Elizabeth II in 1953 (fig.64), seem to have provided people with a sense of pride and participation in royal events, as well as comfort in the continuity they represented. This cup incorporates one of Dorothy Wilding's photographs of the Queen, taken to mark her accession, as well as an image of Elizabeth I, based on the 'Ditchley' portrait, on the reverse. The implication is clearly that the reign of Elizabeth II heralds a new Elizabethan golden age, the juxtaposition of the two queens also associating the royal image with themes of continuity and stability. As we have

seen elsewhere, this has historically been the message of much royal portraiture.

Indeed, in considering the domestic royal artefacts discussed here as a group, it is clear that they are often associated with periods when the monarchy or the country was under significant pressure, periods of crisis or watershed moments when the future looked uncertain.[45] Producing, encountering or owning a royal portrait at such a time, be it when England was threatened by Spanish invasion in the 1580s, in the wake of the execution of the king in the mid seventeenth century, or at the dawn of a new era of post-colonialism in the twentieth century, placed emphasis on a reassuring sense of continuity. Any current uncertainties and anxieties could then be interpreted within the context of a comforting and orderly shared national history in which troubles were always overcome.

Endnotes

For full bibliographic references, see page 230.

1 Reid, 'The Symbolism of Postage Stamps', p.228; Jeffrey, 'Crown, Communication and the Colonial Post', p.49.

2 Jeffrey, 'Crown, Communication and the Colonial Post', p.63.

3 It should be noted that until 1660 the only coins stamped with the sovereign's head were crowns and sovereigns. These, being high value, had relatively limited circulation. Peacock, 'The Visual Image of Charles I', p.177.

4 Harrison, *The Arch's of Triumph*; Dekker, *The Magnificent Entertainment*.

5 Korda, 'Staging Alien Women's Work in Civic Pageants', p.65.

6 Orgel, 'Prologue: I am Richard II', p.34; Dekker, *The Magnificent Entertainment*, Sig. D1v.

7 Larwood and Camden, *English Inn Signs*, p.5; Gordon, "If My Sign Could Speak", pp.35–8; Hamling, 'Visual Culture', pp.88–90.

8 Lomazzo, *A Tracte Containing the Artes of Curious Paintinge, Carvinge and Buildinge*, preface to the reader.

9 Capp, *England's Culture Wars*, p.16; Gordon, "If My Sign Could Speak", pp.42–3.

10 McShane, 'Material Culture and "Political Drinking" in seventeenth-century England', pp.247–76. McShane provides evidence that 'loyal healths' were drunk from such vessels and could be used to 'test' drinkers' loyalty to the monarchy.

11 Reed, ed., *The Ipswich Probate Inventories 1583–1631*, p.105.

12 Watt, *Cheap Print and Popular Piety 1550–1640*, p.195; Kümin and Tlusty, eds., *The World of the Tavern*, pp.8–9; Pittock, *Material Culture and Sedition, 1688–1760*, pp.29–30.

13 Colley, 'The Apotheosis of George III', pp.98–113.

14 Marks, 'The Statue of King George III in New York and the Iconology of Regicide', pp.61–6.

15 Statues of monarchs have been the target of similar actions in other subject nations, notably in Ireland. See Whelan, 'The Construction and Destruction of a Colonial Landscape', pp.508–33.

16 Marks, 'The Statue of King George III', p.66.

17 Ibid., p.82.

18 Although the Sex Pistols argue that it outsold the number one single, Rod Stewart's *The First Cut is the Deepest*, and was suppressed. See http://www.sexpistolsofficial.com/records/god-save-the-queen-7/ (accessed 11 Sept. 2017).

19 Otnes and Maclaren, *Royal Fever*; Long and Palmer, eds., *Royal Tourism*; Balmer, 'A Resource-Based View of the British Monarchy as a Corporate Brand', pp.20–44.

20 Cairns, 'The Object of Sectarianism', pp.444–5; Jarman, 'The Orange Arch', pp.4–6.

21 http://www.grandorangelodge.co.uk/tourism#.WbaZf_krKRw (accessed 11 Sept. 2017).

22 Kahn, *Wayward Contracts*, pp.174–84; Kahn, "The Duty to Love", pp.84–107; King, 'Domestic Buildings: Understanding Houses and Society', p.117; McShane, 'Subjects and Objects', pp.871–86.

23 Similar points are made in McShane, 'Subjects and Objects', p.874, and Auslander, 'Beyond Words', pp.1015–45.

24 Watt, *Cheap Print*, pp.6–7, 162.

25 Ibid., pp.148–9; Fumerton and Palmer, 'Lasting impressions of the common woodcut', pp.386–7.

26 Strong, *Tudor and Jacobean Portraits*, vol.1, p.104.

27 Cooper, 'The Enchantment of the Familiar Face', pp.160–1; Foister, 'Paintings and Other Works of Art in Sixteenth-Century English Inventories', pp.275–7.

28 McShane, 'Subjects and Objects', p.874.

29 Crowley, *The Invention of Comfort*, p.52; Hamling, *Decorating the Godly Household*, pp.220–3; Johnson, *English Houses 1300–1800*, pp.148, 157.

30 McShane, 'Subjects and Objects', p.877.

31 For related engravings of Charles, see NPG D18502 and D18503; for a double woodcut portrait of king and queen, see British Museum 1870,0709.764.

32 McShane, 'Subjects and Objects', p.877; Walsh, 'Domesticating the Reformation', pp.581–5.

33 It should be noted that this analogy could also be conceptualised as troubling because it casts the husband in the feminine role. See Kahn, *Wayward Contracts*, pp.59–60.

34 Clark, 'Queen Caroline and the Sexual Politics of Popular Culture in London, 1820', pp.47–68; Davidoff and Hall, *Family Fortunes*, pp.149–55; Lacquer, 'The Queen Caroline Affair', pp.417–66.

35 Clark, 'Queen Caroline', pp.58–62; Colley, 'The Apotheosis of George III', p.125; Lacquer, 'The Queen Caroline Affair', pp.441–5.

36 Clark, 'Queen Caroline', pp.60–2; Lacquer, 'The Queen Caroline Affair', p.445–7.

37 Anon., 'Queen Caroline', available at ballads.bodleian.ox.ac.uk/view/sheet/230 (accessed 4 Jan. 2018).

38 On this process and ceremony in particular, see Cannadine, 'The Context, Performance and Meaning of Ritual', pp.101–64.

39 Di Bello, *Women's Albums and Photography in Victorian England*, p.26.

40 Plunkett, *Queen Victoria: First Media Monarch*, pp.157–77.

41 Cannadine, 'The Context, Performance and Meaning of Ritual', p.120; Parry, 'Whig Monarchy, Whig Nation', pp.57–75.

42 Smith, "Almost Pathetic … But Also Very Glorious", pp.341–9.

43 Heathorn, "Let Us Remember That We, Too, Are English", pp.420–1.

44 Colley has also noted increased interest in royal figures at such times: see 'Introduction', p.21.

THE
TUDORS

Da s c XPECTAT

THE TUDORS

Charlotte Bolland

The Tudors are perhaps the most famous dynasty to have ruled within the United Kingdom. They were immortalised in portraiture and then written into history in chronicles and plays, before evolving into characters of contemporary fiction on the page and on screen. As a result, the opposing poles of the serially wed Henry VIII (reigned 1509–47) and his daughter Elizabeth I, the 'Virgin Queen' (reigned 1558–1603), often overshadow the success of the 'usurper' Henry VII (reigned 1485–1509) in securing the stability of the realm; the reforming zeal of the boy king Edward VI (reigned 1547–53); the nine-day reign of Lady Jane Grey (reigned 1553); and the transition of Mary I (reigned 1553–8) from 'illegitimate' daughter to England's first queen regnant. The Tudor dynasty's realm encompassed England and Wales and made claims to Ireland and France. Their rule spanned the sixteenth century and the creation of the Church of England, the development of the navy, a fledgling overseas empire and the emergence of an outstanding literary culture.

65 **King Henry VII**
Unknown Netherlandish artist, 1505

Oil on panel
National Portrait Gallery, London
(NPG 416)

This portrait was created as part of marriage negotiations in 1505 between Henry VII and Margaret of Austria following the death of Henry's first wife, Elizabeth of York. Although the marriage did not take place, Margaret kept the portrait.

66 The Coronation of Henry VIII and Katherine of Aragon

Title page from *A ioyfull medytacyon*, written by Stephen Hawes, printed by Wynkyn de Worde, 1509

Woodcut
Cambridge University Library

Henry and Katherine of Aragon's joint coronation took place at Westminster Abbey on 24 June 1509. This image shows Henry seated beneath the Tudor rose and Katherine seated beneath the pomegranate of Granada. These joint heraldic emblems decorated numerous surfaces throughout the royal palaces, but most were destroyed after the annulment of Henry and Katherine's marriage.

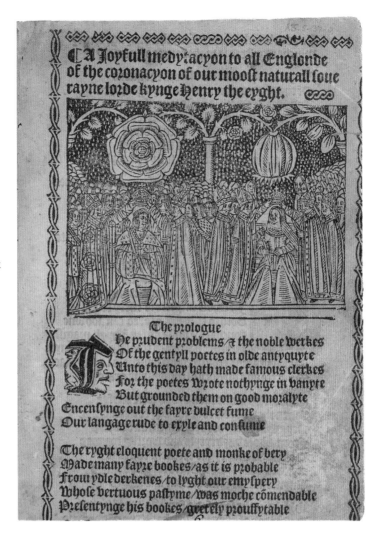

Henry VII was an unlikely candidate for the throne. The son of Edmund Tudor and Margaret Beaufort, his tenuous claim derived from his mother's descent from Edward III (reigned 1327–77). His victory over Richard III (reigned 1483–5) at the Battle of Bosworth Field in 1485 brought an end to thirty years of civil war between the Yorkist and Lancastrian branches of the Plantagenet dynasty, which had ruled England since the twelfth century. Henry's cleverly orchestrated marriage to Elizabeth of York, the daughter of Edward IV (reigned 1461–70 and 1471–83), united the red rose of Lancaster and the white rose of York, founding a family that would rule England and Wales for three generations under the emblem of the red and white Tudor rose.

Henry VII was succeeded by his second son, Henry VIII, whose first act as king was to marry his brother's widow, the Spanish princess Katherine of Aragon. Henry's loyalty to a woman five years his senior, who had been

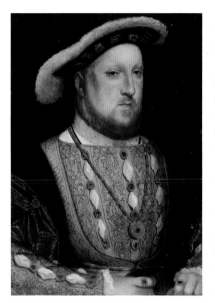

67 King Henry VIII
After Hans Holbein the Younger,
probably seventeenth century,
based on a work of c.1536

Oil on copper
National Portrait Gallery, London (NPG 157)

The German artist Hans Holbein the
Younger undertook a wide variety of
work at the English court but it is for
his portraits that he is most widely
celebrated. This portrait is a version on
copper after Holbein's small-scale portrait
of Henry VIII (fig.25), which survives in
the Museo Nacional Thyssen-Bornemisza
in Madrid, and may have been made as a
diplomatic gift.

marooned in England since Prince Arthur's death, was to last for more than
twenty years. The dynastic imperative of a legitimate male heir, however, spurred
Henry to disavow their entire relationship and to pursue what was to become
one of the most famous divorces in history. Once achieved, Henry was not only
free to marry Anne Boleyn but he had also reshaped the power structures of the
nation, placing himself at the apex of a system in which Parliament stood above
a newly created Church of England that was separate from the authority of the
Catholic Church in Rome.

The assertion of the king's absolute authority claimed many victims during
Henry's reign, including those who had once been his closest advisers, such as
the Roman Catholic Sir Thomas More and the reformer Sir Thomas Cromwell.
The upheaval was also not enough to secure Anne Boleyn's position. She did
not produce the longed-for male heir and was ousted from the king's favour by
factions at court when her daughter Elizabeth was just three years old. Only
Henry's third wife, Jane Seymour, could perhaps have held an unassailable
position at court after she gave birth to Prince Edward; her death shortly after
childbirth, however, set Henry on the path to marital notoriety as he married
Anne of Cleves, Katherine Howard and Katherine Parr in quick succession.
Henry's pursuit of a legitimate male heir bequeathed the question of national
religious identity to his children, which each sought to define in their own
manner: Edward as Protestant, Mary as Roman Catholic and Elizabeth as
Anglican, which saw her valuing loyalty to the Crown above personal beliefs.

Edward VI was only nine years old when he acceded to the throne, so
power was quickly delegated to a ruling council under his uncle Edward
Seymour, Duke of Somerset. Nonetheless, Edward was never simply a
Protestant puppet; his broad humanist education followed the model set for
the ideal Christian prince and prepared him for debate and discourse. His
desire to shape the future events of the realm was clearly evident in his *Devise
for the Succession* that he composed and amended in his final months, aged just
fifteen. This ruled out his half-sisters' claim to the throne in favour of his cousin
Lady Jane Grey, in an attempt to secure the continuation of the Protestant
reformation in England. Edward's early death, however, resulted instead in the
ascension of perhaps the most unlikely of all the Tudor monarchs – England's
first queen regnant, Mary I, the resolutely Catholic princess who had been
declared a bastard after Henry VIII had his marriage to her mother Katherine of
Aragon annulled.

Mary's brief reign of just over five years was dominated by anxiety about
foreign rule following her marriage to her cousin Philip II of Spain, which drew
England into war with France and resulted in the loss of the town of Calais, the
country's last foothold on French soil. Mary died childless in 1558, ensuring the
succession of her Protestant half-sister Elizabeth I and the consequent shaping
of her reputation into the image of 'Bloody Mary' by the anti-Catholic rhetoric
of Elizabeth's reign. Elizabeth I was twenty-five years old when she became

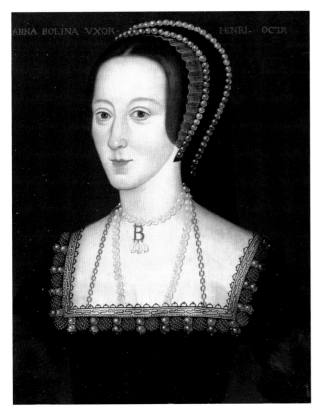

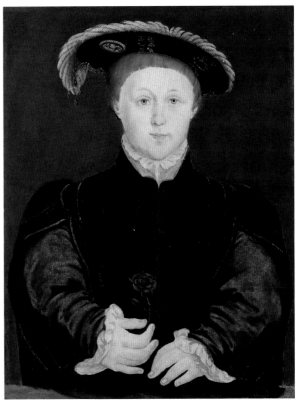

68 Anne Boleyn
Unknown English artist,
late sixteenth century,
based on a work of c.1533–6

Oil on panel
National Portrait Gallery, London (NPG 668)

All the surviving painted portraits of Anne
were created after her death, usually as
part of portrait sets of English monarchs.
They probably derive from a lost
contemporary portrait and conform to
descriptions of Anne's long neck and dark
eyes, and depict her wearing a distinctive
necklace with a pendant letter 'B'.

69 King Edward VI
After Hans Holbein the Younger, c.1542

Oil on panel
National Portrait Gallery, London (NPG 1132)

This image derives from a drawing by
Holbein, made when the young prince
was about five years old, and shows
Edward with a steady frontal gaze that
is notably direct. A number of versions
of the painting survive, suggesting that
Holbein's drawing was intended for wider
circulation as a pattern that could be
shared between artists' workshops.

70 Queen Mary I
Hans Eworth, 1554

Oil on panel
National Portrait Gallery, London (NPG 4861)

Mary was described by an ambassador in 1557 as having eyes 'so piercing that they inspire, not only respect, but fear, in those on whom she fixes them'. This small portrait was made by the Netherlandish artist Hans Eworth and bears his monogram and the date 1554. It was possibly made during marriage negotiations with Philip II.

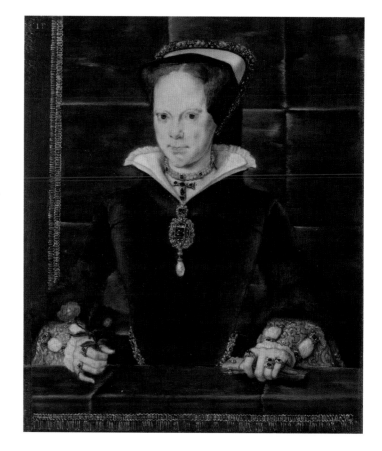

71 Queen Elizabeth I
Unknown English artist, c.1600

Oil on panel
National Portrait Gallery, London (NPG 5175)

Elizabeth is depicted wearing the gold coronation robes with her hair worn loose, as was traditional for the coronation of a queen. She holds the orb and sceptre of state. Tree-ring dating shows that the painting was made many decades after Elizabeth's coronation on 15 January 1559; it may have formed part of the annual celebrations of Elizabeth's accession that occurred throughout her reign.

queen and went on to rule for over forty years. She surrounded herself with able statesmen and advisers, such as William Cecil, Lord Burghley, and together they brought about the re-establishment of the Church of England through the Acts of Uniformity. However, the strength of conservative religious feeling in the country meant that her position was threatened by her Roman Catholic cousin, Mary, Queen of Scots, until the Scottish queen's execution in 1587.

Although Elizabeth never married, she enjoyed the company of men and had several great favourites throughout her reign, including Robert Dudley, Earl of Leicester, and Robert Devereux, Earl of Essex. The relative stability of her reign created an environment in which the arts could flourish, particularly poetry and drama, and in which the country looked to become a world power through the trade, piracy and exploration practised by men such as Sir Walter Ralegh and Sir Francis Drake. Elizabeth adopted the motto *Semper eadem* (Always the same) and projected an image of constancy, which was cemented by her refusal to confirm her successor. Nonetheless, there was a smooth transition of power to the Stuart dynasty after her death as her cousin James VI of Scotland acceded to the throne and assumed the self-styled title of the first King of Great Britain.

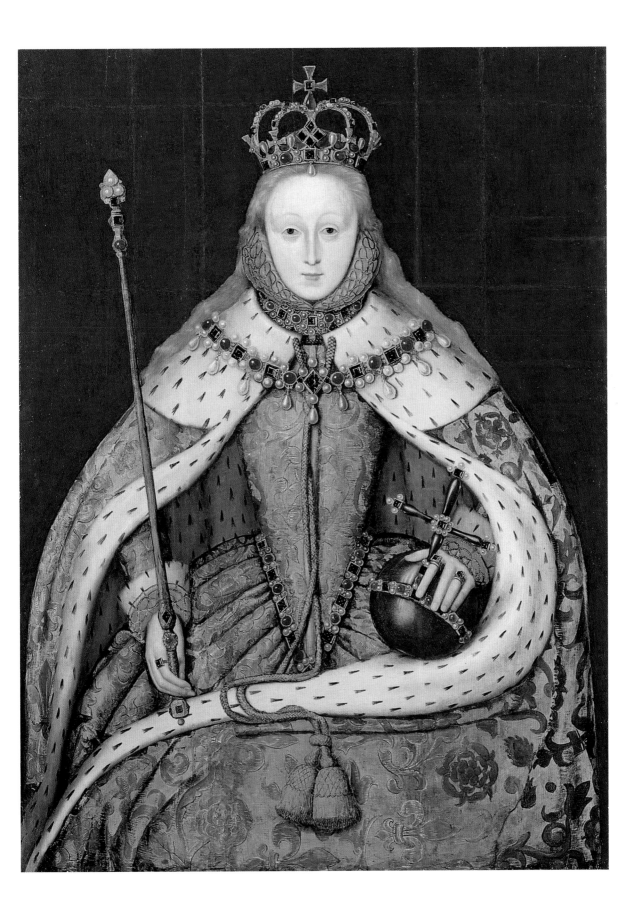

1485
Henry Tudor defeats Richard III at the Battle of Bosworth Field and becomes King Henry VII

1492
An expedition led by Italian explorer Christopher Columbus encounters the Americas whilst searching for a western passage to Asia

1509
Henry VII dies and is succeeded by King Henry VIII

1517
Martin Luther nails his ninety-five theses to the door of the Castle Church in Wittenberg, sowing the seeds of the Protestant Reformation

1534
The Act of Supremacy names King Henry VIII as head of the Church of England

1543
Nicholas Copernicus publishes his claim that the earth moves around the sun

1547
Henry VIII dies and is succeeded by King Edward VI

1553
Edward VI dies and is succeeded by Queen Mary I following a failed attempt to claim the throne for Lady Jane Grey

1558
Mary I dies and is succeeded by Queen Elizabeth I

1564
William Shakespeare is born

1585
English colonists establish the settlement of Roanoke off the coast of present-day North Carolina

1588
The English fleet destroys the Spanish Armada, sent as an invasion force

1603
Elizabeth I dies: the end of the Tudor dynasty

HENRY VII
r.1485–1509

ELIZABETH of York

ARTHUR

KATHERINE
of Aragon

HENRY VIII
r.1509–47
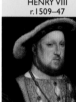

PHILIP OF SPAIN

MARY I
r.1553–8

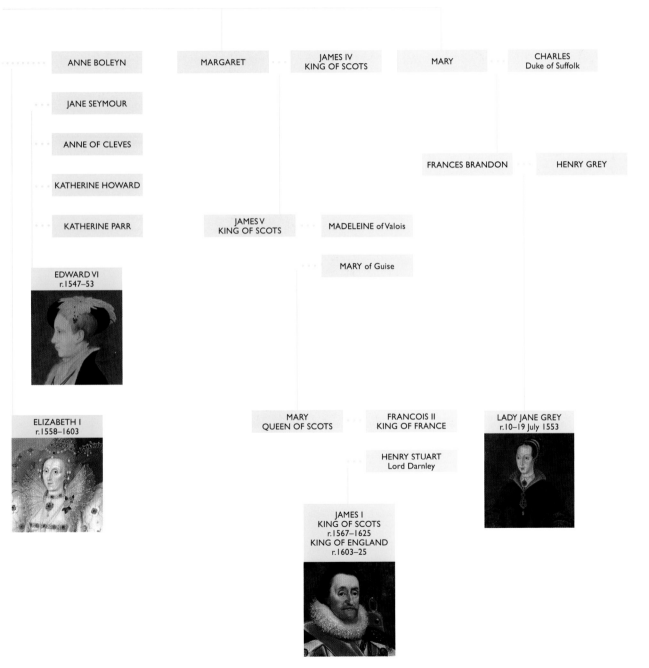

ANNE BOLEYN

MARGARET

JAMES IV
KING OF SCOTS

MARY

CHARLES
Duke of Suffolk

JANE SEYMOUR

ANNE OF CLEVES

KATHERINE HOWARD

FRANCES BRANDON

HENRY GREY

KATHERINE PARR

JAMES V
KING OF SCOTS

MADELEINE of Valois

MARY of Guise

EDWARD VI
r.1547–53

ELIZABETH I
r.1558–1603

MARY
QUEEN OF SCOTS

FRANCOIS II
KING OF FRANCE

LADY JANE GREY
r.10–19 July 1553

HENRY STUART
Lord Darnley

JAMES I
KING OF SCOTS
r.1567–1625
KING OF ENGLAND
r.1603–25

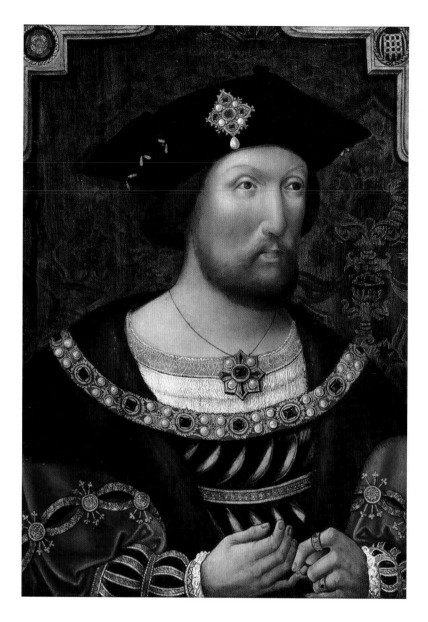

72 **King Henry VIII**
Unknown Anglo-Netherlandish artist,
c.1520

Oil on panel
National Portrait Gallery, London (NPG 4690)

Henry VIII married Katherine of Aragon just before his coronation and
they ruled the country together for over twenty years. They had a number of
children, but only their daughter Mary survived infancy. The pressure to provide
the realm with a male heir to the throne ultimately caused Henry to doubt the
legitimacy of their union and he sought to have his marriage annulled in order
to marry Anne Boleyn.

Various portraits of Henry and Katherine were produced during their
marriage. The composition and pose of these two paintings, dating from
around 1520, suggest that they are examples of portrait types that were probably

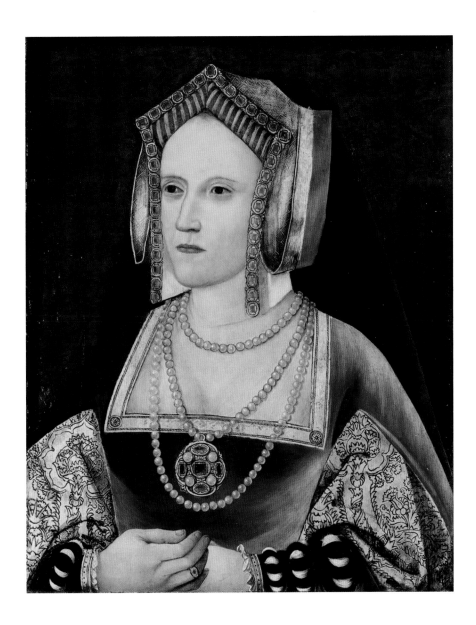

73 Katherine of Aragon
Unknown Anglo-Netherlandish artist,
c.1520

Oil on oak panel
National Portrait Gallery, London (NPG L246)
Lent by Church Commissioners for England

intended for display as a pair. The king and queen are depicted wearing the most luxurious cloths of gold and velvet. Henry is posed in the process of either removing or placing a ring on his right hand; this gesture was frequently used in royal portraits and may refer to the acceptance of kingship or the bestowal of authority.

When Henry married Anne Boleyn, Katherine was exiled from court. She continued to refer to herself as queen, however, and an inventory taken after her death poignantly records that she retained a paired image of herself and Henry among her possessions.

74 King Edward VI

Unknown artist, after William Scrots,
c.1546

Oil on panel
National Portrait Gallery, London (NPG 442)

Prince Edward was born at Hampton Court Palace on 12 October 1537 and was described by Henry VIII as his 'most noble and most precious jewel'. His mother, Jane Seymour, who had been maid of honour to both Katherine of Aragon and Anne Boleyn, died twelve days after giving birth. Although Edward was only nine years old when he became king, his reign, under the stewardship of his uncle Edward Seymour, Duke of Somerset, and subsequently John Dudley, Duke of Northumberland, saw the establishment of the Protestant Church in England. He died after catching a chill early in 1553, aged fifteen.

As a legitimate male heir to the throne, numerous portraits of Edward were commissioned as he grew up in order to disseminate his image and demonstrate that the future of the dynasty was secure in the figure of a healthy boy. A number of versions of this profile portrait of the young prince survive. It would originally have looked even more striking, as the background includes a large amount of the blue pigment smalt, which not only fades from a strong royal blue over time but also causes the oil in the paint mixture to discolour to brown.

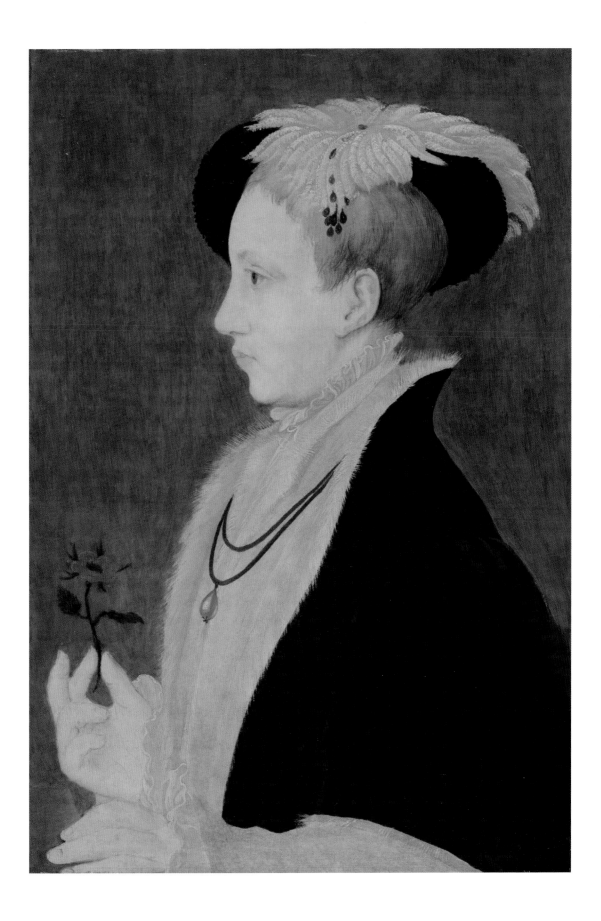

75 Lady Jane Grey

Unknown artist, c.1590–1600

Oil on panel
National Portrait Gallery, London (NPG 6804)

Edward VI attempted to secure the continuation of the Reformation in England by naming his cousin Lady Jane Grey as heir to the throne, in order to block the accession of his Roman Catholic half-sister Mary. Jane was the granddaughter of Henry VIII's youngest sister and was married to Guildford Dudley, the son of the Duke of Northumberland. Following Edward's death, it was Northumberland who moved to place Jane on the throne. Mary's allies rallied, however, and she was proclaimed queen just nine days later. Although condemned for treason, Jane's life was initially spared, but her father's involvement in Sir Thomas Wyatt's rebellion in 1554 sealed her fate.

It is possible that Jane's portrait was never taken during her lifetime and almost certain that no image was made during her very brief period as queen. This portrait bears a fragmentary inscription identifying the sitter as 'Lady Jayne', and tree-ring analysis of the panel support suggests that it was made in the late sixteenth century. It is not clear what the source might have been, so the portrait may be an Elizabethan impression of Jane's likely appearance. It was probably produced in response to Jane's growing reputation as a Protestant martyr during Elizabeth I's reign; the scratched lines across the eyes and mouth may be the result of a deliberate attack at some point in its history.

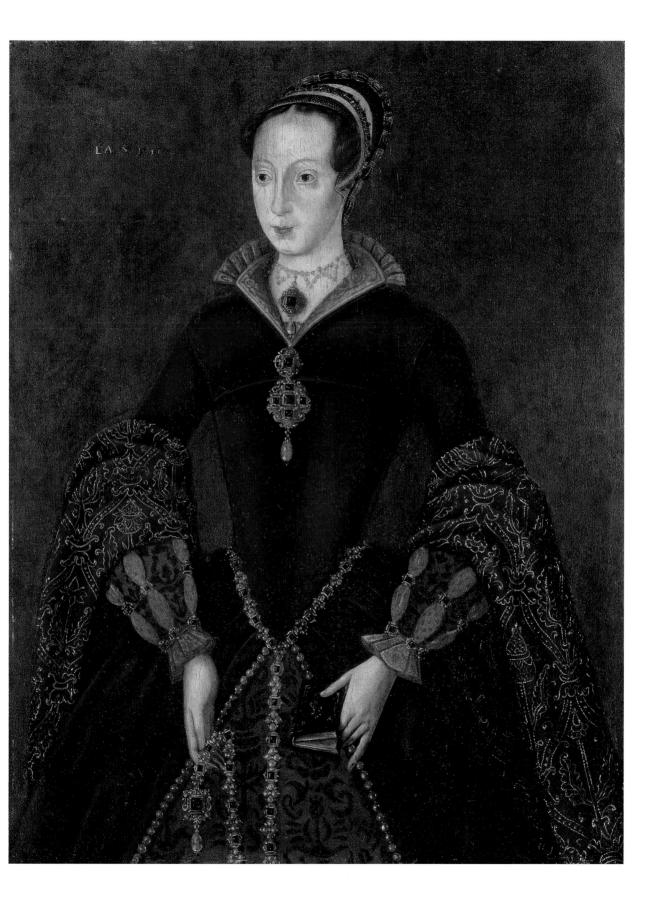

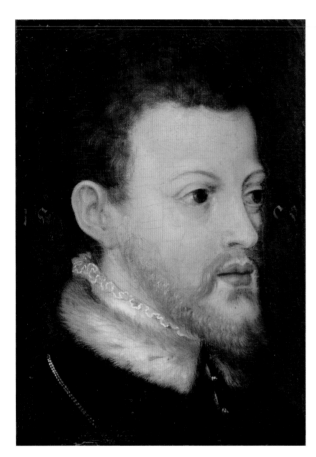

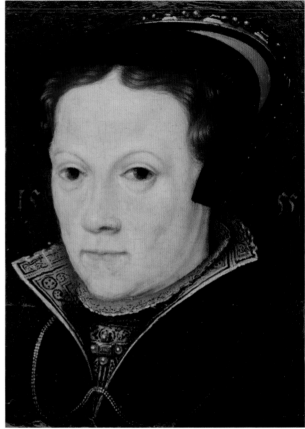

76 Philip II, King of Spain
After Titian, 1555

Oil on panel
National Portrait Gallery, London (NPG 4175)

77 Queen Mary I
After Anthonis Mor, 1555

Oil on panel
National Portrait Gallery, London (NPG 4174)

As the daughter of Henry VIII and Katherine of Aragon, Mary faced years of struggle following the annulment of her parents' marriage. She maintained her Roman Catholic faith and, after the death of her half-brother Edward VI, she successfully rallied supporters to claim the throne. She became England's first crowned queen at the age of thirty-seven, adopting the motto 'Truth, the daughter of time', and restoring Roman Catholicism across the realm.

Despite widespread fears of foreign rule, one of Mary's first acts as queen was to accept her cousin Philip II of Spain's proposal of marriage. These small companion portraits, here shown slightly larger than life-size, derive from a portrait of Philip by the Venetian artist Titian that was sent to England, and a portrait of Mary by the Netherlandish artist Anthonis Mor that was commissioned by Philip's father, Emperor Charles V. Multiple versions of these images could have been made, possibly as gifts for courtiers both in England and abroad. When Mary was thought to have become pregnant soon after the marriage, it seemed as if the Roman Catholic succession was secured. However, it proved to be a phantom pregnancy, and Philip soon left England, returning only briefly in 1557 in order to gather support for war against France.

78 **Queen Elizabeth I
(The 'Ditchley' portrait)**
Marcus Gheeraerts the Younger, c.1592

Oil on canvas
National Portrait Gallery, London (NPG 2561)

The only surviving child of Henry VIII and his second wife, Anne Boleyn, Elizabeth was twenty-five years old when she inherited the throne from her half-sister Mary. As an unmarried woman, Elizabeth was without peer amongst the rulers of Europe and, although the question of succession was ever present, she created a model of rule that skilfully offset the presentation of her femininity with assertions of the power of her rule.

The artificiality of Elizabeth's staged court appearances and her portraiture come together in this late portrait, which was probably commissioned as part of a lavish entertainment staged by Sir Henry Lee at his house in Ditchley, near Oxford, in 1592. Lee had retired from the role of Queen's Champion in 1590. A cartouche halfway down on the right-hand side contains a sonnet on the theme of the sun, the symbol of the monarch, which refers to the queen as the 'prince of light'. Elizabeth is shown standing on a map, her feet placed on Oxfordshire, and turning away from stormy skies, a gesture that may demonstrate her forgiveness of Lee, who had fallen from favour after choosing to live with his mistress following his retirement.

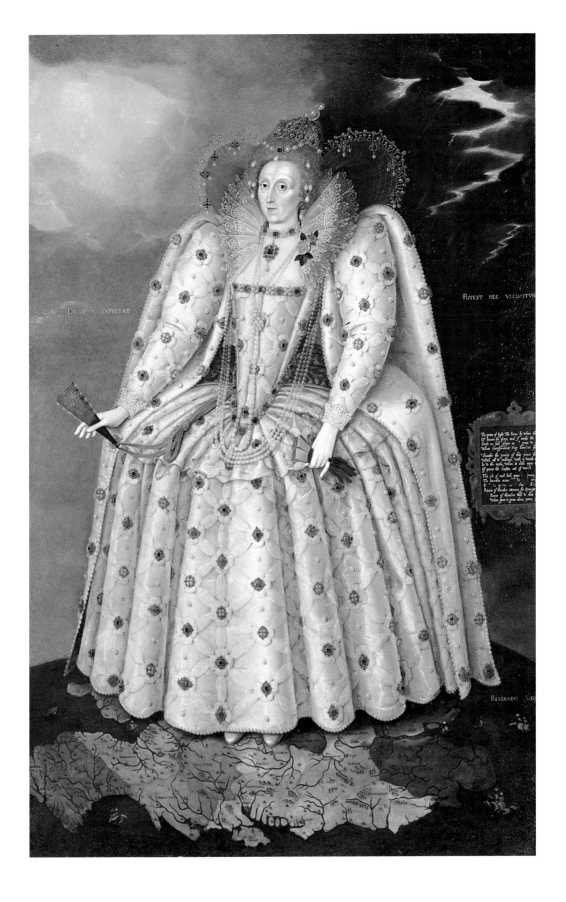

ROYAL FAVOURITES Rab MacGibbon

'Princes ... raise some persons to be, as it were, companions and almost equals to themselves, which many times sorteth to inconvenience.'
Francis Bacon, 1st Viscount St Alban, 'Of Friendship', *Essays* (1598)

Throughout British history, the reigning monarch has operated a system of favour, by which loyalty, support and achievement have been rewarded with privileges, titles and membership of exclusive groups. Britain's highest order of chivalry, the Order of the Garter, which was established by King Edward III in 1348, is the longest-standing and most visible official demonstration of royal favour. Some individuals, however, have risen above all others to attain a unique level of access, affection and trust from the monarch. These favourites wielded considerable power both directly, through responsibility delegated to them by the monarch and, more subtly, through their proximity to the throne.

The degree of intimacy experienced by favourites was a matter of much speculation and accusations of sexual relations were regularly made. The accumulation of wealth and privileges by favourites, combined with their exceptional influence over the monarch, aroused the jealousy of courtiers and politicians. They were regularly surrounded by controversy and their elevated status could be precarious; there was a constant risk of angering the monarch by overstepping royal protocol or abusing their position. Few royal favourites enjoyed a peaceful retirement and many suffered instead a spectacular fall from grace.

Favourites are particularly associated with the Tudor and Stuart courts. This was a period in which the king and queen wielded exceptional levels of personal power, so, as

governing became increasingly complex, a trusted confidant to whom responsibility could be delegated was a valuable asset. Favourites played a notably prominent role during the reign of Queen Elizabeth I. Succeeding to the throne aged twenty-five, Elizabeth inherited a country riven by political and religious division, and under threat from foreign powers. Politically shrewd, she realised that her strength as monarch was greatly enhanced by her unmarried state. Her status as the Virgin Queen, 'married' only to England, was a potent political advantage. Instead she turned marriage proposals into political tools in foreign and domestic affairs and lavished her affection and favour on a succession of favourites.

Her first and greatest favourite was Robert Dudley, 1st Earl of Leicester, whom the queen nicknamed 'Eyes'. He was Elizabeth's only serious English suitor, but his status as a subject, combined with the mysterious circumstances of his first wife's death, meant that a marriage would be damaging to the queen. She instead expressed her favour through gifts, access and preferment. Dudley was made a knight of the Order of the Garter and the Master of the Horse, a role that meant he was regularly by Elizabeth's side. His apartments at court were next to hers and he regularly acted as an unofficial consort at pageants and ceremonies. In 1575 he hosted a lavish entertainment at Kenilworth Castle, which flattered the queen with elaborate allegories of courtly love. His

stately portrait wearing a brilliant red suit (fig.79) was painted around this time by an unknown artist.

The queen's favour also brought political and military power. Robert Dudley was appointed to the Privy Council and commanded the English forces fighting against Spain in the Netherlands. In 1586 he provoked Elizabeth's fury by accepting the Governor-Generalship of the Netherlands and was recalled in disgrace. She soon forgave him, however, and it was Dudley who was given the responsibility for defending London from the Spanish Armada in 1588.

Following his death, a number of dashing and handsome courtiers seeking promotion and opportunities vied for Elizabeth's affection. The principal forum for this competition was the Accession Day tilt, an annual spectacle of jousting and pageantry in which knights competed for the queen's favour. Her last favourite was the brave but impulsive Robert Devereux, 2nd Earl of Essex, who was stepson to the Earl of Leicester. Essex was always conscious of his public image and regularly sat for his portrait, including a full-length miniature that probably celebrates his role in the Accession Day tilt of 1595 (fig.80). He became a popular hero following his attack on Cadiz in 1596, but grew too confident and overstepped his position by attempting to raise a rebellion against the queen's ministers in 1601. He was arrested, found guilty of treason and executed.

The culture of favourites continued in the court of the first Stuart monarch, King

79 Robert Dudley, 1st Earl of Leicester
Unknown
Anglo-Netherlandish
artist, c.1575

Oil on panel
National Portrait Gallery,
London (NPG 447)

80 Robert Devereux, 2nd Earl of Essex
Attributed to studio of
Nicholas Hilliard, c.1595

Watercolour and bodycolour
on vellum
National Portrait Gallery,
London (NPG 6241)

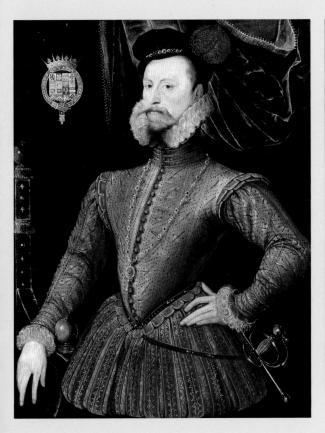

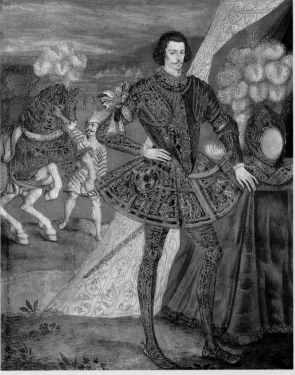

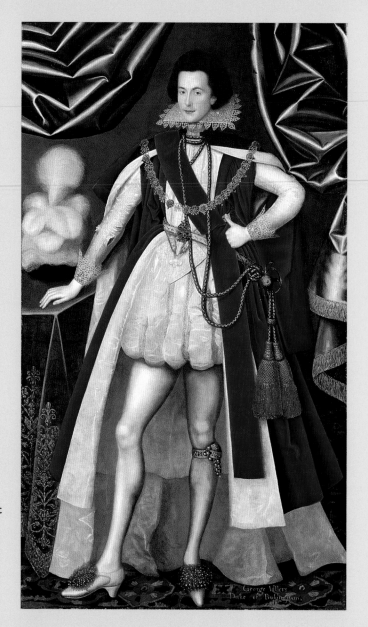

81 George Villiers, 1st Duke of Buckingham
Attributed to William Larkin, c.1616

Oil on canvas
National Portrait Gallery,
London (NPG 3840)

James I. George Villiers, the ambitious son of a Leicestershire knight, caught the king's eye in 1614. Villiers was celebrated as the 'handsomest-bodied man in all of England' and both his charm and vanity can be gauged in his full-length portrait attributed to William Larkin (fig.81). He was full of brave schemes, but lacked both sound judgement and the dedication to carry them out successfully. Despite his diplomatic failings, Villiers was made Duke of Buckingham in 1623 and retained his positions upon the accession of King Charles I. He was finally assassinated in 1628 by a disgruntled soldier following a series of bungled military expeditions.

The last royal favourite of the Stuart era was Sarah Churchill, Duchess of Marlborough. Queen Anne relied on her as a friend and adviser and appointed her to key court positions as Lady of the Bedchamber, Mistress of the Robes and Groom of the Stole. In her portrait by Godfrey Kneller, the duchess wears a gold key to indicate her privileged access to the queen as Keeper of the Privy Purse (fig.82). She used her position to further the military career of her husband John Churchill, 1st Duke of Marlborough, but her forceful personality and political intrigues eventually led to her being dismissed from her offices.

Queen Anne's personal power was diminished by the development of Britain's constitutional monarchy, which increasingly gave Parliament authority over the Crown. This fundamental shift meant that the opportunities available to monarchs to influence policy through the distribution of patronage and favour gradually declined. Monarchs continued to have favourites but the financial, social and political advantages that this status could bring became less significant. In the decades after Prince Albert's death, Queen Victoria was devoted to her Scottish gillie John Brown. He was often by her side but, aside from the liberty of calling his monarch 'wumman', his favoured position as a trusted servant did not bring any political influence or privileges.

82 **Sarah Churchill (née Jenyns), Duchess of Marlborough**
After Sir Godfrey Kneller, c.1702

Oil on canvas
National Portrait Gallery, London (NPG 3634)

83 **John Brown, Queen Victoria**
George Washington Wilson, 1863

Albumen carte-de-visite
National Portrait Gallery, London (NPG x197188)

ROYAL MISTRESSES Rab MacGibbon

Mistresses and lovers have been a frequent and prominent feature throughout the history of the British monarchy. They have, at times, been the cause of scandal and constitutional crisis, but at other times have been openly acknowledged and established members of the royal household. Their intimate access to the monarch could give royal lovers significant power. They were often at the centre of court politics and intrigues, and could even influence state affairs and foreign policy. Alternatively, they could simply provide the monarch with love and happiness. While some royal affairs were frivolous and fleeting, others consisted of a deep commitment over decades, producing families or even resulting in marriage.

Royal lovers are popularly associated with debauchery and immorality. The phenomenon, however, should not be viewed in isolation from the fact that, until the twentieth century, royal marriages were made on the basis of dynastic or political allegiances, with little consideration for the feelings of the participants. Royal couples frequently met their partner for the first time on the day of their wedding, or were even married at a distance via a proxy. Dynastic marriages could also take many years to negotiate, and it was common for male royals to have relationships of their own choosing prior to a marriage being arranged. The offspring of these relationships might be acknowledged by the royal parent and receive titles and privileges, but they were never legitimate heirs to the throne.

During Henry VIII's twenty-year marriage to Katherine of Aragon, he fathered an illegitimate son, Henry Fitzroy (1519–36), with Elizabeth Blount. Fitzroy was made Duke of Richmond and Somerset and Lord High Admiral of England before his early

death from tuberculosis aged seventeen. Henry VIII's eventual determination to divorce Katherine to enable him to secure a male line of succession led to his break with the Roman Catholic Church and the establishment of the Church of England. His marriage to Anne Boleyn in 1533 brought about the elevation of a royal mistress to queen consort. It was exceptional for a monarch to marry one of his subjects and for the choice of wife to have been a personal decision by the king. After three years of marriage, however, Anne's downfall came about due to the same imperative to protect the line of succession that had led to her elevation as queen. Adultery by the consort of the king or Prince of Wales was high treason and, whether true or false, Anne was found guilty of the offence and condemned to the executioner's block.

Queen Elizabeth I had close relationships with her male favourites but it is very unlikely that they were sexual because her status as the Virgin Queen was essential for her royal authority. James VI of Scotland and I of England had passionate friendships with male favourites. There were rumours during James's lifetime and after his death that these included sexual relationships, and this is still subject to debate. Edward II, in the early fourteenth century, and William III, who reigned 1689–1702, are also thought by some to have had male lovers during their reigns.

James I's grandson Charles II was the British monarch with the most open and enthusiastic relationship with mistresses. He was restored to the throne in 1660 following eighteen years of brutal civil war and restrictive republican government under Oliver Cromwell. The religious Puritanism

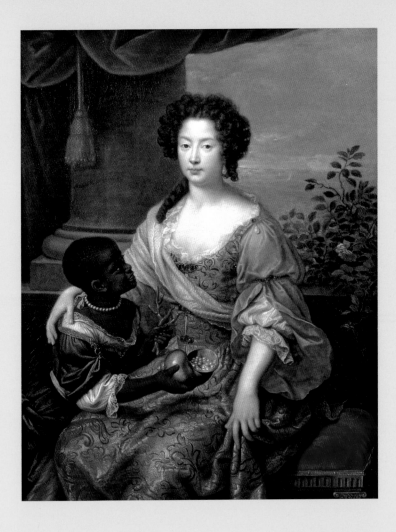

84 **Louise de Kéroualle,
Duchess of Portsmouth**
Pierre Mignard, 1682

Oil on canvas
National Portrait Gallery,
London (NPG 497)

of the interregnum was replaced by a court culture that refashioned social codes and encouraged the loosening of conventional boundaries. Charles had no children with his wife Catherine of Braganza, but fathered fourteen acknowledged illegitimate children by seven mistresses. Barbara Palmer, Duchess of Cleveland (fig.101), established the role of royal mistress in the Restoration court, while the popular actress Nell Gwyn (fig.92) was the most socially transgressive of Charles's mistresses because she was a commoner and continued to work on the stage after the birth of her children by the king.

Nell Gwyn's main rival for the king's affections was her opposite in terms of social and religious background and personality. Louise de Kéroualle, Duchess of Portsmouth (1649–1734), was a French Catholic who became the king's mistress with the encouragement of the French government. She exercised influence at court by acting as an intermediary between the king, his ministers and French ambassadors. The diarist John Evelyn recorded that her apartments at court were 'ten times the richness and glory' of those of the queen. Her portrait by the French court artist Pierre Mignard (fig.84) celebrates her

85 **Maria Anne Fitzherbert (née Smythe)**
Jean Condé, after Richard Cosway, published 1792

Stipple engraving
National Portrait Gallery, London (NPG D2345)

wealth and taste and includes a young black servant offering her coral and pearls.

The Hanoverian monarchs continued the tradition of keeping a royal mistress, with the exception of George III, who, like Charles I in the previous century, was devoted to his wife. In contrast to his father's domestic modesty and fidelity, George IV was the most self-indulgent monarch since Charles II. During his period as Prince of Wales, Prince Regent and then king, he was involved in numerous affairs with women. His most long-standing relationship was with the twice-widowed Maria Fitzherbert (1756–1837). The prince broke down her lengthy resistance by feigning a suicide attempt. Their subsequent secret marriage was illegal because Mrs Fitzherbert (fig.85) was Catholic, but the couple nevertheless maintained a relationship both before and after his unhappy arranged marriage to Caroline of Brunswick in 1795.

George IV's younger brother William IV had a long-term partnership with the actress Dorothy Jordan (1761–1816). Her portrait by John Hoppner in role as Hypolita in the comedy *She Would and She Would Not* (fig.86)

was painted in the first year of her relationship with William. They lived a contented domestic life away from court and had ten illegitimate children, until William's debts and the pressure to make an advantageous and official marriage ended the relationship in 1811.

William IV's childless marriage to Adelaide of Saxe-Meiningen meant that the crown passed to his niece Queen Victoria. Unlike the devoted union between Victoria and Prince Albert, their son Edward VII was notorious for his affairs, including those with the actress Lillie Langtry and the socialite Alice Keppel (1868–1947). Keppel (fig.87) was an accepted and visible presence in the royal entourage and was quietly tolerated by Edward VII's queen consort, Alexandra. The determination of Edward's grandson, King Edward VIII, to marry his divorced mistress Wallis Simpson (fig.168) created a constitutional crisis that resulted in his abdication from the throne in 1936.

Religious and constitutional objections to divorce have softened over the succeeding decades. In 2005, a century after Alice Keppel's relationship with the king, her great-granddaughter, Camilla Parker Bowles, married Charles, Prince of Wales, and received the title Duchess of Cornwall.

86 **Dorothy Jordan**
John Hoppner,
exhibited 1791

Oil on canvas
National Portrait Gallery,
London (NPG 7041)

87 **Alice Frederica Keppel
(née Edmonstone)**
Frederick John Jenkins,
after Ellis William
Roberts, c.1900–10

Heliogravure
National Portrait Gallery,
London (NPG D8115)

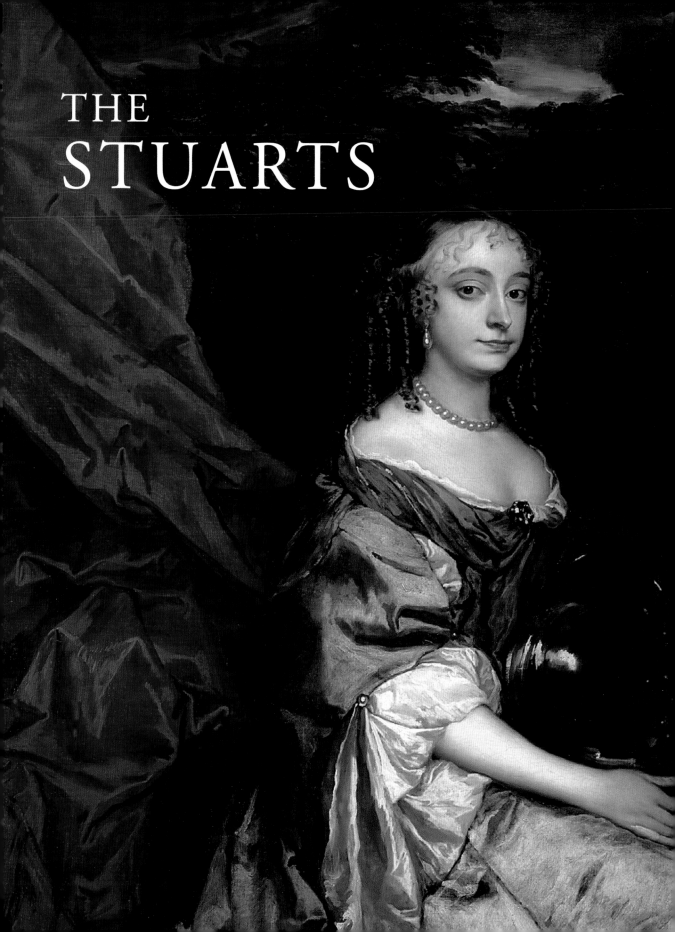

THE
STUARTS

a plausible alternative leader to take up the republican cause, the only answer seemed to be the re-establishment of the monarchy, so in 1660 Charles I's eldest son was invited by Parliament to return from exile abroad to become King Charles II (reigned 1660–85).

The return of the king was met with public rejoicing and optimism. Puritan restraint was lifted: the theatres reopened and women appeared for the first time on the stage. The Royal Society, founded in 1660 and incorporated by the king two years later, promoted and supported scientific inquiry. Charles II's court, however, was soon criticised for excess and debauchery, and his reign was beset with conspiracies and plots, as well as major disasters, such as the Plague, the Great Fire of London and the Dutch invasion of the Medway. Despite having fourteen illegitimate children by a number of different mistresses, including the well-known actress Nell Gwyn, Charles had no legitimate heir. When he died, the throne passed to his brother James, who became King James II (reigned 1685–8).

In the months after his accession to the throne, James II managed to crush a rebellion led against him by Charles's eldest illegitimate son, the Duke of

92 Eleanor ('Nell') Gwyn
Simon Verelst, c.1680

Oil on canvas, feigned oval
National Portrait Gallery, London
(NPG 2496)

Nell Gwyn was the most famous and popular of Charles II's many mistresses. A very successful actress, and one of the first women to perform in public, she is shown here wearing just her shift, or underwear. Actresses were not expected to conform to the usual behavioural norms; Nell allowed the diarist Samuel Pepys (and presumably others) to watch her dressing for her roles.

93 Queen Mary II
Attributed to Jan van der Vaart, c.1692–4

Oil on canvas
National Portrait Gallery, London (NPG 197)

Although this portrait shows Mary II
as Queen of England, with the crown
and sceptre beside her, it is based on an
earlier portrait painted by Willem Wissing
when she was in the Netherlands, where
she is shown in an informal version
of contemporary dress, which was
fashionable in portraiture.

Monmouth, but he was nonetheless deeply unpopular and mistrusted for his
Roman Catholicism. The birth of a son, James Francis Edward Stuart, in 1688 to
the king's second wife, the Roman Catholic Mary of Modena, brought anxieties
to a head; the succession to the throne was now likely to become Catholic in
perpetuity rather than passing to Mary, the Protestant consort of William of
Orange and James's elder daughter by his first wife. In response to this event,
a group of Parliamentarians invited William of Orange to invade England.
William's invasion met little resistance, and James and his family fled the
country. William (reigned 1689–1702) and Mary (reigned 1689–94) were made
joint monarchs of England, Scotland and, after much bloodshed, Ireland.

William III and Mary II reigned together until Mary's death in 1694, after
which William reigned alone until 1702. The beginning of their joint reign was
marked by the passing of the English Bill of Rights of 1689, and a similar act
in Scotland, which limited monarchical power and set out important rights of
Parliament and also of the individual. This bill made the revolution of 1688 of

94 King William III
Unknown artist, c.1695

Oil on canvas
National Portrait Gallery, London (NPG 1026)

Equestrian portraits were increasingly popular towards the end of the seventeenth century, and William III, with his impressive military record, was particularly suited to this kind of imagery. It is possible that the battle scene in the background is intended to be the Battle of the Boyne (1690), a famous victory in Ireland in which he defeated the forces of the deposed King James II.

much more lasting impact than the civil wars of the 1640s, as it formed the basis of the *de facto* British constitution. In addition, it inspired the constitution of the United States and underpins the laws of all the Commonwealth countries.

William and Mary, who were childless, were succeeded on the throne by Mary's younger sister Anne (reigned 1702–14). Anne is famous for having had seventeen pregnancies in seventeen years, but only five live births, and just one child who lived beyond infancy, only to die at the age of eleven. This relentless personal tragedy, however, was the backdrop to a relatively calm and peaceful period in British history. Anne's achievements included the Act of Union between England and Scotland in 1707, bringing the two countries together as a single kingdom. Her death in 1714 without an heir ended over a century of Stuart rule, as Anne's distant cousin George of Hanover was invited to ascend the British throne.

1603
James VI of Scotland succeeds Elizabeth I, becoming King James I of England

1605
The Gunpowder Plot to blow up James I and his government is discovered

1616
William Shakespeare dies

1620
The English ship the *Mayflower* lands at Plymouth Rock in present-day Massachusetts

1625
James I dies and is succeeded by King Charles I

1629
Charles I dissolves Parliament and begins eleven years of personal rule

1642
The start of the English civil wars

1649
Charles I is executed at Whitehall for high treason

1653
Oliver Cromwell becomes Lord Protector of England, Scotland and Ireland

1658
Oliver Cromwell dies and is succeeded as Lord Protector by his son Richard

1660
The Restoration of the Monarchy: Charles II is invited to return to England and claim the throne

1666
The Great Fire of London destroys two-thirds of the city

1685
Charles II dies and is succeeded by King James II

1688-9
The Glorious Revolution ousts Roman Catholic James II and places Protestant William III and Queen Mary on the throne

1701
Parliament passes the Act of Settlement, ensuring a Protestant succession to the throne

1702
William III dies and is succeeded by Queen Anne

1707
The Act of Union between England and Scotland creates Great Britain

1714
Queen Anne dies: the end of the Stuart dynasty

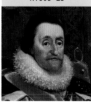

JAMES I
KING OF SCOTS
r.1567–1625
KING OF ENGLAND
r.1603–25

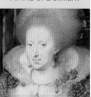

ANNE of Denmark

ELIZABETH STUART · · · FREDERICK V
of Bohemia

SOPHIA · · · ERNEST
Elector of Hanover

GEORGE I
r.1714–27

HENRY FREDERICK
Prince of Wales

CHARLES I
r.1625–49

HENRIETTA MARIA

WILLIAM II
PRINCE OF ORANGE

MARY

JAMES II
r.1685–8

ANNE HYDE

MARY OF MODENA

CHARLES II
r.1660–85

WILLIAM III
r.1689–1702

MARY II
r.1689–94

ANNE
r.1702–14

JAMES FRANCIS
EDWARD STUART

CHARLES EDWARD
STUART

95 King James I of England and VI of Scotland

After John de Critz the Elder, early seventeenth century, based on a work of c.1606

Oil on panel
National Portrait Gallery, London (NPG 548)

James VI of Scotland's claim to the English throne stemmed from his descent from Henry VII. The Tudor king was James's great-great grandfather, Henry VII's daughter Margaret having married the Scottish King James IV. From 1601, James engaged in secret correspondence about the succession with Robert Cecil, Elizabeth I's chief minister. On the death of Elizabeth, the English Privy Council immediately offered him the throne and the new king travelled to London with much ceremony. Although he promised to return to Scotland every three years, he did so only once, in 1617. James's reliance on close favourites at court and his belief in the absolute rule of kings, together with financial difficulties, led to conflict with Parliament. His commitment to peace and reconciliation, however, balanced religious divisions and he successfully held the three kingdoms of England, Scotland and Ireland together under one ruler for the first time.

This portrait is based on an original by the king's Serjeant Painter, John de Critz, produced shortly after James had inherited the English throne. The numerous surviving versions are testament to the demand for images of the new king. In this portrait he wears a jewel called the 'Feather of Great Britain' in his fashionable hat.

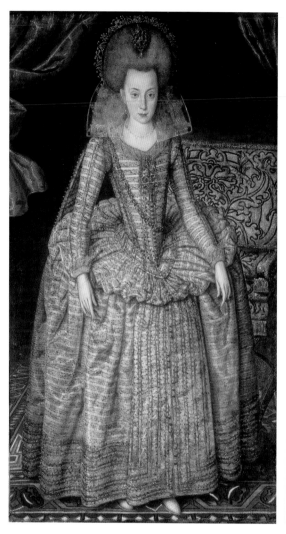

96 Princess Elizabeth
(later Electress Palatine and
Queen of Bohemia)
Robert Peake the Elder, c.1610

Oil on canvas
National Portrait Gallery, London (NPG 6113)

97 Henry, Prince of Wales
Robert Peake the Elder, c.1610

Oil on canvas
National Portrait Gallery, London (NPG 4515)

When James VI of Scotland ascended the throne of England as James I in 1603, one of the major factors in the optimism felt by the English public was the fact that James, unlike his predecessor Elizabeth I, had a family: an heir, a 'spare' and a marriageable daughter. Henry, Prince of Wales was seen as a particularly promising prince. Brave, handsome, clever, athletic, noble, cultured and ardently Protestant, he became the focus for courtiers who advocated a more militant foreign policy, and for those who sought to make London a great cultural centre in Europe. His unexpected death from typhoid fever at the age of eighteen led to widespread grief, both within his family and among the wider population.

Elizabeth, James's daughter, was also a focus for hope and expectation, and an important pawn in the game of international royal marriage negotiations. She was married at the age of sixteen to Frederick, Elector Palatine, a German Protestant prince from Heidelberg. In 1619, Frederick took the disastrous decision to accept the throne of Bohemia, and he and Elizabeth moved to Prague, where they reigned for less than a year before being ousted by the armies of the Roman Catholic Habsburg emperor, Ferdinand II. The rest of Elizabeth's life, much of it as a widow, was lived in exile in The Hague, where she worked hard to keep her plight and that of her children in the minds of her allies, and came to symbolise militant Protestantism as the tragic 'Winter Queen'.

Robert Peake, the artist, jointly held the post of Serjeant Painter. He was responsible for much of the decorative painting at court, but also painted numerous portraits of the royal children. He shows Henry in a pose and setting that echo those in a portrait of Edward VI, his predecessor as Prince of Wales. The view through the window is thought to represent the grounds of Richmond Palace, which Henry had redesigned. Peake's portrait of Elizabeth, like that of her brother, draws attention to her rich clothing and jewellery, including a ruby and diamond brooch pinned to her hair, and a diamond chain across her chest, advertising her eligibility as a wealthy and beautiful potential bride.

98 King Charles I
Gerrit van Honthorst, 1628

Oil on canvas
National Portrait Gallery, London (NPG 4444)

The younger son of James I and Anne of Denmark, Charles became heir to the throne on the death of his brother Henry in 1612. He suffered from a speech impediment and physical disabilities as a child, and from comparisons with his much-admired elder brother as a young man, but his personal life flourished, with a successful marriage to Henrietta Maria of France and six children who survived beyond early childhood. His dismissal of Parliament and his imposition of unpopular taxes, however, along with his attempts to impose religious uniformity, contributed to increasing civil and political unrest and eventually to civil war, culminating in his execution outside the Banqueting House on Whitehall on 30 January 1649.

This unusually informal and intimate portrait is probably a study, made from life, for an allegorical group portrait now at Hampton Court. Charles, a passionate collector and patron of art, had invited the Dutch artist Gerrit van Honthorst to come to England in 1628. He commissioned a huge painting that shows himself and his queen as Apollo and Diana, along with his favourite, the Duke of Buckingham, as Mercury, presenting the Seven Liberal Arts. The portrait captures something of the king's serious-minded, scholarly character.

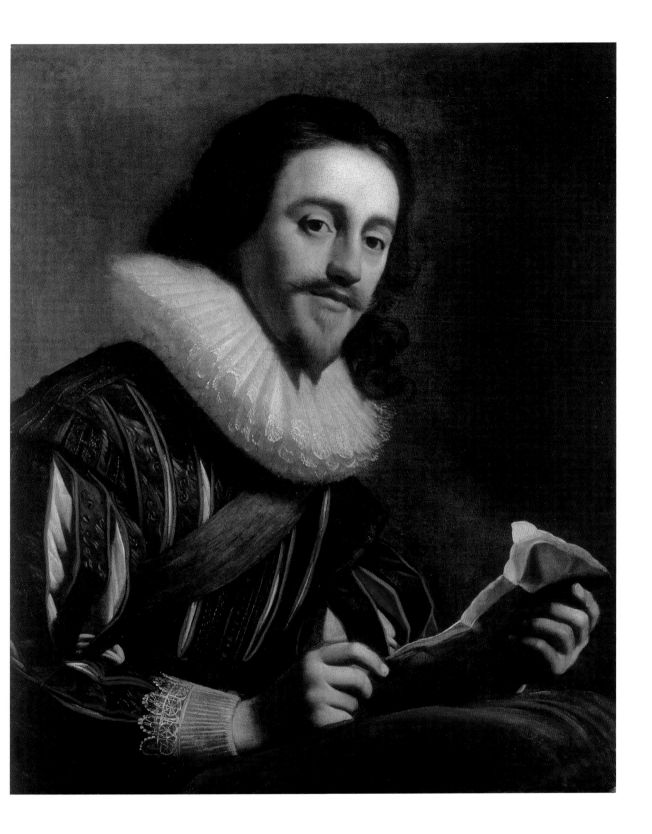

99 Oliver Cromwell

After Samuel Cooper, based on a work of 1656

Oil on canvas, feigned oval
National Portrait Gallery, London (NPG 514)

Oliver Cromwell rose from the position of a country gentleman to become a leading statesman, soldier and finally head of state as Lord Protector (1653–8). His political and military careers were shaped by strongly held religious beliefs. As a Puritan, he was distrustful of Charles I and felt that the Church of England was insufficiently Protestant. As the country descended into civil war, Cromwell emerged as a natural leader, and his military skill was a decisive factor in the Parliamentary victory over the Royalists. Following the execution of the king in 1649, he led the New Model Army in brutal campaigns in Ireland and Scotland. His death in 1658 left a power vacuum that would only be filled by the restoration of the monarchy in 1660.

Despite their differing political and religious beliefs, Cromwell and other Parliamentary soldiers and civilian supporters were depicted in portraiture in very similar ways to their Royalist enemies, sometimes even by the same artists. This portrait is based on an unfinished miniature by Samuel Cooper, who worked for both Royalist and Parliamentarian clients; he was a prominent portraitist during the Commonwealth and went on to work for Charles II after the Restoration. Many versions of this portrait exist, indicating a demand for images of the Lord Protector, whose role in many ways echoed that of monarch. Although he had refused the crown in 1657, Cromwell's funeral effigy was crowned as it lay in state.

100 King Charles II

Attributed to Thomas Hawker, c.1680

Oil on canvas
National Portrait Gallery, London (NPG 4691)

This portrait shows King Charles II near the end of his life and conveys both his striking appearance and something of his personality. He was unusually tall and dark for an Englishman of his time, and whilst charming, clever and affectionate, he was also cynical and lazy. His childhood and youth, dominated by civil war, the execution of his father and years of uncertainty and poverty in exile, shaped him both as a man and a ruler. Often criticised in his lifetime and subsequently for his numerous mistresses and illegitimate children, and his secret treaty with France, he nevertheless maintained a certain degree of popularity with the general public and was at ease with ordinary people. He also supported the development of science and technology, and managed a sometimes very difficult political context with a degree of adroitness.

The artist Thomas Hawker was a follower of Peter Lely, working in a style close to Lely's after his death in 1680. Little is known of Hawker's work, but he painted a full-length portrait of one of Charles's illegitimate sons, Henry, Duke of Grafton, which is comparable to this portrait of the Duke's father, with its shimmering textiles and soft modelling of the hands.

101 Barbara Palmer (née Villiers), Duchess of Cleveland, with her son, Charles Fitzroy, as the Virgin and Child
Sir Peter Lely, c.1664

Oil on canvas
National Portrait Gallery, London (NPG 6725)

A household name in her day, Barbara Villiers was mistress to King Charles II for the first decade of his reign. She bore six children, five of whom he acknowledged as his own. Famous for her beauty, she was despised by many for her lifestyle, and came to symbolise the excess and promiscuity of the Restoration court. As a result of her access to the king, she had some political influence and is thought to have both made and broken political careers.

The artist Peter Lely was the leading portrait painter of the day and the king's Principal Painter. Barbara Villiers was effectively his muse, and her heavy-lidded, 'sleepy' look became the fashionable style of beauty for court women partly as a result of Lely's paintings. Lely depicted her in a wide range of roles: as Minerva, St Catherine, St Barbara, a shepherdess and, here, most audaciously, as the Virgin Mary, with her child – probably her eldest son by the king – as the Christ Child. Portraits depicting the sitters in a religious or allegorical role such as this were usually intended to flatter the sitter, but here the irony of depicting the notorious Barbara Villiers in this way must have been noted by contemporary viewers. That such a portrait could exist at all is a reflection of the relative permissiveness of the Restoration court.

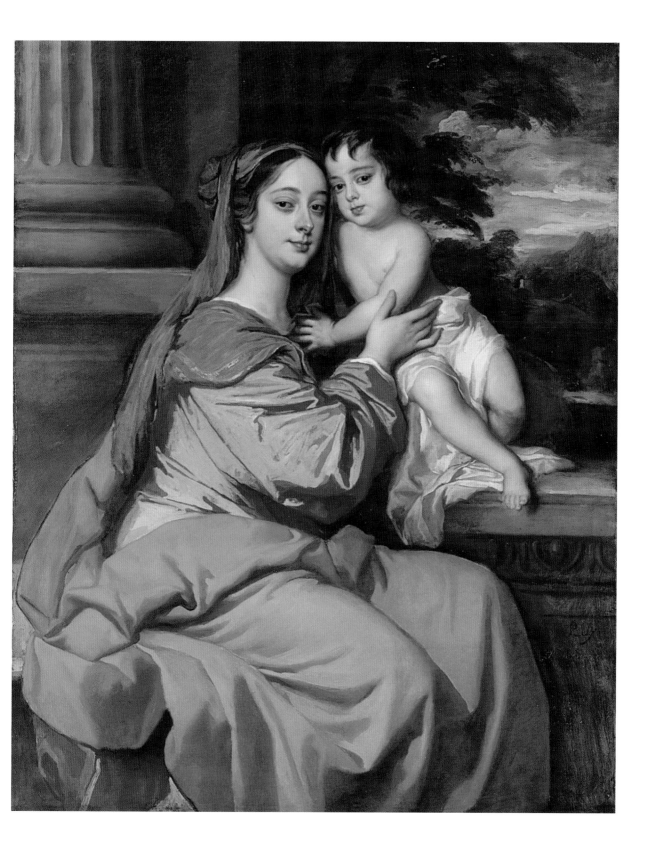

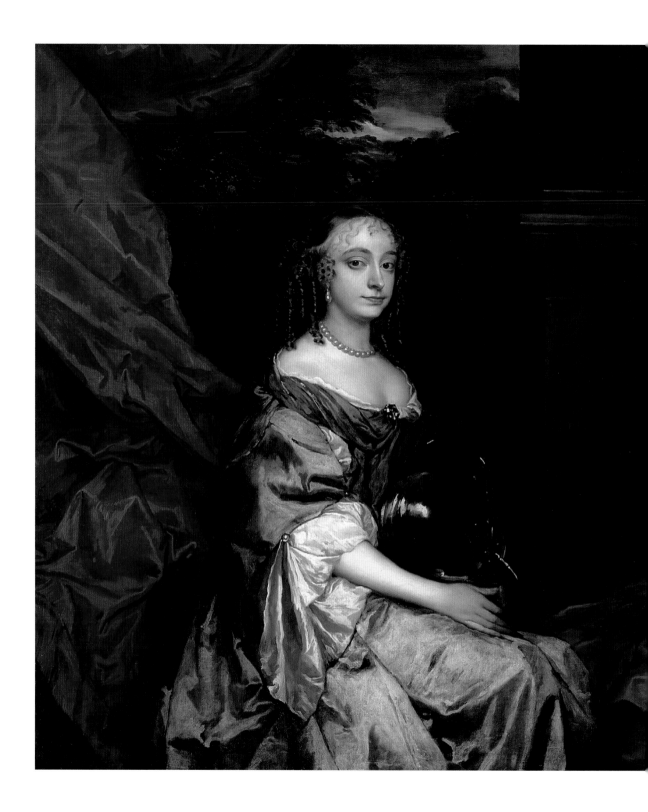

occasions, members of the royal family typically wear simple tailored daywear, with an emphasis on relatively conservative and demure styles. Royal women wear bright colours so that they stand out from the crowd. In the 1980s, Princess Diana was credited with reviving the British fashion industry through her patronage of designers such as Bruce Oldfield and Catherine Walker. One of the most photographed individuals of the century, Diana was highly influential in terms of fashion trends and the press even gave names to some of her outfits, including the 'Elvis Dress' (fig.109). This cream Catherine Walker dress, encrusted with pearls, was worn by Diana to the British Fashion Awards in October 1989, and is now in the collection of the Victoria and Albert Museum in London.

Today Catherine, Duchess of Cambridge, wields similar fashion influence and her style, which mixes items of clothing from high-street shops with designer pieces, is much copied and previewed in fashion magazines. In April 2016, the Duchess appeared on the cover of the centenary edition of *British Vogue*, in one of a series of photographs by Josh Olins, organised in collaboration with the National Portrait Gallery, of which she is a patron. In these images, shot in the Norfolk countryside, the Duchess wears casual clothes, the selection of which she was personally involved in. She is the most recent of a long line of royal women to have been photographed for the magazine, including Queen Elizabeth, the Queen Mother, Princess Margaret, Queen Elizabeth II and Diana, Princess of Wales.

108 **Princess Margaret**
Dorothy Wilding, 1953

Gelatin silver print on tissue and card mount
National Portrait Gallery, London (NPG x34080)

109 **Diana, Princess of Wales**
Terence Donovan, 1990

Gelatin silver print
National Portrait Gallery, London (NPG P716(13))
Given by the photographer's widow, Diana Donovan, 1998

ROYAL SATIRE Paul Cox and Lucy Peltz

Visual satire uses humour, parody and irony to ridicule public figures and engender political debate. Whilst it has a long history dating back to ancient Greece, satire flourished in Britain during the eighteenth and early nineteenth centuries. This golden age saw the genre become a dynamic element of popular culture that could comment on current affairs, express public anxiety and outrage, and have the potential to instigate political change. As a result of Britain's constitutional monarchy, which gave rise to a relative freedom of the press and liberal censorship laws, British satirists have long been able to include the royal family among their targets.

The earliest satirical prints relied on recognisable portraits of their subjects. To make their point, these satires used lengthy inscriptions and depictions that cast their subjects in comical or perverse situations. One example is a mezzotint (fig.110) questioning the legitimacy of James II's son, the Prince of Wales (later known as the Old Pretender). The print depicts James II's wife, Mary of Modena, being pawed suggestively by Father Petre, her husband's confessor, who was rumoured to be the child's father. A potentially treasonable image, this print was circulated among anti-Catholic supporters of William III. Like much satire

110 **Sir Edward Petre, 3rd Bt, Mary of Modena, Prince James Francis Edward Stuart**
Attributed to Peter Schenck, c.1688

Mezzotint
National Portrait Gallery, London (NPG D10694)

111 *Anti-saccharrites, – or – John Bull and his family leaving off the use of sugar*
James Gillray,
27 March 1792

Hand-coloured etching
National Portrait Gallery, London (NPG D12446)

Dignity!
"Grace was in all her steps, Heaven in her eye;
In all her actions dignity."

REFORM BILL!

HANDWRITING upon the WALL.

criticising the Crown at this time, it was printed in Holland to avoid criminal charges.

Caricature arrived in Britain from Italy in the mid eighteenth century and was swiftly employed in satire. Its exaggerated qualities appealed due to the fashion at the time for reading physiognomy and gesture as the index of the mind. James Gillray, the leading satirist of life, society and politics in the late eighteenth century, was particularly creative in his use of caricature to target the royal family. His *Anti-saccharrites, – or – John Bull and his family leaving off the use of sugar* (fig.111) suggests that George III and Queen Charlotte were spendthrifts by rejecting West Indian sugar – although the public boycott was actually a protest against the slave trade. Gillray's prints display a special venom towards the queen; her features are grotesquely parodied, with a gap-toothed smile revealing teeth filed to sharp points. In other well-known works, Gillray highlighted the scandalous behaviour of the Prince of Wales (fig.121). The power of Gillray's satires to turn public opinion is indicated by the fact that in 1797 the government bought him off with a pension.

Most graphic satire criticised the political and social elites, including the royal family. A significant exception was a series of prints that take George IV's side in his divorce proceedings against Caroline of Brunswick. Prints in the series, which include *Dignity!* (fig.112), criticise the behaviour of her retinue and the foreignness of her lover Bartolomeo Pergami. Both the depiction of Caroline's lewd conduct and the irony of the title would have resounded with a society in thrall to politeness and refinement.

At the start of the nineteenth century, satirical etchings gave way to lithographs. *Handwriting upon the Wall* by John Doyle ('HB') is a typical example, showing a barely caricatured King William IV examining a piece of graffiti about the Reform Bill (fig.113). The humour is provided by a simple pun on his name: William becoming 'Bill'.

112 *Dignity!*
Attributed to Theodore Lane, published by George Humphrey, 7 June 1821

Etching
National Portrait Gallery, London (NPG D17907b)

113 *Handwriting upon the Wall*
John Doyle ('HB'), 26 May 1831

Lithograph
National Portrait Gallery, London (NPG D41066)

114 *A Change for the Better*
After John Tenniel,
published in *Punch*
magazine, 31 July 1869

Wood engraving
National Portrait Gallery,
London (NPG D47458)

PUNCH, OR THE LONDON CHARIVARI.—July 31, 1869.

A CHANGE FOR THE BETTER.

Ghost of Queen Elizabeth. "AGREED, HAVE THEY? ODS BODDIKINS! GADS MY LIFE, AND MARRY
COME UP, SWEETHEART! IN *MY* TIME I'D HAVE KNOCKED ALL THEIR ADDLEPATES TOGETHER TILL
THEY *HAD* AGREED!"

'HB' published his prints anonymously for many years, eventually revealing his identity in a letter of 1843 to Sir Robert Peel, in which Doyle claimed that he had always avoided 'indelicacy, private scandal and party bitterness'. Clearly, by this period, the use of cruel humour and irony in satire was considered less acceptable than it was in previous decades.

The simple black and white satirical lithograph paved the way for cartoons in illustrated journals. The most famous of these was *Punch,* a magazine that ran from 1841 until the 1990s. One of their regular contributors was John Tenniel (1820–1914); his *A Change for the Better* shows Queen Victoria being admonished by Queen Elizabeth I for indulging in protracted mourning at the expense of her public duties (fig.114). Despite the implied criticism, it is the ghost of Elizabeth, rather than the reigning queen, that is cruelly depicted.

In marked contrast with Gillray and his era, Tenniel's approach exemplifies a degree of deference and self-censorship that was the norm among mid to late nineteenth-century satirists and their audiences. This politeness and respect continued through much of the twentieth century, the product of the sentiments of the public as much as the self-control of the artists. Since the final decades of the twentieth century, however, little about the royals has been off limits, with satires in all media proliferating. *Spitting Image,* Peter Fluck and Roger Law's TV series using latex caricature puppets, was one of the most savage, its creators acknowledging the influence of precursors such as Gillray. Running on British television from 1984 to 1996, the show regularly featured the royal family (fig.115), portraying the Queen Mother, for example, as a coarse, gin-soaked, horse-racing fanatic.

One of the most critically acclaimed cartoonists working today is Steve Bell, who

144 TUDORS TO WINDSORS

115 **Spitting Image, The Royal Family** *c.*1985

Publicity still by ITV/REX/ Shutterstock

116 *Whose land is it anyway? or Berkshire Gothic* Steve Bell, published 23 March 2001

Ink and watercolour on paper

publishes in the *Guardian* newspaper. Like his predecessors from the golden age of British satire, he often quotes well-known visual predecessors to inflect his images. His *Berkshire Gothic*, for example (fig.116), is based directly on Grant Wood's 1930 painting *American Gothic*. In 2001, election campaigning in rural areas was dominated by an outbreak of foot-and-mouth disease. By showing the Queen and Prince Charles against a hellish background of flaming carcasses, as actually seen in the countryside during this period, Bell created an image both comic and sinister.

The ability of British artists to lampoon those in positions of power and influence, combined with the willingness of British consumers to pay for their work, has created a powerful genre of visual art. By constantly reinventing its iconography, formats and techniques, and also looking back to its roots, the genre has now reclaimed its original political bite.

THE
GEORGIANS

THE GEORGIANS

Lucy Peltz

The Georgian era derives its name from the succession of four kings all named George. Despite continued religious conflict and a series of wars with France, it was during this period that Britain became a world power, an industrial giant and a dynamic commercial society. These developments were framed by the Acts of Union between England and Scotland in 1707, and with Ireland in 1801, the establishment of the Bank of England in 1694 and the Great Reform Act of 1832. These events defined the nation and laid the foundations for modern commerce and, ultimately, democracy.

In 1714, Britain faced a crisis when Queen Anne died without an heir. To guarantee the constitutional monarchy and the Protestant succession (previously secured by the Act of Settlement in 1701), Parliament invited George of Hanover, great-grandson of James I, to take the throne. King George I (reigned 1714–27) spoke little English, spent little time in Britain and continued to rule Hanover. The need to underscore the legitimacy of the new royal dynasty is emphasised in the portraits of George I and his son George II (reigned 1727–60). These tend towards tradition and ensure the prominence of crown, orb, sceptre and the Order of the Garter – the symbols of royal authority.

The accession of the House of Hanover had triggered unrest among the Jacobites, portraits of whom served as rallying points for their supporters. One example is a flamboyant portrait of Bonnie Prince Charlie, James II's grandson (fig.119). Painted in Rome by a French artist, the image asserts the proud identity of the Catholic Stuart monarchy in exile. Brave and impetuous, Bonnie Prince Charlie landed in Scotland in 1745 to lead an uprising to claim the throne for the Stuarts. After marching as far south as Derby, his men were beaten back to Scotland, where the Jacobites were finally defeated at the Battle of Culloden.

Despite successive wars with Catholic France and the king's frequent absences abroad, George II's reign witnessed rapid financial growth and increasing political stability. He was the last monarch to lead his troops into battle, when the French were defeated at Dettingen in 1743. It was also during his reign that the Hanoverians achieved a measure of popularity; indeed, 'God Save the King', the national anthem, was first performed to celebrate George II. While the king had little interest in the arts, his son Frederick, Prince of Wales, was a great patron of art and music. He died before he could come to the throne, however, so George II was succeeded in 1760 by his grandson George III (reigned 1760–1820). On the opening of his first Parliament, with the Earl of Bute as his prime minister, George III declared that he 'gloried in the name of Briton' – publicly celebrating his identity as the first British-born king of Georgian Britain.

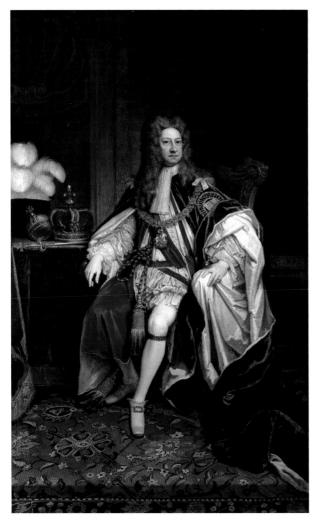

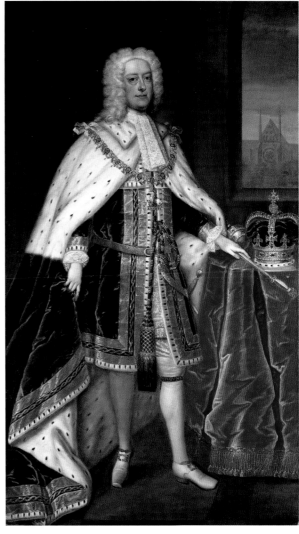

117 King George I
Replica by Sir Godfrey Kneller, 1716,
based on a work of 1714

Oil on canvas
National Portrait Gallery, London (NPG 5174)

Painted by Sir Godfrey Kneller, the most
eminent portrait artist working in Britain at
the time, this is one of many contemporary
versions of George I's coronation portrait.
The royal regalia and the richness of his
surroundings convey his power and status
rather than his personality.

118 King George II
Studio of Charles Jervas, c.1727

Oil on canvas
National Portrait Gallery, London (NPG 368)

This is a version of the portrait
commissioned by the Corporation of
London after George II's coronation in
1727. The picture employs similar
conventions to those in his father's 1714
portrait. The king stands before a window
through which can be seen Westminster
Abbey, where he was crowned.

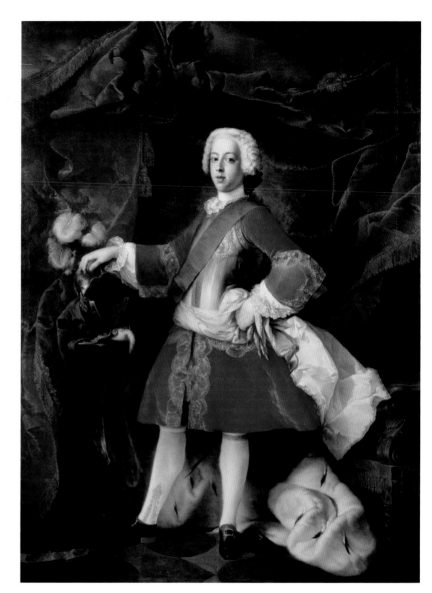

119 Prince Charles Edward Stuart
Louis Gabriel Blanchet, 1738

Oil on canvas
National Portrait Gallery, London (NPG 5517)

Born in exile in Rome, the young prince had charisma and charm, which earned him the popular name Bonnie Prince Charlie. In this dashing portrait he is presented in armour alongside royal regalia. Such confident assertions of the Stuart claim to the British throne served to rally their Jacobite supporters.

With his German wife, Queen Charlotte, George III tried to live more like Britain's new 'middling sort', made up of provincial gentry, wealthy merchants, urban entrepreneurs and industrial innovators. While his rejection of fashion and luxury won him the nickname 'Farmer George', his children did not follow his model of restraint, as depicted in many of the satirist James Gillray's prints. The Prince of Wales (later George IV) was renowned for his lack of self-restraint, his greed and his hedonism, which increased, along with his spending power, as regent and then king.

Although George IV (reigned 1811–19 as regent; 1820–30 as king) was not actually installed as Prince Regent until 1811, the stylistic and cultural period

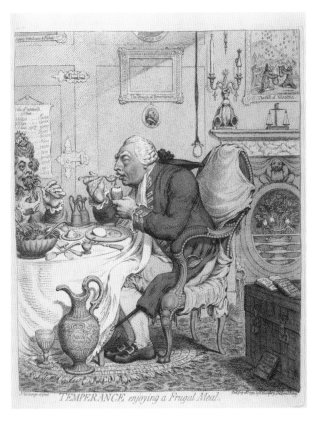

120 *Temperance enjoying a frugal meal*
(Charlotte of Mecklenburg-Strelitz,
King George III)
James Gillray, published
by Hannah Humphrey,
28 July 1792

Hand-coloured stipple engraving
National Portrait Gallery, London (NPG D12461)

121 *A voluptuary under the horrors
of digestion*
(King George IV)
James Gillray, published
by Hannah Humphrey,
2 July 1792

Hand-coloured stipple engraving
National Portrait Gallery, London (NPG D33359)

The royal family were frequent subjects
of the greatest satirist of the age, James
Gillray. These two prints contrast the
parsimonious king and queen eating boiled
eggs and salad, while their notoriously
extravagant son, the Prince of Wales,
reclines in his chair having gorged himself
on a huge meal of mutton, jellies and
brandy. He is surrounded with multiple
examples of his self-indulgence, gluttony
and debauchery.

122 King George IV
Sir Thomas Lawrence, c.1814

Oil on canvas
National Portrait Gallery, London (NPG 123)

The flamboyant and profligate Prince of Wales was well served by the brilliant portraitist Thomas Lawrence. This unfinished profile was created as the model for a medal that was never struck. The overweight Prince was regularly mocked as the 'Prince of Whales' and Lawrence had to defend this elegant portrait as a true likeness.

known as the Regency began in 1788. This was when the Prince of Wales first pressed Parliament to establish a temporary regency during King George III's first severe outbreak of mental instability, believed to be a symptom of the hereditary blood disease porphyria. At the same time, the young prince, who was a serial womaniser, fell passionately in love with Maria Fitzherbert (figs.85, 130), one of the great beauties of the day. A woman of tact and discretion, the widowed Mrs Fitzherbert had resisted George's advances for two years until he feigned a suicide attempt to win her over. Mrs Fitzherbert was a Catholic, but George persuaded her to marry him in a secret ceremony in 1785. The marriage was illegal, as the heir to the throne could not marry a Catholic without losing the right to rule. George consequently convinced his friend Charles James Fox, a Whig politician and leader of the Opposition, to perjure himself by denying the marriage in Parliament.

King George III recovered within months and returned to rule, so the Regency of George IV was not yet fully established. Pressure was put on the prince to make an official marriage, and promise of a financial settlement led him to agree to marry his first cousin Caroline of Brunswick in 1795. Caroline had been brought up in the informal atmosphere of her father's ducal court and was naturally vivacious and sociable. Her manners and high spirits were

123 Caroline of Brunswick
Sir Thomas Lawrence, 1804

Oil on canvas
National Portrait Gallery, London (NPG 244)

Thomas Lawrence's portrait captures Caroline of Brunswick in a defiant mood after her separation from the Prince of Wales. She was taking sculpture lessons at the time and is shown with a modelling tool and clay bust of her father, reflecting her allegiance to her family rather than her estranged husband. She engages the viewer with a confident gaze, while her left hand and wedding ring are hidden by shadow.

disapproved of by the English courtiers, whose preoccupation with etiquette she found stifling. Having refused to give up his current mistress, Lady Jersey, Prince George finally abandoned Caroline just after the birth of their daughter Princess Charlotte in 1796. Caroline repaid her husband's scorn by leading a life of defiant behaviour, taking lovers, developing an alternative court at her house in Blackheath and travelling on the Continent.

Public opinion despaired at the morality of the new generation of royals, and all hopes were placed on Princess Charlotte coming to the throne. This was not to happen. She died in childbirth in 1817, to great public lament, so, with a divorce between George IV and Caroline imminent, public attention turned to Prince William, George's younger brother, as his successor. William was forced to abandon his twenty-one-year affair with the actress Dorothy Jordan and their ten illegitimate children in order to make a dynastic marriage to Princess Adelaide of Saxe-Meiningen. He became King William IV (reigned 1830–7) on George IV's death, and in 1832 signed the Great Reform Act that began the slow enfranchisement of the British people.

124 King William IV
Sir Martin Archer Shee, c.1800

Oil on canvas
National Portrait Gallery, London (NPG 2199)

Depicted here in the full-dress uniform of an admiral, William spent much of his life as a naval officer. Known for his robust quarterdeck attitudes and his lower-deck language, he was described by his neice Queen Victoria as 'very odd and singular'.

Year	Event
1714	George, Elector of Hanover, is proclaimed King George I of Great Britain
1715	The first Jacobite uprisings attempt to restore the Stuart dynasty to the British monarchy but are defeated
1718	British convicts start being transported to penal colonies overseas
1727	George I dies and is succeeded by King George II
1743	George II is the last British Monarch to lead his army into battle, at Dettingen
1746	Final defeat of the Jacobites at the Battle of Culloden
1760	George II dies and is succeeded by King George III
1768–71	Captain James Cook leads his first expedition to the Pacific and charts the east coast of Australia
1775	Beginning of the American War of Independence
1776	The 'Thirteen Colonies' in America declare their independence from Britain
1787	The first fleet of British convicts sets sail for Australia
1788–9	George III is temporarily incapacitated by mental illness
1801	An Act of Union dissolves the Irish Parliament, creating the United Kingdom of Great Britain and Ireland
1805	Victory at the Battle of Trafalgar results in British dominance of the seas
1807	Britain abolishes the slave trade
1811	George III suffers a second bout of mental illness; Parliament passes the Regency Act, allowing the Prince of Wales to rule in his stead
1815	Napoleon is defeated at the Battle of Waterloo
1820	George III dies and is succeeded by King George IV
1830	George IV dies and is succeeded by King William IV
1833	Slavery is abolished throughout the British Empire
1837	William IV dies: the end of the Hanoverian dynasty

GEORGE I
r.1714–27
KING OF GREAT BRITAIN AND ELECTOR OF HANOVER

· · · **SOPHIA DOROTHEA** of Celle

GEORGE II
r.1727–60

· · · **CAROLINE** of Brandenburg-Ansbach

GEORGE IV
r.1820–30

· · · **CAROLINE** of Brunswick

CHARLOTTE · · · **LEOPOLD** of Saxe-Coburg

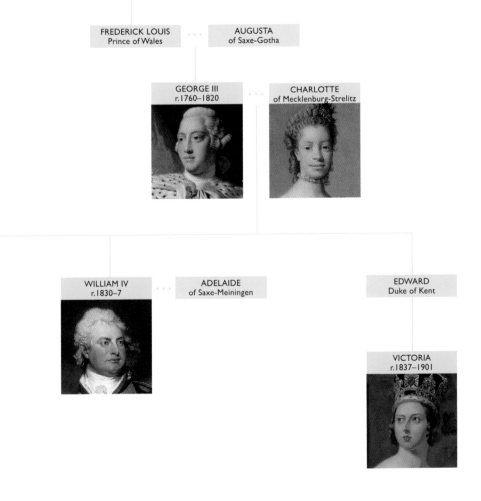

FREDERICK LOUIS
Prince of Wales

· · ·

AUGUSTA
of Saxe-Gotha

GEORGE III
r.1760–1820

· · ·

CHARLOTTE
of Mecklenburg-Strelitz

WILLIAM IV
r.1830–7

· · ·

ADELAIDE
of Saxe-Meiningen

EDWARD
Duke of Kent

VICTORIA
r.1837–1901

GEORG.I.

125 King George I
Studio of Sir Godfrey Kneller, c.1714

Oil on canvas
National Portrait Gallery, London (NPG 4223)

Georg Ludwig of Hanover was the great-grandson of James I through his mother Sophia of the Palatine (1630–1714). He succeeded to the British throne as George I in 1714, on the death of the last Stuart monarch, Queen Anne, under the terms of the Act of Settlement of 1701, which was designed to ensure a Protestant succession. As the first king of a new dynasty, it was necessary to pioneer a new visual identity for the monarchy and to establish quickly the legitimacy and authority of the new regime, as the succession was contested by supporters of the Jacobite claimant to the throne, James Francis Edward Stuart.

This profile portrait is one of several versions made as part of the campaign to disseminate the new king's image and is related to the preparation for new coinage at the Royal Mint. Coins are the most widely disseminated royal images and historically were, perhaps, the most potent symbols of royal authority. This important commission went to Sir Godrey Kneller, the Principal Painter to the Crown, and a payment of £20 'for the coin' was made to Kneller on 6 May 1715. The king wears gold-edged armour draped in a silk cloth and is presented as being ready and determined to defend both the Protestant faith and his new realm.

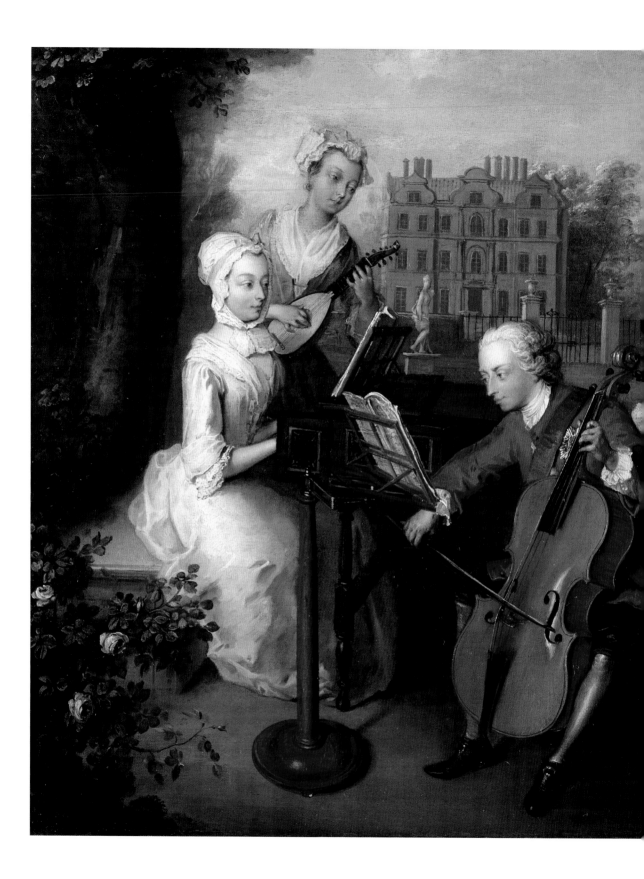

126 *The Music Party*
Philip Mercier, 1733

Oil on canvas
National Portrait Gallery, London (NPG 1556)

This family portrait shows the children of George II
and Caroline of Brandenburg-Ansbach making music.
The 26-year-old Frederick, Prince of Wales, sits centrally
playing the bass viol, an early cello. His sister Anne,
Princess Royal (aged twenty-four), sits to the left playing
a harpsichord, and behind her Princess Caroline (aged
twenty) plucks a mandola, a form of lute. Princess Amelia
(aged twenty-two) leans against the harpsichord with a
volume of Milton's poems on her lap. In the background
is the Dutch House at Kew (now the main surviving part
of Kew Palace in the Royal Botanic Gardens, Kew), where
Anne lived before her marriage in 1734 to Prince William
of Orange. The sisters are shown modestly dressed, while
Frederick is more formally attired in a red suit and wearing
the blue sash of the Order of the Garter.

The portrait was painted by Frederick's Principal
Painter and Librarian Philip Mercier, one of a number
of artists that Frederick attracted to the court. The
composition brings a new sense of relaxed informality to
royal portraiture. Frederick clearly approved of this manner
of presentation as a number of versions were made. The
suggestion of harmony between the siblings belies the
antipathy felt by his family for Frederick; he was hardly on
speaking terms with Anne in the year that this portrait was
painted. Frederick died at the age of 44 and was succeeded
as heir to the throne by his son, George III.

127 **Charlotte of Mecklenburg-Strelitz**
Studio of Allan Ramsay, 1761–2

Oil on canvas
National Portrait Gallery, London (NPG 224)

The eldest son of Frederick, Prince of Wales, George III was the first Hanoverian king to be born and bred in England. His reign was one of the longest and most eventful in modern times, and included the loss of the American colonies. Although plagued by mental illness, he maintained a meticulous personal interest in government until 1811. He first met German-born Charlotte on their wedding day on 8 September 1761. Overcoming initial obstacles of language, they forged a strong and affectionate bond and had fifteen children, of whom thirteen survived into adulthood.

128 **King George III**
Studio of Allan Ramsay, 1761–2

Oil on canvas
National Portrait Gallery, London (NPG 223)

Issued by the talented Scottish court artist Allan Ramsay, these portraits are two of several versions of the State portraits that he painted in 1761 and 1762 (fig.36). The royal couple are shown in great splendour wearing the matching gold and ermine costumes worn at the coronation on 22 September 1761. Ramsay presents the young king with a grace and elegance that is complementary to the dignity and power of majesty. Many of the studio versions of these pictures found their way to Britain's newly acquired colonial territories, where they represented the authority of the nascent British Empire.

129 **King George IV**
Richard Cosway, 1792

Watercolour on ivory
National Portrait Gallery, London (NPG 5389)

As Prince of Wales, George was given no official duties by his father King George III. As had become typical, as the eldest son of the monarch, he sought to undermine the king by siding with his political opponents. When the king suffered a bout of mental illness in 1788, the prime minister William Pitt proposed a restricted regency to protect the king's interests. The king's recovery three months later ended the 'regency crisis'. Pitt's Regency Bill was revived, however, during the king's final illness: George was sworn regent in 1811, crowned king in 1820 and ruled until 1830.

This miniature, here shown slightly larger than life-size, by George's friend and Principal Painter Richard Cosway, depicts the prince in van Dyck-style masquerade costume with a heavily powdered grey wig. It is mounted in a fine gold locket with a 'true-love' lock of plaited hair on the reverse. The precious and intimate nature of this object suggests that it was intended as a love-token for either Mrs Fitzherbert or Mrs Crouch, the prince's two lovers in 1792.

130 **Maria Anne Fitzherbert (née Smythe)**
Sir Joshua Reynolds, c.1788

Oil on canvas
National Portrait Gallery, London (NPG L162)

The wealthy Catholic widow Maria Fitzherbert entered London high society following the death of her second husband in 1781. The Prince of Wales became infatuated with her but she refused to become his mistress. Following months of resistance, the prince finally convinced her to marry him following a feigned suicide attempt. The prince did not have the king's approval and, under the terms of the Act of Settlement in 1701, the heir could not marry a Catholic without forfeiting the right to the throne. Their marriage in 1785 took place, therefore, in a secret ceremony and was never publically acknowledged. Mrs Fitzherbert was condemned to a life of deception as the prince's 'mistress'. She patiently maintained her position for almost a decade after George's official marriage to Caroline of Brunswick in 1795, but she eventually ended their relationship in 1803. She remained the love of the prince's life and, decades after their separation, he was buried with her portrait miniature.

This portrait is by the most fashionable portraitist of the age, Sir Joshua Reynolds. It was originally full-length and may have been intended as a companion to a full-length portrait of the prince. The painting was never finished and it was cut down to its current size in 1816.

131 Princess Charlotte Augusta of Wales, Leopold I, King of the Belgians
William Thomas Fry, after George Dawe, based on a work of 1817

Coloured engraving
National Portrait Gallery, London (NPG 1530)

Princess Charlotte's parents, King George IV and Queen Caroline of Brunswick, separated a few months after her birth, their marriage having lasted only a year. Charlotte was brought up by governesses and saw little of her mother. She resisted her father's pressure to marry the Prince of Orange and instead fell in love with Prince Leopold of Saxe-Coburg.

This hand-coloured engraving marks one of the first public engagements of the newly-weds in 1816. They are shown in a box at the Drury Lane Theatre, London, but are so absorbed in each other that the play cannot compete for their interest. After a period of public appearances, the couple retreated to their home, Claremont House, near Esher in Surrey, where they styled a life for themselves as 'Mr & Mrs Coburg'. Their happiness was cut tragically short when Charlotte died giving birth to a stillborn son in 1817. Public grief at her death was deeply felt. Leopold retained an important role in the British monarchy: he was an adviser to his niece, the young Queen Victoria, and arranged her marriage to his nephew, Prince Albert, in 1840.

ROYAL WEDDINGS Louise Stewart

On 29 April 2011, an estimated 2 billion people in 180 countries around the world tuned in to watch the wedding of Prince William and Catherine Middleton. The public pored over every detail of the ceremony, the guests and the wedding dress; however, this surge of interest was nothing new. From the late fifteenth century, written accounts of British royal weddings have provided readers with the particulars of ceremonies, clothing and celebrations, and in later centuries these have been supplemented with a wealth of visual images in painting, engraving and photography. It is clear that the customs associated with royal weddings have always

been, and remain to this day, a powerful influence on the marriage celebrations of ordinary people.

Historically, British weddings have featured a procession to the church, then the religious ceremony itself, which marks the transition from single to married state, followed by celebrations with family and community. In the case of royal weddings, celebrations were always spectacular, and provided opportunities for the display of wealth and power. New sets of clothing commissioned for royal brides and grooms were used to demonstrate the prestige and wealth of both parties. For his wedding to Anne of Cleves in 1540, Henry VIII wore a doublet of cloth of gold, a crimson coat and diamond collar, while his new queen was dressed in cloth of gold embroidered with pearls, which were associated with both purity and fertility. According to the sumptuary laws, only the royal family could wear cloth of gold, so these outfits were intentional indicators of rank and royal authority.

Until 1840, most royal brides wore silver, probably because the expense of silver thread provided a clear indication of wealth, and also drew on the metal's symbolic association with innocence and purity, as outlined in early modern writing on art. For her wedding to Frederick, Elector Palatine, on St Valentine's Day 1613, Princess Elizabeth Stuart wore a gown of white satin embroidered with silver, while in 1816, Princess Charlotte wore a net dress embroidered with silver lamé over a white and silver petticoat (fig.132). In 1840 Queen Victoria dispensed with the traditional silver and chose a simple white dress made from British silk satin and trimmed with Honiton lace. Prince Albert was married in military

132 **Princess Charlotte's wedding dress**
Mrs Triaud of Bolton Street, 1816

Royal Ceremonial Dress Collection, London

uniform, a practice established in the late eighteenth century when uniforms became fashionable. Victoria's wedding became a model for those of her children and thus the traditional white wedding was born. The white dress could be much more than a symbol of bridal purity; for Princess Elizabeth's wedding in 1947, designer Norman Hartnell adorned her dress with motifs of spring flowers, transforming the princess into a symbol of new hope as an antidote to post-war austerity.

The celebrations following royal wedding ceremonies have traditionally included spectacular pageants, firework displays and the consumption of food and drink. The entertainments after Princess Elizabeth

Stuart's 1613 wedding included a mock battle on the Thames, fireworks, masques and a performance of Shakespeare's *The Tempest*. By the time of Princess Charlotte's marriage in 1816, it was more usual to host a 'nuptial drawing room', which involved the new couple being shown off to dignitaries and politicians.

From the sixteenth century, weddings tended to be performed between the canonical hours of 8am and 12pm, and in the Victorian period the morning wedding gave rise to the wedding breakfast. The centrepiece was the wedding plum cake, which derived from the medieval 'bride cake'. Queen Victoria's cake weighed 136 kilograms and was almost

133 **HRH The Princess Royal's Wedding Cake**
Unknown photographer,
28 January 1858

Albumen print
Royal Collection, London

134 **William II, Prince of Orange, Mary Stuart**
Sir Anthony van Dyck,
1641

Oil on canvas
Rijksmuseum, Amsterdam

3 metres in circumference. On the marriage of her daughter, the Princess Royal, the tiered wedding cake became fashionable; the princess's cake was almost 2 metres high and was surmounted by cupids and likenesses of the bride and groom (fig.133). Although the tiered fruit cake has remained a traditional feature of royal wedding celebrations, contemporary couples have often favoured other confections. In 2012, Prince William requested a chocolate biscuit cake; this contained 1,700 Rich Tea biscuits and 17 kilograms of chocolate.

Prior to the twentieth century, royal marriages were intended to form international alliances, consolidate power and property, and produce heirs to secure dynasties. Until the Victorian period, royal couples were not expected to be in love when they married; indeed, many met for the first time on their wedding day. As a result, portraits have played an important part in royal wedding celebrations since the sixteenth century, when they were circulated in connection with marriage negotiations. Henry VII's portrait (fig.65) was sent to a potential bride, Margaret of Savoy, in 1505. Portraits were also painted to mark the occasion of the royal wedding itself. Van Dyck's celebratory portrait of William II, Prince of Orange, and his English bride, Mary Stuart, depicts them in their wedding clothes (fig.134). The bride and groom were aged only fourteen and nine respectively at the time of their marriage in 1641, and the portrait, commissioned by William's father, Frederick Henry, provided an important visual record of a union that was yet to be consummated.

Medals, coins and ceramics were also made as mementos of royal weddings. Plates decorated with slip (coloured liquid clay)

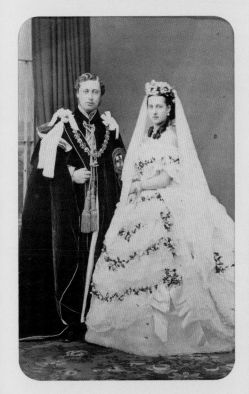

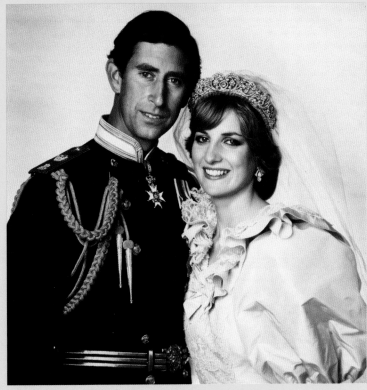

often featured royal subjects; one example by Thomas Toft celebrates the marriage of the Duke of York (later James II) and Anne Hyde, with its portraits of the bride and groom (fig.135). These large plates (known as chargers) were relatively cheap and were probably purchased by the well-to-do middle class for display at home. The wedding of Princess Charlotte in 1816 was the first to be accompanied by the mass production of souvenirs for purchase by the general public. Moulded jugs bearing portraits of the prince and princess were extremely popular, made possible by new developments in transfer printing. In 1840, cheap prints and souvenirs of the wedding of Victoria and Albert helped to make the white wedding dress and veil popular with the wider population (fig.136).

The arrival of photography also provided new opportunities for the dissemination of the royal image. Photographs of the Prince of Wales (later Edward VII) and Princess Alexandra in their wedding outfits were issued as cartes-de-visites, which the public could collect (fig.137). By the late twentieth century, royal weddings had become media events, as exemplified by the wedding of Prince Charles and Lady Diana Spencer in 1981 (fig.138). In the run-up to the wedding, newspapers and magazines speculated on every aspect of the day, as 'royal wedding fever' swept the nation, and souvenirs were produced in their thousands. An estimated global TV audience of 750 million people watched the modern 'fairytale' ceremony, which epitomised the combination of tradition and innovation associated with royal weddings since the sixteenth century.

137 Edward, Prince of Wales (later King Edward VII), Princess Alexandra
John Jabez Edwin Mayall, 18 March 1863

Albumen carte-de-visite
National Portrait Gallery, London (NPG Ax24156)

138 Prince Charles, Diana, Princess of Wales
Patrick Lichfield, July 1981

Colour coupler print on card mount
National Portrait Gallery, London (NPG x29864)

ROYALS AT WAR Paul Cox and Paul Moorhouse

The earliest portrait in the National Portrait Gallery collection is of a king who gained his throne in battle (fig.65). The drama of the story is enhanced by Henry VII being crowned by his followers on the battlefield in 1485, using the crown taken from the slain Richard III. Henry VII became king at a time when royal power was intimately entwined with martial prowess; in the fifteenth century it remained necessary for a monarch to express his power through personal demonstrations of military ability. In subsequent centuries, the relationship between royal power and military prowess has altered, and not since the eighteenth century has the reigning monarch risked his or her life so directly in action. Nevertheless, the connection between the throne and Britain's military remains strong to this day. Members of the royal family are titular commanding officers of many regiments in the army, while younger members may still play an active part in military life.

In the seventeenth century, King Charles I faced the ultimate challenge to his authority when religious and political disputes led to a series of civil wars in England, Ireland and Scotland. He delegated command of his armies to experienced generals but his visible presence during battles, which exposed him to real danger, boosted the morale of the Royalist forces. Despite this, Parliamentary victory in the civil wars led to Charles I's trial and execution, although, after a brief and inconclusive period of republican government, his son would be invited to return to England as King Charles II.

Charles I's second son James converted to Catholicism and, after he succeeded his brother to the throne, James II's religion led to disputes with Parliament. In what became known as the Glorious Revolution, James's son-in-law, William of Orange, invaded with an army of Dutch troops and was proclaimed king. William III defeated James at the Battle of the Boyne in 1689 and some of his most familiar portraits are the equestrian military images commemorating this victory (fig.94).

Following the accession of the Hanoverian kings, continued support for the Catholic Stuart dynasty led to attempts to take back the throne. Prince Charles Edward Stuart, the grandson of King James II, later known as Bonnie Prince Charlie, landed in Scotland in 1745, where he raised an army. Military success in Scotland was followed by a march into England as far as Derby, but the army returned north after anticipated French and English support failed to materialise. George II's son William, Duke of Cumberland, was recalled from the Continent with his troops and finally defeated the Jacobite army at the Battle of Culloden, near Inverness, in 1746.

The last British king to command his army in battle was George II (fig.139), who retained his position as Elector of Hanover after he was crowned in 1727. When Hanover was threatened during the War of the Austrian Succession, he took the field at the head of an army composed of British, Hanoverian, Hessian and Dutch troops, and defeated the French army at the Battle of Dettingen in modern Germany. This was not the first time George had risked his life; he had been a cavalry commander at the Battle of Oudenaarde in 1708, when he had been so close to the fighting that his horse had been killed.

Even after reigning British monarchs ceased to take an active part in warfare, links with the armed forces were maintained through members of their immediate family; King George III, for example, sent Prince

William, later William IV, into the Royal Navy at the age of thirteen. As a nineteenth-century queen, Victoria could never have been expected to take an active part in the life of the armed forces herself, but she acknowledged the contribution her fighting men made to the expansion of the British Empire, and cemented the bond between them and herself with the introduction in 1856 of the Victoria Cross, the highest award in the United Kingdom honours system.

During the twentieth century, reigning monarchs continued to remain detached from active military service, and royal involvement during times of war was principally associated with younger family members. Queen Victoria's eldest son, Edward, had hoped for a career in the British Army, and on his seventeenth birthday was awarded the rank of colonel. His mother, however, discouraged a military career, so the future king's aspirations were short-lived. His successor, George V, was an exception, as it fell to him to respond to the extraordinary circumstances of the First World War. Although he did not participate in the fighting, he wore uniform and was determined to promote the war effort. He first visited the Western Front in December 1914, and during the course of the conflict, he made numerous visits to the soldiers serving in France, and to hospitals, munitions factories and shipyards in Britain (fig.140).

139 **King George II**
Thomas Hudson, 1744

Oil on canvas
National Portrait Gallery,
London (NPG 670)

140 **King George V visiting the Red Cross War Hospital, Torquay**
Dinham & Sons,
September 1915

Gelatin silver print
National Portrait Gallery,
London (NPG x136885)

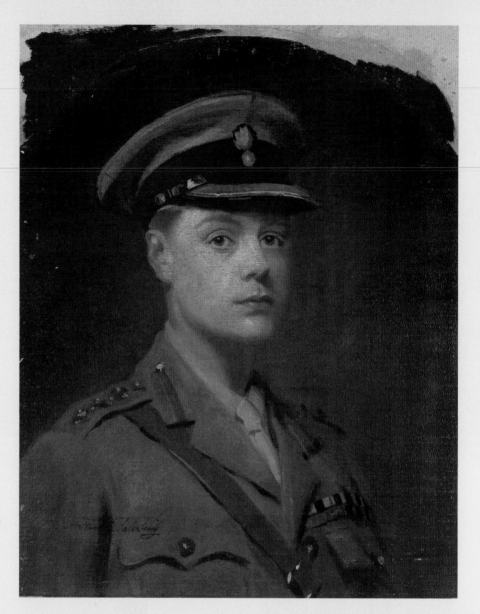

George V's sons, Prince Edward (later Edward VIII) and Prince Albert (later George VI), were both actively involved in the Great War. Prince Edward (fig.141) joined the army in July 1914 and, on the outbreak of hostilities, was keen to see action. Once again, however, this was denied, as an heir to the throne could not be exposed to risk of capture or death. The Prince of Wales, therefore, had to resign himself to filling an ambassadorial role, in which he nevertheless made a significant contribution. His younger brother Prince Albert (fig.142) was intended for a naval career and was at sea when war was declared. In May 1916 he saw action at the Battle of Jutland, the major naval engagement of the war, while serving as acting sub-lieutenant on HMS *Collingwood*.

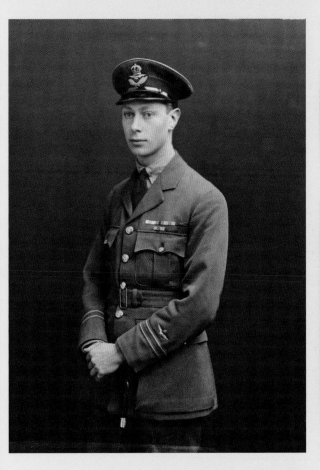

The present royal family has maintained close links with the armed forces, and several individuals have seen active service in their youth. During the Second World War, Princess Elizabeth (later Elizabeth II) became the first female member of the royal family to enter the armed forces (fig.143); in 1945, at the age of eighteen, she joined the Women's Auxiliary Territorial Service as an honorary second subaltern. She trained as a driver and was later promoted to honorary junior commander. The Queen's consort, Prince Philip, Duke of Edinburgh, and her son Prince Andrew, served with distinction during the Second World War and the Falklands War respectively.

The Queen's grandsons, Princes William and Harry (fig.174), have both served as members of the armed forces. William graduated from Sandhurst in 2006 as Second Lieutenant and later transferred his commission to the RAF. Harry also completed officer training at Sandhurst and subsequently saw action in Helmand, Afghanistan. Owing to their royal responsibilities, however, neither William nor Harry were able to contemplate a long-term military career. William ended active service as an RAF search-and-rescue pilot in 2013, and Harry's army career ended in 2015, while on secondment to the Australian Defence Force. The relationship between royalty and the armed forces nevertheless remains conspicuous, being rooted in both history and their official duty to the defence of the realm.

142 **Prince Albert (later King George VI)**
Speaight Ltd, 1918

Gelatin silver print
National Portrait Gallery,
London (NPG x134718)

143 **Princess Elizabeth (later Queen Elizabeth II)**
Topical Press, 1945

Gelatin silver press print
National Portrait Gallery,
London (NPG x139784)

THE
VICTORIANS

THE VICTORIANS

Rosie Broadley

Queen Victoria (reigned 1837–1901) was just eighteen when she ascended to the throne, following the death of her uncle William IV. By virtue of her youth and gender, Victoria was perceived as untainted by the familial disputes and debaucheries that had characterised the reigns of her Hanoverian predecessors. Her coronation in 1837 was hailed as a new era for Britain, and this idealism is conveyed in Sir George Hayter's official coronation portrait (fig.150). Victoria married her handsome German cousin Prince Albert of Saxe-Coburg-Gotha in 1840. Over the next eighteen years the couple had nine children, and while Victoria reigned as sovereign over the country, within the home the couple adopted more conventional gender roles. The idea of a traditional, patriarchal and morally upstanding royal family profoundly influenced social mores of the Victorian era.

Major developments in science, technology and philosophy occurred during the long reign of Queen Victoria and continue to shape the way we live today. In medicine, these included the development of anaesthetics and germ theory, whilst the discoveries made by geologists and astronomers alongside Charles Darwin's theory of evolution challenged conventional religious views of man's place in nature. The mathematicians Charles Babbage and Ada Lovelace pioneered computer technology, and communication was transformed by the discovery of radio waves. In popular culture it was the age of the novel, and the serialisation of works by Charles Dickens, Wilkie Collins and Thomas Hardy in popular magazines kept the nation gripped.

In portraiture, artists attempted to reconcile the contradictory realities of the queen's public power with traditional womanly virtues. During the first decades of Queen Victoria's reign, there was huge demand for informal images of the young royal family. Developments in print processes, allowing for mass production, meant that coloured lithographs, such as *Domestic Life of the Royal Family* and *The Queen and Prince Albert at Home* (figs.145, 146), were widely available.

Under Queen Victoria, the British Empire became a global power, with colonial rule in Canada and Australia extending to India, Malaya and West Africa. Thomas Jones Barker's portrait *The Secret of England's Greatness (Queen Victoria presenting a Bible in the Audience Chamber at Windsor)* epitomises the Victorian concept of the British Empire, in which the perceived benefits of European civilisation, and Christianity in particular, were conferred on the peoples over whom it ruled (fig.147). The empire was run on the domestic model of Parliamentary government. In spite of an increasingly urban

144 Prince Albert of Saxe-Coburg-Gotha
Franz Xaver Winterhalter, 1867,
based on a work of 1859

Oil on canvas
National Portrait Gallery, London (NPG 237)

This replica was commissioned by Queen
Victoria and depicts Albert wearing the
uniform of a colonel of the Rifle Brigade.
On its presentation to the National
Portrait Gallery by the queen, the portrait
was accompanied by a letter stating
that its accuracy had given her 'much
satisfaction'.

population, however, the land-owning aristocratic class continued to
dominate in the country's government. As the century progressed, more
of the male population gained the franchise, but women continued to
be excluded from voting, despite the concerted attempts of campaigners
such as Millicent Garrett Fawcett. Queen Victoria was personally
opposed to women's suffrage, describing it as a 'wicked folly'.

The expansion of the empire during Victoria's reign resulted in
significant military interventions in Afghanistan, India, Egypt, Africa
and the Crimea, the last of these a war that laid the foundations
for the First World War. Developments in military equipment,
including armoured vehicles and automatic artillery, marked the

145 *Domestic Life of the Royal Family*
Unknown artist, c.1848

Hand-coloured lithograph
National Portrait Gallery, London (NPG D20924)

This image draws on a well-known portrait by the queen's favourite painter Sir Edwin Landseer entitled *Windsor Castle in modern times; Queen Victoria, Prince Albert and Victoria, Princess Royal* (1841–3, Royal Collection) and presents a series of vignettes of family life with an emphasis on outdoor pursuits.

146 *The Queen and Prince Albert at Home*
Unknown artist, published by George Alfred Henry Dean, c.1844

Hand-coloured lithograph
National Portrait Gallery, London (NPG D20925)

In this popular print, the royal couple are imagined playing with their four eldest children, emulating a scene made popular by Victorian artists, including Richard Parkes Bonington, who had depicted the French King Henri IV playing horse with his grandchildren (c.1827, Wallace Collection). A pair of doors was originally attached to the image, which opened to reveal the intimate scene.

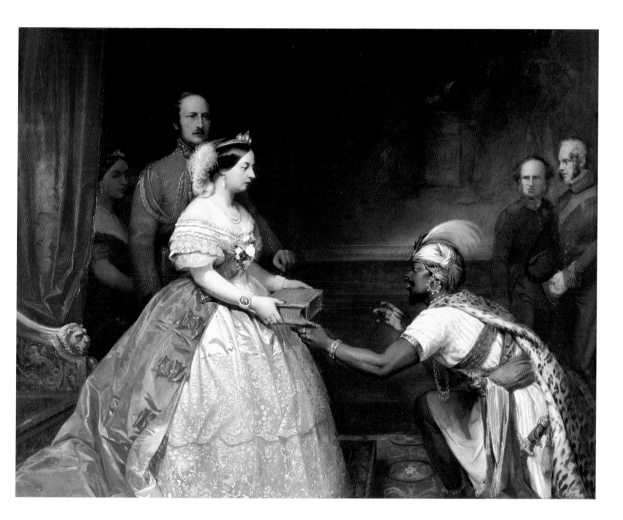

147 *The Secret of England's Greatness (Queen Victoria presenting a Bible in the Audience Chamber at Windsor)*
Thomas Jones Barker, c.1863

Oil on canvas
National Portrait Gallery, London (NPG 4969)

In this imagined scene, Queen Victoria, attended by Prince Albert, who had died in 1861, and government ministers, is depicted presenting a Bible to an East African envoy, probably based on Ali bin Nasr, Governor of Mombasa, who attended Victoria's coronation in 1838 and returned again in 1842. From 1863, the painting was sent on a tour of Britain to promote the mezzotint reproduction.

beginning of modern warfare. While few people came out of the Crimean War (1853–6) with credit, Florence Nightingale and Mary Seacole, who nursed the sick and wounded soldiers, emerged as heroes, and Nightingale laid the foundations for lasting reforms in nursing care. The role of protecting British interests worldwide grew alongside industrial might, and for a significant few decades, Britain became the 'workshop of the world', a period when British-manufactured goods dominated world trade. Consumer culture flourished as the country's economy shifted from agriculture to industry and trade.

One of the most crucial developments in portraiture and popular culture occurred in the Victorian era – the invention of photography. Pioneering practitioners included William Henry Fox Talbot, who began experimenting with photography in 1834, Julia Margaret Cameron and Lewis Carroll (Charles Dodgson), also known as the author of *Alice in Wonderland*. Within a matter of decades, photography became a relatively inexpensive and commercially viable medium, and photographic postcards or cartes-de-visite of celebrity

148 John Brown, Queen Victoria
W. & D. Downey, 1868

Albumen print
National Portrait Gallery, London
(NPG P22(4))

This photograph shows the queen
mounted on horseback whilst dressed
in widow's black. She is in the company
of her loyal Scottish gillie and trusted
companion John Brown. When Brown
died, the Queen described him as 'my
best & truest friend, – as I was his', much
to the disapproval of her family.

149 King Edward VII
Sir (Samuel) Luke Fildes, 1902–12,
based on a work of 1902

Oil on canvas
National Portrait Gallery, London (NPG 1691)

This portrait was given to the National
Portrait Gallery by the sitter's son,
George V, and is a replica of the king's
official state portrait made for the Royal
Collection. The artist received so many
orders for replicas from embassies around
the world that he was forced to employ
a team of artists to undertake the work,
which took place in St James's Palace.

sitters became widely available in the 1860s. Victoria and Albert embraced
the medium, and images of the royal family were constantly reproduced,
transforming the monarch's relationship with her subjects all over the world.
The premature death of Prince Albert in 1861 left Victoria devastated, and
subsequent portraits, for example W. & D. Downey's photograph of the queen
on horseback (fig.148), show her in a state of perpetual mourning.

By the time Victoria's son King Edward VII (reigned 1901–10) came to
the throne, the steam train, bicycle and motor car had replaced horse-drawn
transport; candles and oil lamps had given way to gas lights and then electricity;
postal services had been supplemented by the telegraph and telephone; and
quill pens had made way for typewriters. King Edward loved sport, high living
and novelty but, unlike his parents, had little interest in the visual arts. Sir
Luke Fildes' coronation portrait of the first twentieth-century monarch is laden
with the traditional regalia and strikes an anachronistic note – in the age of
photography, the official state portrait, once so crucial in shaping a monarch's
identity, seemed to have lost its relevance.

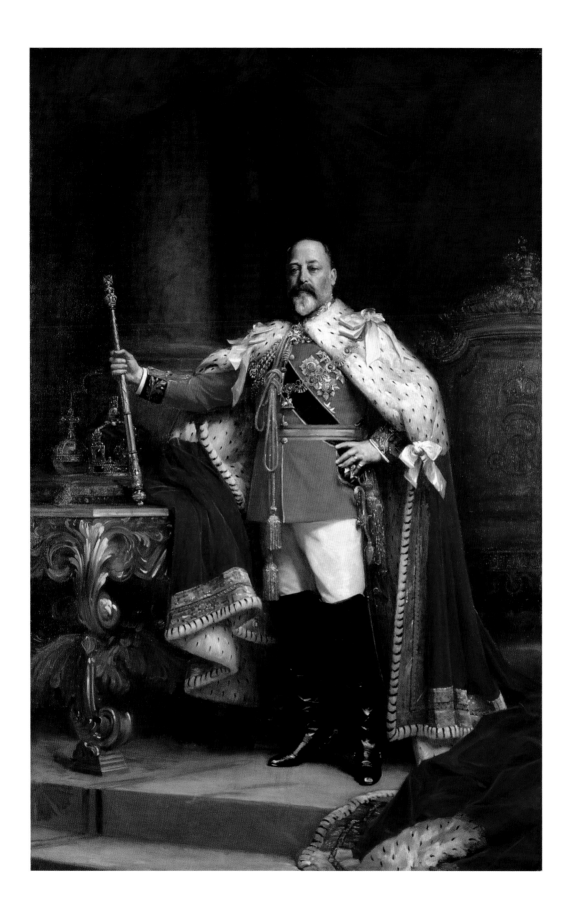

1837
Victoria is crowned
Queen of Great Britain

1838
Charles Dickens's *Oliver Twist*
is published

1839
Louis Daguerre announces his
invention of the Daguerrotype,
the first commercially available
photographic process

1845–50
Irish potato famine

1853
Beginning of the Crimean War

1856
End of the Crimean War

1859
Charles Darwin's *On the Origin
of Species* is published

1861
Victoria's husband Prince Albert
dies aged 42

1868
Britain ends penal
transportation to Australia

1876
Queen Victoria is declared
Empress of India

1887
Queen Victoria's Golden Jubilee
celebrations mark the fiftieth
anniversary of her accession

1897
Queen Victoria's Diamond
Jubilee celebrations mark
the sixtieth anniversary
of her accession

1901
Queen Victoria dies and is
succeeded by King Edward VII

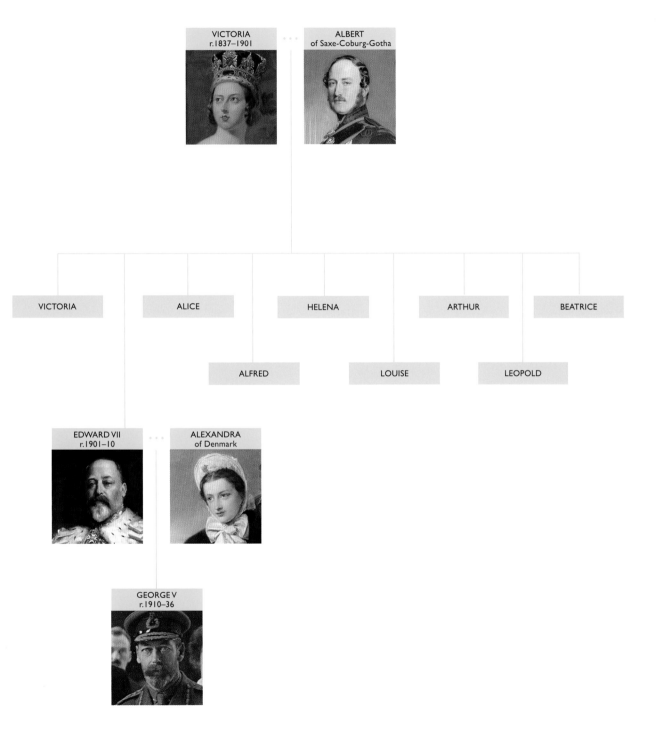

VICTORIA
r.1837–1901

ALBERT
of Saxe-Coburg-Gotha

VICTORIA

ALICE

HELENA

ARTHUR

BEATRICE

ALFRED

LOUISE

LEOPOLD

EDWARD VII
r.1901–10

ALEXANDRA
of Denmark

GEORGE V
r.1910–36

150 Queen Victoria
Sir George Hayter, 1863,
based on a work of 1838

Oil on canvas
National Portrait Gallery, London (NPG 1250)

Queen Victoria came to the throne at the age of eighteen on the death of her uncle, William IV, in 1837 and was crowned queen on 28 June 1838. On the day of her coronation she wrote in her journal: 'I really cannot say how proud I feel to be the Queen of such a Nation.' Hayter had been appointed the young queen's official portrait painter in 1837, when she described him as 'out and out the best portrait painter in my opinion'. This is a replica of the original official coronation portrait that was painted from life during the summer of 1838, when the queen gave the artist twelve sittings. The original remained in Hayter's studio until 1871, allowing him to make replicas for state purposes. This version was commissioned for the National Portrait Gallery in 1863 by the queen herself. Hayter also made a small version for the queen's private apartments, which she described as 'excessively like and beautifully painted'.

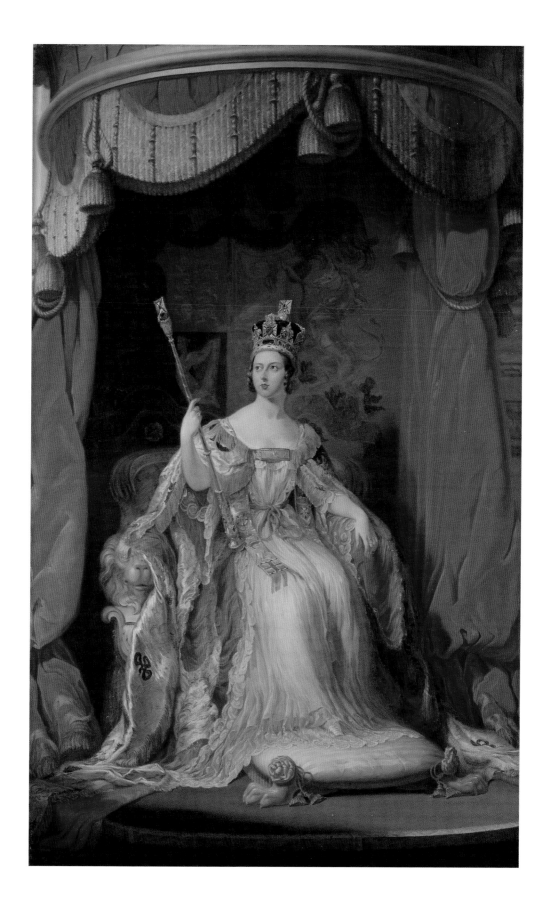

151 **Queen Victoria**
Replica by Sir Francis Chantrey, 1841,
based on a work of 1839

Marble
National Portrait Gallery, London (NPG 1716)

Sir Francis Chantrey had made portraits of three successive British monarchs (George III, George IV, William IV) during their lifetimes before commencing this bust of Victoria. Perhaps in recognition of this distinction, the new queen initiated this commission from the sculptor shortly after her coronation. Chantrey is said to have been daunted by the prospect, worried that he would not be able to imbue his youthful sitter with sufficient gravitas. Victoria sat for him seven times and was encouraged to converse or to attend to her correspondence for a more dynamic aspect. Studies included two drawings produced with the aid of a camera lucida, also in the National Portrait Gallery's collection. When the clay model for the bust was complete, Victoria gave her approval, noting in her diary that it was 'perfect'. The marble bust, based on the original clay, was then worked up by Chantrey and studio assistants, including a marble carver named James Heffernan. A plaster cast made from the original clay model allowed the sculptor's studio to produce replicas, such as this bust, which was made two years later, and ordered by the queen as a gift for the prime minister Sir Robert Peel.

THE QUEEN

152 Prince Albert of Saxe-Coburg-Gotha
John Francis, 1844

Plaster
National Portrait Gallery, London (NPG 1736)

Prince Albert was the second son of Ernest, Duke of Saxe-Coburg-Gotha, and spent his childhood in the ducal summer palace on the borders of the forest of Thuringen. Encouraged by his ambitious uncle Prince Leopold, widower of Princess Charlotte of Wales, Albert began courting his cousin Victoria from her seventeenth birthday, but she responded with only mild interest. On becoming queen, Victoria relished her new-found autonomy and sought to avoid marriage. Albert's visit to England in 1839, however, transformed her opinion of the studious young man, of whom she wrote: 'Albert's *beauty* is *most striking*, and he is so amiable and unaffected—in short, very *fascinating* looking.' They married the following year. As consort, Prince Albert had no political power but was influential as a patron of arts, taking the lead in organising the major British cultural event of the century – the Great Exhibition of 1851. The prince's good looks are evident in this bust, made of plaster and painted black to emulate bronze. The sculptor, John Francis, started his career as a farmer, but went on to teach and supervise Prince Albert in the art of sculpture, collaborating with him on a statue of the prince's much-loved greyhound, Eos.

PHOTOGRAPHED FROM LIFE BY W. BAMBRIDGE, AT WINDSOR CASTLE, MARCH 28, 1862.

"May all love,
His love unseen but felt, o'ershadow Thee;
The love of all Thy sons encompass Thee;
The love of all Thy daughters cherish Thee;
The love of all Thy people comfort Thee.

153 *Royal mourning group, 1862*
William Bambridge, March 1862

Albumen print
National Portrait Gallery, London (NPG P27)

Prince Albert died at Windsor Castle in December 1861. Earlier in the year the royal couple had celebrated their twenty-first wedding anniversary, and the rapid decline of Albert's health had taken Victoria unawares. She was utterly devastated by his loss and went into a period of deep mourning that extended beyond the year that was customary for Victorian widows, withdrawing from public life until 1868. This group portrait is one of a series made by William Bambridge in March 1862 and shows Victoria with three of her children – Princesses Alice and Victoria, and Prince Alfred. They sit near a bust of Prince Albert adorned with flowers, while the queen gazes at a photograph of her deceased husband. In subsequent years, Victoria sought comfort in portraits of Albert; a photograph showing him on his deathbed hung over his pillow in every bed the queen slept in. She also initiated a programme of public memorials, including statues (one of the most famous is the Albert Memorial in London's Hyde Park), and commissioned numerous posthumous portraits. The photographer William Bambridge was regularly employed by the royal family, acting as photographer, printer, calligrapher and organiser of the queen's private negatives.

154 *The Landing of HRH The Princess Alexandra at Gravesend, 7th March 1863*
Henry Nelson O'Neil, 1864

Oil on canvas
National Portrait Gallery, London (NPG 5487)

This portrait, which includes over fifty figures, commemorates Princess Alexandra's arrival in England from Denmark for her wedding to Queen Victoria's eldest son, Prince Albert, known as Bertie, and the future King Edward VII. The prince leads his fiancée along the Terrace Pier at Gravesend, accompanied by Alexandra's parents, Christian and Louise, the future king and queen of Denmark (who stand immediately behind them), and other members of the Danish royal family, officials and dignitaries, and, as the *Illustrated London News* reported, a 'bevy of pretty maids who, ranged on each side of the pier, awaited, with dainty little baskets filled with spring flowers, the arrival of the Princess'. Their wedding was a muted affair, coming in the midst of the mourning for Prince Albert. Victoria's good wishes for her son and his bride were tinged with her own feelings of loss: 'Here I sit, lonely and desolate, and Bertie has taken his lovely, pure, sweet Bride to Osborne, such a jewel whom he is indeed lucky to have obtained.' Henry Nelson O'Neil was a genre painter and member of The Clique, an artistic group who positioned themselves in opposition to the Pre-Raphaelite brotherhood.

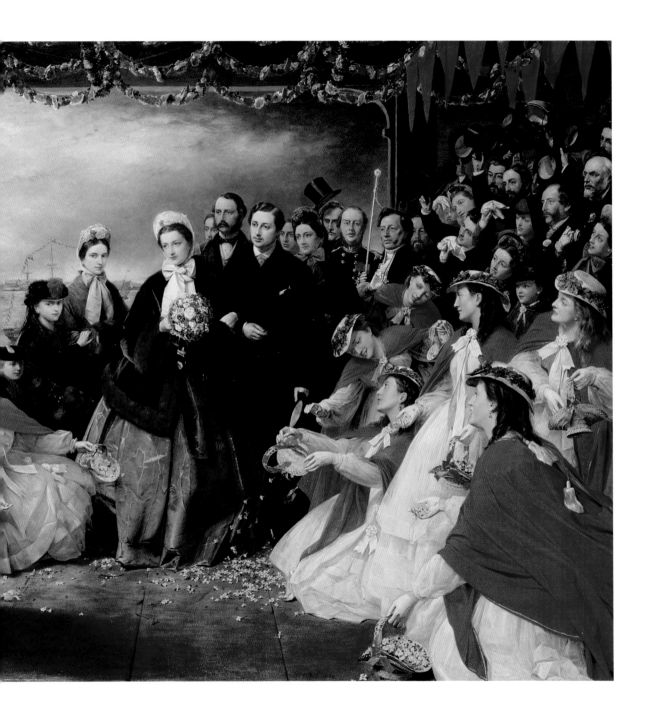

155 Princess Alexandra
Symonds & Co., 1877

Carbon print
National Portrait Gallery, London (NPG x17460)

Alexandra of Denmark was fifth on a list of seven princesses selected as possible brides for the Prince of Wales, and future Edward VII. Although less eligible than her rivals, Alexandra's beauty eclipsed her competition, as it was hoped an attractive wife would curb the prince's wayward behaviour. His elder sister, Princess Victoria, declared Alexandra to be the ideal choice: 'her voice, her walk, carriage and manner are perfect, she is one of the most ladylike and aristocratic looking people I ever saw!' Alexandra brought glamour to the sombre royal family and the new couple became the focus of high society. The advent of photography and illustrated magazines meant that images of the stylish princess were in high demand. Portraits of Alexandra fulfilling various roles – as royal consort, leader of fashion, devoted mother and patron of charities – created a blueprint for images of modern royal women, in particular Diana, Princess of Wales. In this photograph she is shown relaxing on board the Royal Yacht *Osborne* in the company of her favourite dogs. The image was issued as a postcard in 1877.

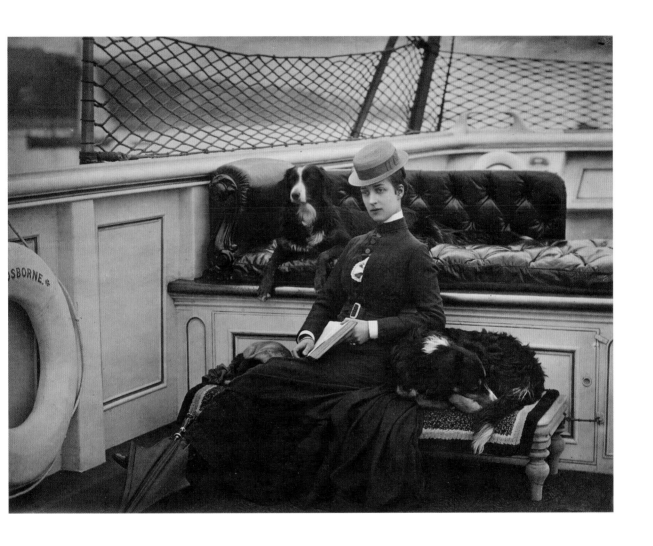

ROYALS AND PHOTOGRAPHY Sabina Jaskot-Gill

In January 1839, the revolutionary invention of photography was announced, with several people staking their claim to be the first to discover the medium. At a meeting of the Royal Society in London, the British polymath William Henry Fox Talbot (1800–77) exhibited examples of his 'photogenic drawings' on paper. He later wrote of the excitement he felt: 'imagine that one has at one's call the Genius of Aladdin's lamp. [...] It is a little bit of magic realised.' Talbot's cousin Theresa Digby, who worked at Buckingham Palace as Woman of the Bedchamber, showed examples of his invention to Queen Victoria, whose accession coincided with the early years of these new photographic technologies. Captivated by this 'curious' process, the young monarch declared herself to be 'very much interested in it'.

Both Queen Victoria and Prince Albert would go on to shape the popularity of the medium. They attended exhibitions, commissioned portraits and regularly purchased fine examples of art photography from celebrated photographers such as Roger Fenton (1819–69) and Oscar Rejlander (1813–75). In 1853, Victoria and Albert were announced as patrons of the newly established Photographic Society and royal enthusiasm undoubtedly helped to garner public and artistic attention. Photographs were offered as gifts to relatives and friends, as well as to state leaders. Fenton's Crimean portraits, for example, were given to Napoleon III on the occasion of a state visit to Paris. The democratic nature of photographic image-making also appealed to the royal couple. Victoria commissioned the Scottish photographer George Washington Wilson (1823–93) to photograph the families of

foresters and gillies that worked on the Balmoral estate, sitters who would not usually have been depicted in painted portraits, but could now be immortalised through photography.

The young queen was also astutely aware that photography could prove instrumental in fashioning the public image of her monarchy, and this signalled a new approach to state portraiture. In 1860, Queen Victoria gave permission for portraits of herself, Albert and their children to be released on sale to the public. Taken by the studio photographer John Jabez Edwin Mayall (1813–1901), they were published as a set of fourteen carte-de-visite portraits (fig.156). The appetite for these photographs proved insatiable and hundreds of thousands of copies are reported to have been sold. The carte-de-visite was a small, cheap portrait photograph mounted on card and patented by André-Adolphe-Eugène Disdéri (1819–89) in France in 1854. The cards – collectible items for the upper and middle classes, which could be exchanged between friends and assembled into albums – became enormously popular in England. Family portraits could be mounted alongside eminent personalities of the day. Victoria herself was not immune to this form of popular entertainment. In her 'Reminiscences', she recollects the joyful evenings spent with Albert looking at photographs and carefully arranging the images into albums.

Queen Victoria's decision to release these photographs transformed the image of the monarchy. While official painted portraits could idealise or flatter the monarch, photography offered the tantalising possibility of seeing the queen as she really was. Despite the perceived fidelity of photography to

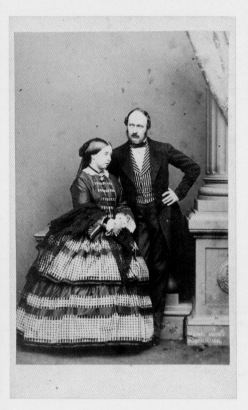

H.R.H. THE PRINCESS OF WALES
W. & D. DOWNEY COPYRIGHT

nature, these images were released in a calculated fashion, sharing a specially constructed image of the monarch intended to convey a particular message. Early portraits show Victoria as a doting mother, without the trappings of royal regalia; later portraits emphasise her social standing and power as queen and empress.

Victoria and Albert passed their enthusiasm for the medium on to their family. Their daughter-in-law and keen amateur photographer, Princess Alexandra of Denmark (fig.157), is said to have studied at the London Stereoscopic School, and her interest in the medium of photography helped to popularise the activity among middle-class women. At a time when photography opened up possibilities for women in the commercial sphere, Alexandra also embraced new technological developments. In 1888 the

George Eastman Company launched a new camera that liberated photography from messy darkroom work and made it much easier to practise. With the motto, 'You press the button, we do the rest', the Kodak camera was pre-loaded with a roll of film containing one hundred exposures that, once used, could be returned to the factory for developing. Alexandra compiled many albums of snapshot photographs taken with this new technology, both at home and on travels abroad. Her photographs were exhibited in the 1890s and later published in magazines and books. While the themes of her images would have been familiar – holidays, special occasions, dressing up – what proved particularly appealing was the opportunity to see members of the royal family in this informal manner.

During the twentieth century, photography continued to be carefully utilised by the royal

156 Queen Victoria, Prince Albert of Saxe-Coburg-Gotha
John Jabez Edwin Mayall, February 1861

Albumen carte-de-visite
National Portrait Gallery, London (NPG x26100)

157 **Princess Alexandra, Princess Louise, Duchess of Fife**
W. & D. Downey, September 1868

Albumen carte-de-visite
National Portrait Gallery, London (NPG x135624)

158 Queen Elizabeth II,
Prince Charles
Cecil Beaton,
September 1950

Gelatin silver print from
original negative
National Portrait Gallery,
London (NPG x29299)

159 Queen Elizabeth II
Dorothy Wilding, hand-
coloured by Beatrice
Johnson, 26 February
1952

Hand-coloured gelatin silver
print
National Portrait Gallery,
London (NPG x34852)

family in a bid to bring the monarchy closer to
their populace. Printing developments allowed
newspapers and magazines to be illustrated
with photographic imagery and this generated
a constant need for pictures to fill their pages.
The advent of newsreels and television also
helped to make the royal family a familiar
subject; the marriage of Princess Elizabeth
and Prince Philip in 1947 was screened to
audiences across the globe and marked the first
time newsreel cameras had been allowed into
Westminster Abbey.

Dorothy Wilding, a portrait photographer
sought after by high society, was granted
the first official sitting with the new Queen
Elizabeth. In February 1952, the sovereign was
photographed in a variety of Norman Hartnell
gowns and luxury jewels (fig.159). Portraits
from this sitting were sent to embassies around
the world and were used as the basis for stamps
and banknotes that circulated for nearly two
decades. The celebrated fashion photographer
Cecil Beaton also photographed Elizabeth

for over three decades; his portraits of her
coronation feature elaborate painted backdrops
and symbols of sovereignty, endowing
his sitter with stately aura and glamour
(fig.170), although he was just as at home
photographing her at more relaxed moments
(fig.158). A portrait of the monarchy as a
modern and accessible family began to emerge,
culminating in the 1969 BBC documentary,
Royal Family, which showed them at home
and at leisure. The monarchy's proximity to
and familiarity with photographers such as
Patrick Lichfield and Lord Snowdon (Antony
Armstrong-Jones), the husband of Princess
Margaret, also allowed the public privileged
access to unguarded moments of family life.

Perhaps the most photographed royal
figure of the twentieth century, Princess Diana
generated global interest and was constantly
scrutinised by paparazzi photographers eager
to generate tabloid sensation, particularly
after her divorce from Prince Charles in 1996.
The following year, Diana sat for fashion

photographer Mario Testino and together they created some of the most iconic portraits of the Princess of Wales (fig.160). Styled without royal paraphernalia, the images suggested a relaxed and modern woman exuding polished glamour. They were later published in *Vanity Fair* magazine and were to be the last official photographs taken before Diana's untimely death later that same year.

Today the appetite for photographs of the royal family continues unabated. Successive generations also continue to show an interest in photography. The Duchess of Cambridge (fig.161) has broken with tradition by taking the official portraits of her children herself, rather than appointing a professional photographer. In 2017, the duchess was granted honorary membership to the Royal Photographic Society, 164 years after Victoria and Albert were named the society's patrons, thus ensuring the affinity between the royal family and the medium of photography for at least another generation.

160 **Diana, Princess of Wales** Mario Testino, 1997

Gelatin silver print National Portrait Gallery, London (NPG P1015)

161 **Catherine, Duchess of Cambridge, with members of GB Women's Hockey Team** Jillian Edelstein, 15 March 2012

Gelatin silver print National Portrait Gallery, London (NPG P1705)

THE
WINDSORS

THE WINDSORS

Rosie Broadley

As the second son, King George V (reigned 1910–36) had not expected to become king, but the death of his elder brother Prince Albert, Duke of Clarence, in 1892 during the reign of their grandmother Queen Victoria made him heir to his father, Edward VII. George married Princess Mary of Teck in 1893 and the couple had six children. When he became king in 1910, George V faced numerous challenges, including trade union unrest and, most significantly, the First World War, which brought him into direct conflict with his first cousin, Kaiser Wilhelm, ruler of Germany. Given the hostilities, the family's German connections and name Saxe-Coburg, inherited from Prince Albert, were problematic. In 1917, George V announced that all descendants of Queen Victoria would bear the name Windsor.

At a time when ruling dynasties were being swept away by revolution, the British monarchy remained relatively stable. The king's personal experience as a naval commander in the 1890s – he wore naval uniform for public engagements throughout the war – endeared him to the wartime public, as did his pragmatic attitude to Parliamentary rule. His reaction to the first Labour government in 1924 was to remark: 'They have different ideas to ours as they are all socialists, but they ought to be given a chance.' George and his wife Queen Mary had a strong sense of duty and service, and the royal couple and the eldest of their six children actively participated in the war effort.

George V's eldest son Edward VIII (reigned 1936) was good-looking, charming and popular. He was the first monarch to adopt a handshake when making official visits, and his attitude seemed to augur a new, more modern and more familiar approach. During the First World War he had been commissioned into the Grenadier Guards and spent time visiting troops on the front line. As Prince of Wales, he delegated for his father on tours of Canada, North America, Australia, New Zealand and India. However, he reigned for less than a year before abdicating – a constitutional crisis brought about by his determination to marry Wallis Simpson who, as a twice-divorced woman, was considered an unsuitable queen. There had not been time for a coronation and he did not reign long enough to have a state portrait. After the couple married in 1937, they were styled the Duke and Duchess of Windsor and lived primarily in Europe with relatively little contact with the new royal family.

After the abdication, the throne passed to Edward's serious and shy brother George VI (reigned 1936–52). He had grown up in Edward's shadow and suffered from a serious stammer that had made official duties as Duke of York difficult. He had served with distinction in the navy and air force during

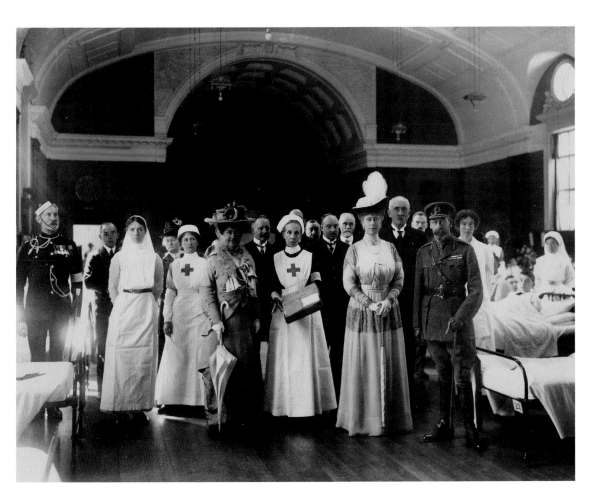

162 **King George V and Queen Mary visiting the Red Cross War Hospital, Torquay**
Dinham & Sons, September 1915

Gelatin silver print
National Portrait Gallery, London (NPG x136886)

King George V and Queen Mary, front right in this group photograph, are shown visiting a makeshift hospital that was set up in the town hall in Torquay, Devon, during the First World War. They are flanked by patients, nurses and local dignitaries. During the course of the war, King George made 450 visits to troops, 300 to hospitals and almost as many to shipyards and munitions factories.

the First World War and, like his father, had a strong sense of duty. During his sixteen years as king, he became a respected statesman. The Second World War years saw him, his wife Queen Elizabeth and their daughters, Princesses Elizabeth and Margaret, became a potent focus of national pride, visiting sites affected by the Blitz. After the war, he presided over major changes at home and abroad, including the introduction of the welfare state in 1946, and the beginning of the dismantling of the British Empire, marked by the independence of India in 1947, and the development of the Commonwealth. In spite of these major changes, the monarchy remained stable through a policy of political non-interference and increasing openness; in addition, royal palaces and art collections became more accessible to the public.

The succession of Elizabeth II in 1952 was hailed as a new Elizabethan age, and coronation imagery often drew, sometimes playfully, on Tudor paintings and heraldry, and brightened an otherwise austere post-war period. Although Elizabeth came to the throne aged just twenty-five, she had been preparing

163 Queen Elizabeth II
Dorothy Wilding, hand-coloured by
Beatrice Johnson, 1952

Hand-coloured gelatin silver print
National Portrait Gallery, London (NPG x34846)

Dorothy Wilding first photographed
the Queen as a child in 1937, at the
coronation of her father King George VI.
She subsequently made portraits of the
Queen on numerous significant occasions
and was the first woman photographer
to be granted 'by appointment' status to
the royal family. This portrait was one
of a series made to mark Elizabeth's
accession and coronation.

since the abdication of her uncle Edward VIII, and brought to the role a belief
in public service, becoming patron of over 600 charities and organisations.
Elizabeth II has ruled longer than any monarch in British history, the record
having previously been held by Queen Victoria, but she has less immediate
power over her subjects than her predecessors. Like Queen Victoria a century
before, she has negotiated the potentially conflicting roles of monarch and
mother, albeit in an era more accepting of women's diverse roles. Formal
images of the Queen incorporate traditional regalia that echo historic royal
portraits, exemplified in portraits by Cecil Beaton (fig.170). By contrast, more
informal photographs, such as Joan Williams's *Christmas at Windsor Castle,
decorating the tree* (fig.165), present a domesticated image that recalls earlier
photographs of Queen Victoria and her family. In an age of mass media,
however, Elizabeth II has led her life more publically than any monarch before
her and is one of the most recognised people in the world. As such, she has
become a subject of fascination for international artists, such as Andy Warhol,
who was intrigued by the ubiquity of her public persona.

164 Queen Elizabeth II
Andy Warhol, 1985

Silkscreen print
National Portrait Gallery, London (NPG 5882(1))

This portrait is part of a series by Warhol
entitled *Reigning Queens* and is based on
an official Silver Jubilee photograph by
Peter Grugeon taken in 1977. Having once
said, 'I want to be as famous as the Queen
of England,' in this portrait Warhol treats
the Queen not as a monarch, but as one
of the many celebrities he depicted.

165 *Christmas at Windsor Castle, decorating the tree*
Joan Williams, 1969

Colour coupler print
National Portrait Gallery, London
(NPG x199582)

Portraying the Queen, the Duke of Edinburgh and their four children, this photograph was taken during the filming of the documentary *Royal Family*, which gave audiences an unprecedented view of a year in the private and public life of the Queen and her family. It was watched by an estimated audience of 40 million people worldwide.

While the public's fascination with a monarch has always extended to their family, this has intensified in the modern era. When the Queen's eldest son, Prince Charles, married 19-year-old Lady Diana Spencer in 1981, their wedding was watched on television by an estimated global audience of 750 million. Beautiful and stylish, Diana, Princess of Wales, became a hugely popular royal figure, who supported numerous charities and was widely photographed. Her death in a car crash in 1997 caused an extraordinary outpouring of public grief and increasing critical scrutiny of the private lives of the royal family.

In recent years, many of the Queen's duties have been delegated to her heirs. The younger members of the royal family, headed by Prince William, Duke of Cambridge, and his brother Prince Harry, have developed their own public roles in the glare of the media spotlight.

166 **Royal Wedding,**
Diana, Princess of Wales
Patrick Lichfield, 29 July 1981

Colour coupler print
National Portrait Gallery, London (NPG x29570)

Taken by Patrick Lichfield, official
photographer at the wedding of Prince
Charles and Lady Diana Spencer,
this image strikes an informal note.
Photographed after the ceremony, the
new princess is shown chatting with
her youngest bridesmaid, Clementine
Hambro. Diana had previously worked
as a nanny and nursery teacher, and her
rapport with young children is evident.

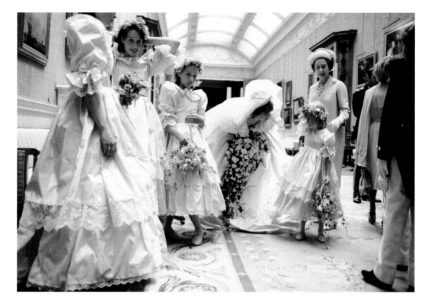

167 *The Royal Family:*
A Centenary Portrait
John Wonnacott, 2000

Oil on canvas on foamboard
National Portrait Gallery, London
(NPG 6479)

Commissioned by the National Portrait
Gallery to celebrate the 100th birthday
of the Queen Mother, this portrait of
four generations of royals was suggested
by the artist himself, as a way of
immortalising the royal family on the eve
of a new millennium. John Wonnacott
depicts his sitters in the White Drawing
Room at Buckingham Palace, recalling
Lavery's 1913 portrait of the family of
George V (fig.20).

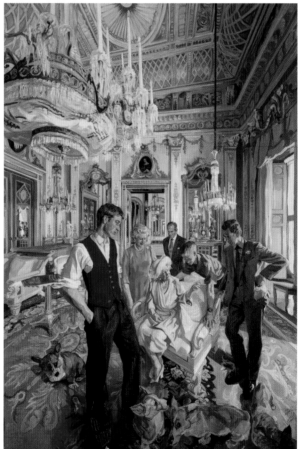

1910
Edward VII dies and is succeeded by King George V

1912
Sinking of the RMS *Titanic*

1914
Assassination of Archduke Franz Ferdinand, sparking First World War

1917
The royal family change their name from Saxe-Coburg-Gotha to Windsor in response to anti-German sentiment

1918
End of First World War; Representation of the People Act grants the vote to women over thirty

1928
A Reform Act gives women the vote on the same terms as men

1929
The Wall Street Crash prompts the Great Depression

1936
George V dies and is succeeded by Edward VIII, who subsequently abdicates and is succeeded by George VI

1939
Outbreak of Second World War

1945
Britain celebrates the end of Second World War on Victory in Europe (VE) Day

1952
George VI dies and is succeeded by Queen Elizabeth II

1953
James Watson and Francis Crick publish their discovery of the structure of DNA

1967
Abortion and homosexuality are legalised in the UK under certain conditions

1979
Margaret Thatcher becomes Britain's first female prime minister

1989
Tim Berners-Lee invents the World Wide Web

1997
Scotland and Wales vote in favour of devolution, or the creation of national assemblies with legislative powers; Diana, Princess of Wales, dies in a car crash in Paris

1998
The Good Friday Agreement establishes a devolved Northern Irish Assembly

2002
Elizabeth II's Golden Jubilee celebrations mark the fiftieth anniversary of her accession

2012
Elizabeth II's Diamond Jubilee celebrations mark the sixtieth anniversary of her accession

2014
Same-sex marriage is legalised in the UK

2015
Elizabeth II becomes the longest-reigning British monarch in history

GEORGE V
r.1910–36

MARY of Teck

EDWARD VIII
r.1936

WALLIS SIMPSON

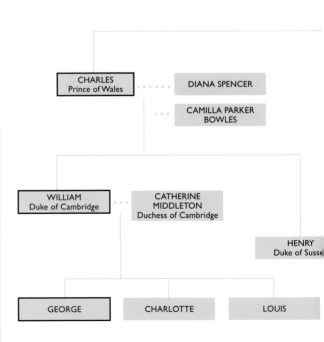

CHARLES
Prince of Wales

DIANA SPENCER

CAMILLA PARKER BOWLES

WILLIAM
Duke of Cambridge

CATHERINE MIDDLETON
Duchess of Cambridge

HENRY
Duke of Susse‹

GEORGE

CHARLOTTE

LOUIS

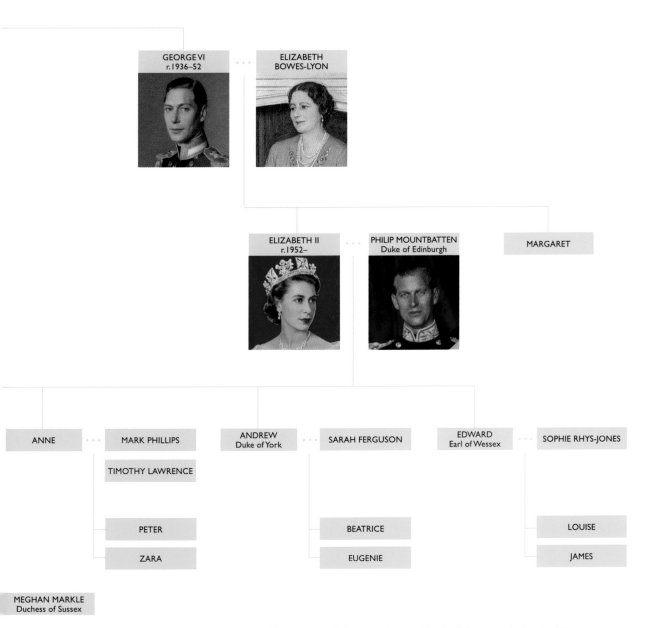

The line of succession following Queen Elizabeth II is marked in bold.

168 **Wallis, Duchess of Windsor, Prince Edward, Duke of Windsor (previously King Edward VIII)**
Cecil Beaton, 1937

Gelatin silver print
National Portrait Gallery, London (NPG P273)

Cecil Beaton's portrait of Prince Edward and Wallis Simpson was taken on their wedding day at the Château de Candé in France in 1937. In the previous year, the prince had acceded to the throne as King Edward VIII, but his desire to make Mrs Simpson his wife sparked a constitutional crisis that culminated in his abdication. The couple had met in London in 1931 and, in the light of the history of royal mistresses, the duke's relationship with a married woman was relatively unremarkable. Shortly after becoming king, however, Simpson initiated divorce proceedings against her second husband and it became clear that the king was determined to marry her. In the face of united opposition by the royal family, the government and the Church of England on the grounds that a twice-divorced woman would be an unsuitable queen, Edward formally gave up the throne on 10 December 1936. He made an historic radio broadcast the following day, in which he stated that he found it impossible to discharge his duties as king 'without the help and support of the woman I love'.

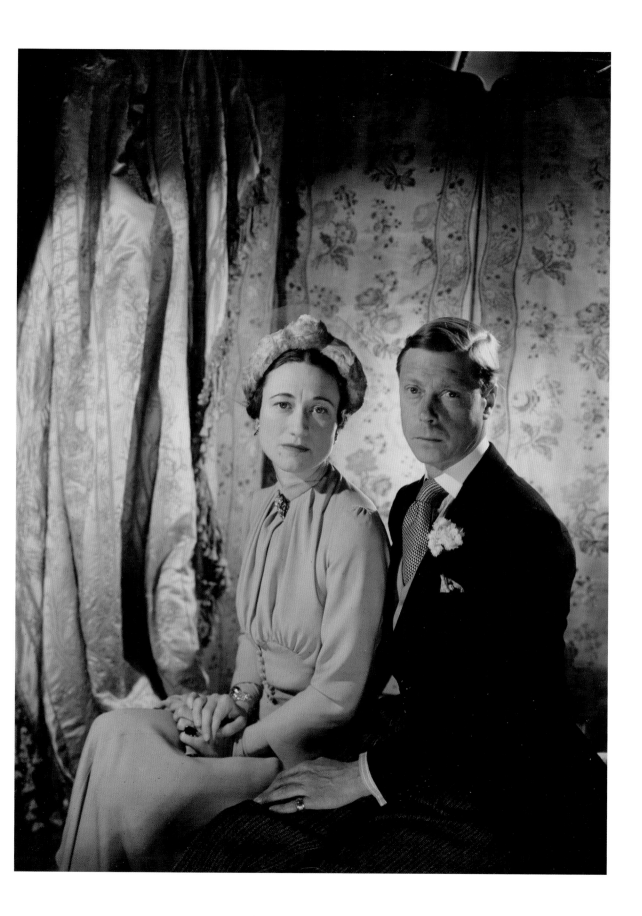

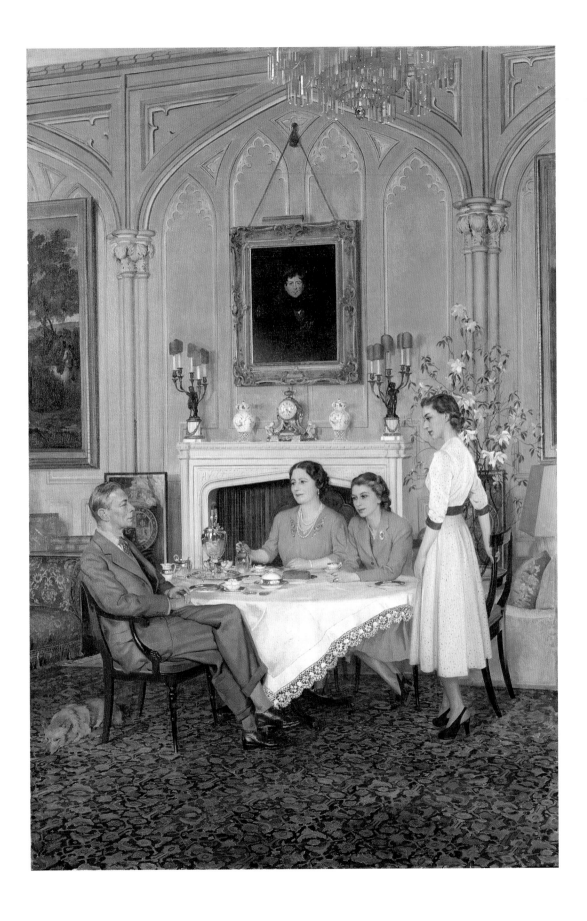

169 *Conversation piece at the Royal Lodge, Windsor*
Sir James Gunn, 1950

Oil on canvas
National Portrait Gallery, London (NPG 3778)

In Sir James Gunn's portrait, King George VI is joined by his wife, Queen Elizabeth, and daughters Princess Elizabeth and her younger sister, Princess Margaret, for tea. The women's attention is fixed on the king, who is shown enjoying a cigarette while the family's pet corgi sleeps nearby. The relaxed intimacy of this depiction was entirely new in the context of formal royal portraiture and its small size is in marked contrast to traditional large-group portraits of the royal family.

Throughout the Second World War, the royal family had remained in London, demonstrating a determination to share in the fate of the nation, which won them popular approval. This portrait was an official commission for the National Portrait Gallery, and in representing the very British ritual of afternoon tea, it manages to be both patriotic and informal, and is reflective of a new spirit in the monarchy. In his final Christmas radio broadcast, George VI reflected on the importance of 'friendliness', an approach in contrast with that of more remote monarchs of previous centuries: 'among all the blessings which we may count today, the chief one is that we are a friendly people … in an age which is hard and cruel.'

170 **Queen Elizabeth II,**
Prince Philip, Duke of Edinburgh
Cecil Beaton, 2 June 1953

Colour coupler print
National Portrait Gallery, London (NPG P1458)

The coronation of Queen Elizabeth II was the first to be televised and it was watched by an estimated 27 million people worldwide. Cecil Beaton, who had photographed Princess Elizabeth on numerous occasions since childhood, was appointed official photographer and the sittings took place in the Picture Gallery at Buckingham Palace after the ceremony. Several portraits in the set show the Queen alone, wearing the Imperial State Crown and carrying the orb and sceptre; the seated pose and richness of her regalia echo historic coronation portraits, notably George Hayter's portrait of her great-great-grandmother Queen Victoria (fig.150). Unlike Victoria, though, Elizabeth was already a wife and mother, and this image includes her husband Prince Philip, Duke of Edinburgh, his position behind the throne alluding to the consort's supportive role. Elizabeth's dress, designed by Norman Hartnell, was embroidered with flowers symbolising Great Britain and the Commonwealth. Beaton's portraits incorporate painted backdrops depicting the interior and exterior of Westminster Abbey; in this image the view is based on a nineteenth-century engraving by Edward Goodall. Whilst the use of photography to document the occasion was new, the artificiality of the setting is strangely archaic and expressive of the fascinating anachronism of an ancient monarchy within a modern democracy.

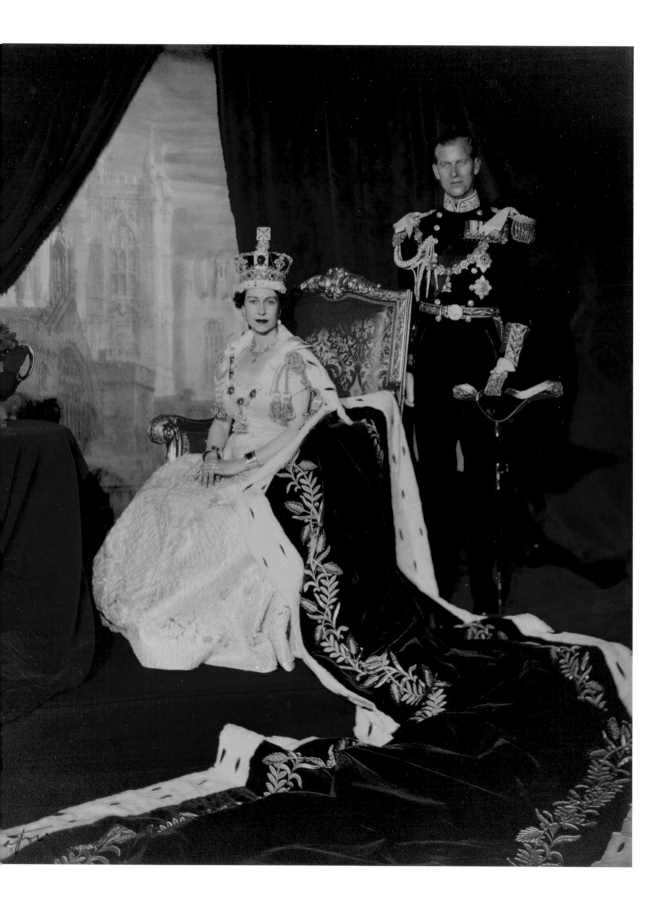

171 **Queen Elizabeth II**
Pietro Annigoni, 1969

Tempera grassa on paper on panel
National Portrait Gallery, London (NPG 4706)

When this portrait was commissioned by the National Portrait Gallery in 1969, the Italian artist Annigoni was a natural choice, having previously painted Elizabeth in 1954 to great acclaim. The timing of the commission coincided with the transmission of the documentary *Royal Family*, which included unprecedented scenes of Queen Elizabeth and her family in private and domestic settings, and was watched by over 40 million viewers worldwide. In spite of this surge of interest in the royal family, Annigoni chose to depict the Queen in a stark and solitary environment. When the portrait was unveiled, it generated enormous public and media interest. Reactions focused on the contrast between this representation and the famous portrait Annigoni had made of the Queen in 1954 for the Worshipful Company of Fishmongers, which was romantic and idealised (fig.42). The artist explained his radically different approach: 'I did not want to paint her as a film star; I saw her as a monarch, alone in the problems of her responsibility.' These words signal a reaction against the impression of glamour that had coloured the public's perception of the Queen during the early part of her reign.

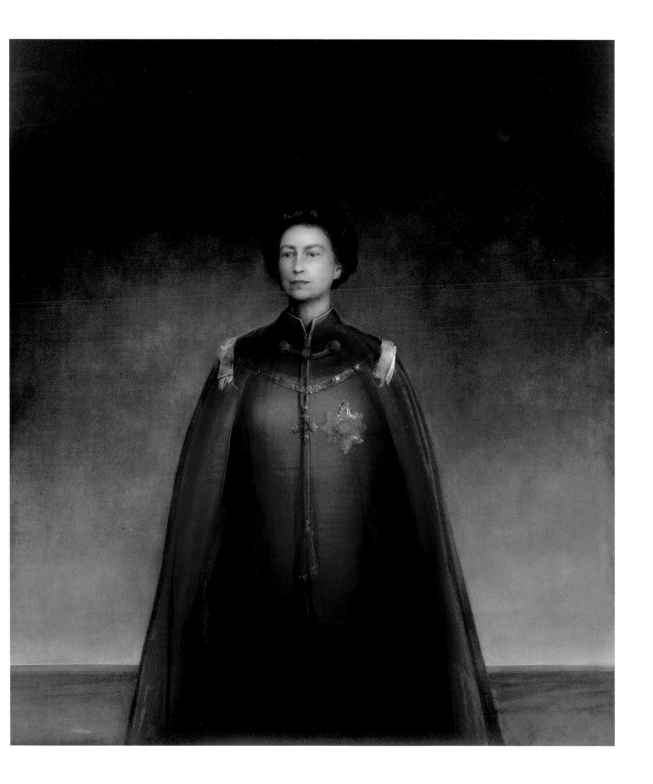

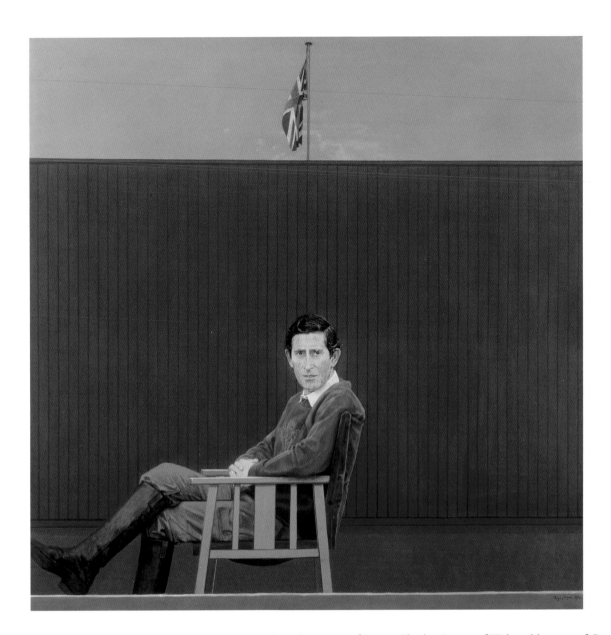

172 **Prince Charles**
Bryan Organ, 1980

Acrylic on canvas
National Portrait Gallery, London (NPG 5365)

Bryan Organ's portrait of Prince Charles, Prince of Wales, eldest son of Queen Elizabeth II, was commissioned by the National Portrait Gallery in 1980. The artist's portrait of Lady Diana Spencer (as she was before her marriage) was commissioned the following year as a companion piece, made to mark the couple's engagement. Based on sittings, studies and photographs, both portraits are relatively informal and utterly devoid of royal regalia – the Prince of Wales wears his polo clothes – and the only indication of the prince's royal identity is the presence of the Union Jack flag in the background, while the setting for the portrait of Lady Diana was the Yellow Drawing Room at Buckingham Palace.

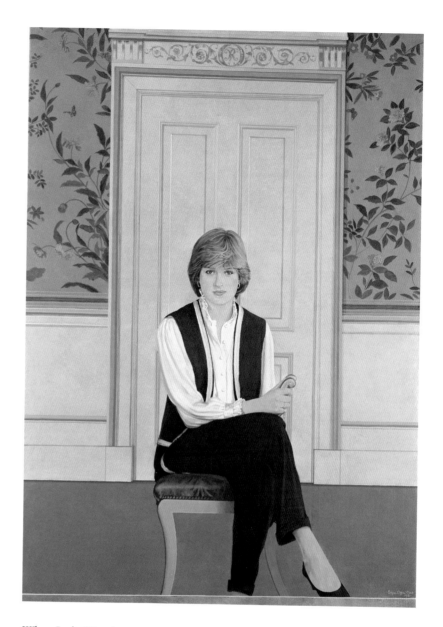

173 Diana, Princess of Wales
Bryan Organ, 1981

Acrylic on canvas
National Portrait Gallery, London (NPG 5408)

When Lady Diana's portrait was unveiled just days before her wedding at St Paul's Cathedral, press attention focused on the unusual depiction of a female member of the royal family in trousers – a foretaste of what was to become a media obsession with the Princess of Wales's clothes and appearance. Within months of its unveiling, the portrait had been slashed as a political protest over British involvement in Ireland, but was successfully restored, the damage remaining only barely perceptible. The royal couple had two sons, Princes William and Harry, but their marriage was dissolved in 1996, a year before Diana, Princess of Wales, was tragically killed in a car crash.

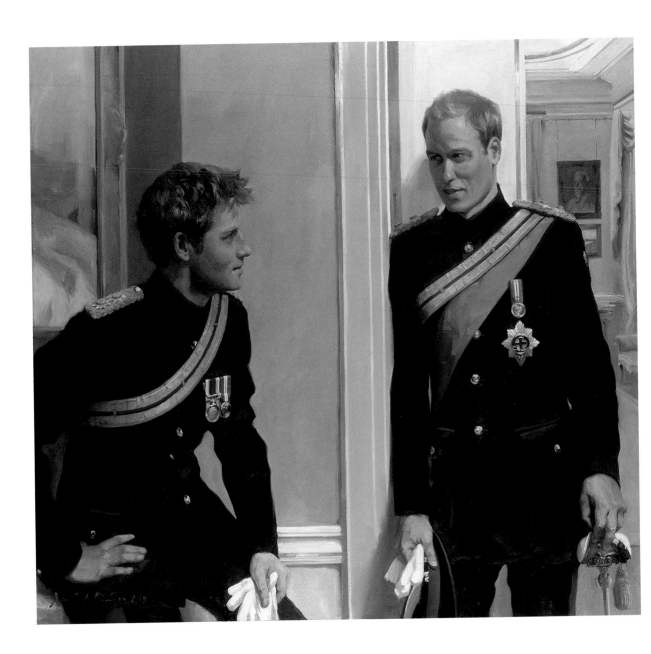

174 **Prince William
(later Duke of Cambridge),
Prince Harry (later Duke of Sussex)**
Nicola Jane ('Nicky') Philipps, 2009

Oil on canvas
National Portrait Gallery, London (NPG 6876)

Commissioned by the National Portrait Gallery, these portraits represent the
new generation of the Windsors. Nicky Philipps painted Queen Elizabeth II's
grandsons, Princes William and Harry, at a unique moment in their lives –
when they served as fellow officers in the Household Cavalry (Blues and
Royals). They are depicted wearing the regiment's dress uniform and Prince
William, later the Duke of Cambridge, wears the star and sash of the Order
of Garter. Philipps was given sittings in Clarence House and in her studio,
and whilst the painting sits comfortably within the tradition of historic royal
portraiture, it subtly refreshes the format to convey what the artist described
as an 'informal moment within a formal context'.

**175 Catherine,
Duchess of Cambridge**
Paul Emsley, 2012

Oil on canvas
National Portrait Gallery, London (NPG 6956)

In 2011, the Duke of Cambridge married Catherine Middleton at Westminster Abbey, and Paul Emsley's portrait of the new duchess was painted the following year to mark her role as patron of the National Portrait Gallery. Emsley had two sittings with the newest Windsor, at Kensington Palace and in his studio. The large-scale head-and-shoulders format is unusual in royal portraiture, with an immediacy that directly connects sitter and viewer. The duchess holds a degree in art history from the University of St Andrews and was directly involved in selecting the artist for this portrait. Since starting a family, the Duke and Duchess of Cambridge have become increasingly involved with charitable causes that support young people.

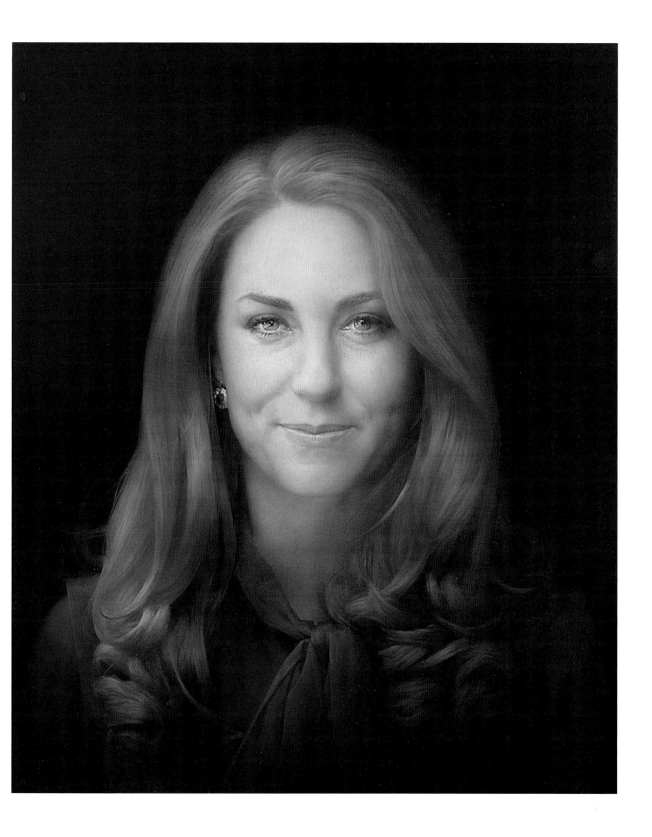

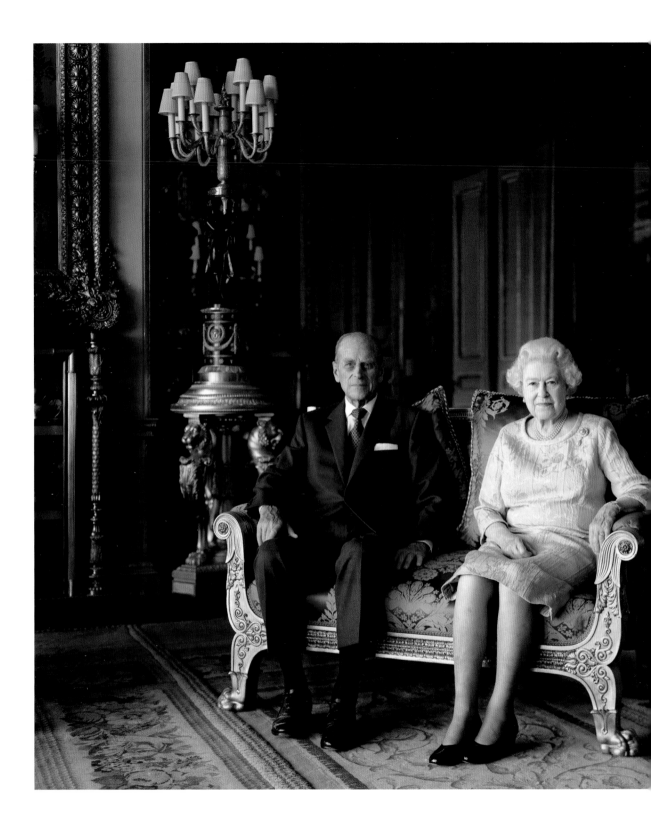

176 Queen Elizabeth II and Prince Philip, Duke of Edinburgh
Thomas Struth, 7 April 2011

Colour coupler print
National Portrait Gallery, London (NPG P1665)

This portrait of Queen Elizabeth II and Prince Philip, Duke of Edinburgh, is by the celebrated German photographer Thomas Struth. It was commissioned by the National Portrait Gallery to mark the Queen's Diamond Jubilee in 2012. The couple are posed in the Green Drawing Room at Windsor Castle shortly before Prince Philip's ninetieth birthday and during what was the sixty-fourth year of their marriage. Born in Corfu, Prince Philip is the nephew of the former king of Greece, Constantine I, and, like his wife, a descendant of Queen Victoria. The couple became engaged shortly after the Second World War, during which Philip had served in the Royal Navy. On their marriage, the prince renounced his own royal title to become a Windsor; together they have four children. Struth's portrait is a sensitive portrayal of the royal couple away from their official and ceremonial roles, but the splendid setting reminds the viewer that his sitters are far from being an ordinary elderly couple. The image is exceptionally frank but still manages to reflect royal protocol, by subtly placing the Queen in a more prominent position than Prince Philip, and recalls Cecil Beaton's coronation portrait, in which Prince Philip stands in close attendance on the Queen (fig.170). In 2017 they celebrated their seventieth wedding anniversary, with Elizabeth becoming the longest-married reigning sovereign in history.

GLOSSARY

Absolute monarchy
A form of monarchy, usually hereditary, in which the ruler has complete authority.

Accession
The attainment or acquisition of a position of power, i.e. the moment at which an heir assumes the throne.

Act of Settlement
An act of parliament of 1701 that determined that the succession to the English and Irish crowns must settle only upon those of Protestant faith.

Act of Union
An act of parliament of 1707 that united the kingdoms of England and Scotland under one crown and one parliament.

Church of England
The State church of England, formed after Henry VIII's split from the Roman Catholic Church. The British monarch is the supreme governor.

Commonwealth of Nations
An intergovernmental organisation of fifty-two self-governing member states comprised mainly of former territories of the British Empire.

Constitutional monarchy
A form of government in which a monarch acts as head of state within the parameters of a democratic constitution.

Coronation
The ceremony or initiation rite in which a monarch is officially crowned as the new head of state and invested with the regalia. In the United Kingdom, the sovereign swears an oath to uphold the law and the Church and is then anointed with holy oil, invested with regalia and crowned, before receiving the homage of his or her subjects.

Court
The extended household of a monarch or other ruler, including family, courtiers and servants. The term can also be used to refer to the building where the court is housed.

Commonwealth
The republican government established in England between the execution of Charles I in 1649 and the Restoration in 1660.

Dissolution of the monasteries
A purge that took place under Henry VIII as part of the Reformation in religion. The monasteries were abolished and their assets taken by the Crown.

Duke of York
The title of nobility usually given to the second son of a British monarch.

Favourites
The intimate companions of rulers who, historically, were granted substantial political power, titles and estates by European monarchs.

Glorious Revolution
The overthrow, in 1688, of King James II of England by a union of English Parliamentarians and Prince William, the Dutch ruler of Orange, who was married to James II's daughter, Princess Mary. The couple ruled jointly as William III and Mary II of England.

Great Reform Bill
The Representation of the People Act 1832, also known as the Great Reform Bill, instituted changes to the electoral system in England and Wales. These included the creation of sixty-seven new constituencies, the disenfranchisement of fifty-six boroughs and a widening of voting rights. Although change was limited, this precedent resulted in further calls for parliamentary reform.

Jacobite Rebellion
Jacobites (from the Latin *Jacobus*, meaning James) were the followers of the deposed Roman Catholic King James II and his descendants. They mounted a number of military campaigns in an attempt to restore the Stuart kings to the throne of Great Britain. Their final defeat came in 1746 at the Battle of Culloden.

Line of succession
The order in which members of the British royal family inherit the throne. Traditionally this has privileged the eldest male offspring of the monarch. See also Succession to the Crown Act.

Order of the Garter
The highest order of chivalry in Britain. It comprises male and female knights who are appointed by the monarch in recognition of public service.

Parliamentarians
The formal name of the Parliamentary forces in the civil wars (1642–51). They were nicknamed 'Roundheads' by their Royalist opponents because of their closely cropped hair.

Pedigree
The record of a person's or family's ancestry.

Prime minister
In Britain, the elected head of government who selects members of their party for ministerial positions. Elections must be held every five years and there is no limit to the number of terms a prime minister can serve, provided they have the support of the House of Commons.

Prince Consort
A formal title given to the husband of a reigning queen who is not a king in his own right. Prince Albert is the only British royal to have held this title.

Prince of Wales

A title generally given to the eldest son of a reigning British monarch and heir apparent to the throne. It is bestowed as a personal honour and not automatically inherited.

Principal Painter-in-Ordinary

Title awarded to leading court artists, mainly portraitists. It was first used by Antony van Dyck and later held by Peter Lely, Godfrey Kneller, Allan Ramsay and Joshua Reynolds, amongst others.

Privy Council

A formal body of advisers to the British sovereign, traditionally made up of favoured courtiers. Today it generally comprises senior politicians from both houses.

Queen Consort

The wife of a reigning king. She shares equal social rank and status with her husband, but not political or military power.

Reformation

The sixteenth-century movement that took place in certain European states, particularly Germany, England and the Low Countries, to reform the doctrines and practices of the Church of Rome.

Regalia

The ornamental bejewelled objects that act as emblems of royalty at formal or ceremonial occasions, and which are used at a coronation to symbolically invest the new monarch with power. In Britain they include the Crown, Orb, Sceptres and Sword of State.

Regent

A person (usually a close relative) appointed to rule the country because the monarch is too young (in the case of Edward VI), absent or incapacitated (in the case of George III).

Restoration

The return of a Stuart monarch, Charles II, to the throne of England in 1660, after the collapse of the Parliamentary government, which had ruled since the execution of Charles I in 1649. The term is also sometimes used to refer to the whole of Charles II's reign, which ended in 1685.

Robe of State

A long mantle or cape worn by the British monarch at their coronation, and at the annual State Opening of Parliament. It is made of ermine and crimson velvet and trimmed with gold lace.

Serjeant Painter

From 1527 until the mid seventeenth century, the principal officer at the English court responsible for the painted decoration of royal palaces, including the embellishment of ships and barges, the production of decorations for festivities and the painting of royal portraits.

St Edward's Crown

The crown used at the coronations of British monarchs. Although named after Edward the Confessor (reigned 1042–66), the original crown was sold during the civil wars and the crown used today was made for Charles II.

Succession to the Crown Act

An Act of Parliament passed in 2013 to change the rules of succession to the British throne, so that the first-born child inherits regardless of gender. Also, candidates are not disqualified upon marriage to a Catholic.

Sumptuary Laws

Rules defining what type of dress different social groups were permitted to wear. Some fabrics, including cloth of gold, were reserved for the monarch.

The Troubles

A term used to refer to the conflict in Northern Ireland from 1968 to 1998 during which over 3,600 people were killed. Central to the conflict was the constitutional status of Northern Ireland as part of the United Kingdom of Great Britain and Northern Ireland.

Tory

A term for members or supporters of the Conservative party in Britain. In the USA, it also refers to colonists who supported the British during the American War of Independence.

Whig

The name of the dominant British political party between the 1680s and 1850s, which advocated liberal reforms and opposed absolute monarchy. They were the main rivals of the Tory party. In the USA, it also refers to colonists who supported independence during the American War of Independence.

BIBLIOGRAPHY

Jonathan Alexander and Paul Binski, *The Age of Chivalry: Art in Plantagenet England 1200–1400* (exh. cat., Royal Academy of Arts, London, 1987)

Stijn Alsteens and Adam Eaker, *Van Dyck: The Anatomy of Portraiture* (Frick Collection in association with Yale University Press, New Haven and London, 2016)

Anon, 'Queen Caroline', *Johnson Ballads* (London, *c*.1820), fol.123, available at ballads. bodleian.ox.ac.uk/view/sheet/230

Leora Auslander, 'Beyond Words', *The American Historical Review*, vol.110, no.4, Oct. 2005, pp.1015–45

John M.T. Balmer, 'A Resource-Based View of the British Monarchy as a Corporate Brand', *International Studies of Management and Organisation*, vol.37, no.4, Winter 2007–8, pp.20–44

Susan Barnes, Nora de Poorter, Oliver Millar and Horst Vey, *Van Dyck: A Complete Catalogue of the Paintings* (Yale University Press, New Haven and London, 2004)

Carol Blackett-Ord and Richard Ormond, *Franz Xaver Winterhalter and the Courts of Europe 1830–70* (National Portrait Gallery, London, 1987)

Claude Blair, ed., *The Crown Jewels: The History of the Coronation Regalia in the Jewel House of the Tower of London*, 2 vols (HMSO, London, 1928)

Charlotte Bolland and Tarnya Cooper, *The Real Tudors* (National Portrait Gallery, London, 2015)

Humphrey Brooke, ed., *The Age of Charles I* (exh. cat., Royal Academy of Arts, London, 1960–1)

Xanthe Brooke and David Crombie, *Henry VIII Revealed: Holbein's Portrait and Its Legacy* (Paul Holberton, London, 2003)

Christopher Brown, *Van Dyck* (Phaidon, Oxford, 1982)

Christopher Brown, *Van Dyck 1599–1641* (exh. cat., Royal Academy of Arts, London, 1999)

David Cairns, 'The Object of Sectarianism: The Material Reality of Sectarianism in Ulster Loyalism', *Journal of the Royal Anthropological Institute*, vol.6, no.3, Sept. 2000, p.437–52

David Cannadine, 'The Context, Performance and Meaning of Ritual: The British Monarchy and the "Invention of Tradition"', *The Invention of Tradition*, ed. Eric Hobsbawm and Terence Rangers (Cambridge University Press, Cambridge, 2010), pp.101–64

Bernard Capp, *England's Culture Wars: Puritan Reformation and Its Enemies in the Interregnum, 1649–1660* (Oxford University Press, Oxford, 2012)

Anna Clark, 'Queen Caroline and the Sexual Politics of Popular Culture in London, 1820', *Representations*, no.31, Summer 1990, pp.47–68

Deborah Clark, 'Charles II by John Michael Wright', *Charles II: Art and Power*, ed. Rufus Bird and Martin Clayton (exh. cat., Royal Collection Trust, London, 2017), cat.49, pp. 114–17

Linda Colley, 'The Apotheosis of George III: Loyalty, Royalty and the British Nation 1760–1820', *Past and Present*, no.102, Feb. 1984, pp.94–129

Linda Colley, 'Introduction' in *Crown Pictorial: Art and the British Monarchy*, ed. Linda Colley, Elisabeth Fairman, Joy Pepe and Duncan Robinson (Yale Center for British Art, New Haven, 1990), pp.3–22

Tarnya Cooper, 'The Enchantment of the Familiar Face: Portraits as Domestic Objects in Elizabethan and Jacobean England' in *Everyday*

Objects: Medieval and Early Modern Material Culture and Its Meanings, ed. Tara Hamling and Catherine Richardson (Ashgate, Hampshire, 2010), pp. 157–77

John E. Crowley, *The Invention of Comfort: Sensibilities and Design in Early Modern Britain and Early America* (Johns Hopkins University Press, Baltimore, 2003)

Catharine Daunt, 'Heroes and Worthies: Emerging Antiquarianism and the Taste for Portrait Sets in England', *Painting in Britain 1500–1630: Production, Influences and Patronage*, ed. Tarnya Cooper, Aviva Burnstock, Maurice Howard and Edward Town (Cambridge University Press, Cambridge, 2015), pp.362–75

Catherine Daunt, *Portrait Sets in Tudor and Jacobean England* (University of Sussex, 2016, unpublished PhD thesis)

Leonore Davidoff and Catherine Hall, *Family Fortunes: Men and Women of the English Middle Class, 1780–1850* (Routledge, London, 2002)

Sharon DeLano, ed., *Annie Leibovitz at Work* (Jonathan Cape, London, 2008)

Thomas Dekker, *The Magnificent Entertainment Given to King James ... 15 of March 1603*, (London, 1604)

Patrizia Di Bello, *Women's Albums and Photography in Victorian England: Ladies, Mothers and Flirts* (Ashgate Publishing, Aldershot, 2007)

Susan Foister, 'Paintings and Other Works of Art in Sixteenth-Century English Inventories', *Burlington Magazine*, vol.123, no.938, 1981, pp.273–82

Patricia Fumerton and Megan E. Palmer, 'Lasting impressions of the common woodcut' in *The Routledge Handbook of Material Culture in Early Modern Europe*, ed. Catherine Richardson, Tara Hamling and David Gaimster (Routledge, London and New York, 2017), pp.383–400

Katharine Mary Beatrice Gibson, *The Iconography of Charles II* (Courtauld Institute of Art, London, 1997, unpublished PhD thesis)

Robin Gibson, 'The National Portrait Gallery's Set of Kings and Queens at Montacute House', *The National Trust Yearbook* (Europa Publications, London, 1975), pp. 81–7

Andrew Gordon, '"If My Sign Could Speak": The Signboard and the Visual Culture of Early Modern London', *Early Theatre*, vol.8, no.1, 2005, pp.35–51

Dillian Gordon, *The Wilton Diptych* (National Gallery, London, 2015)

Tara Hamling and Richard Williams, eds, *Art Reformed: Re-Assessing the Impact of the Reformation on the Visual Arts* (Cambridge Scholars, Newcastle, 2007)

Tara Hamling, *Decorating the Godly Household: Religious Art in Post-Reformation Britain* (Yale University Press, New Haven and London, 2010)

Tara Hamling, 'Visual Culture' in *The Ashgate Research Companion to Popular Culture*, ed. Andrew Hadfield, Matthew Dimmock and Abigail Shinn (Ashgate Publishing, Farnham and Burlington, 2014), pp.88–90

Stephen Harrison, *The Arch's of Triumph* (London, 1604)

Edward Hawkins, *Medallic Illustrations of the History of Great Britain and Ireland to the Reign of George II* (British Museum, London, 1885)

Stephen Heathorn, '"Let Us Remember That We, Too, Are English": Constructions of Citizenship and National Identity in English

Elementary School Reading Books, 1880–1914', *Victorian Studies*, vol.38, no.3, 1995, pp.395–427

Nicholas Hilliard, *The Arte of Limning*, ed. R.K.R. Thornton and T.G.S. Cain (Carcanet Press, Ashington, 1992)

Henry Holland, *Baziliologia, a Booke of kings: being the true and lively effigies of all our English kings ...* ' (London, 1618)

Neil Jarman, 'The Orange Arch: Creating Tradition in Ulster', *Folklore*, no.112, 2001, pp.1–21

K. Jeffrey, 'Crown, Communication and the Colonial Post: Stamps, the Monarchy and the British Empire', *Journal of Imperial and Commonwealth History*, no.34, 2006, pp.45–70

Matthew Johnson, *English Houses 1300–1800: Vernacular Architecture, Social Life* (Pearson Longman, London, 2010)

Victoria Kahn, '"The Duty to Love": Passion and Obligation in Early Modern Political Theory', *Representations*, no.68, Autumn 1999, pp.84–107

Victoria Kahn, *Wayward Contracts: The Crisis of Political Obligation in England 1640–1674* (Princeton University Press, Princeton, 2004)

Chris King, 'Domestic Buildings: Understanding Houses and Society' in *The Routledge Handbook of Material Culture in Early Modern Europe*, ed. Catherine Richardson, Tara Hamling and David Gaimster (Routledge, London and New York, 2017), pp.115–29

Victor von Klarwill, *Queen Elizabeth and Some Foreigners*, trans. T.H. Nash (John Lane, London, 1928)

Natasha Korda, 'Staging Alien Women's Work in Civic Pageants' in *Working Subjects in Early Modern English Drama*, ed. Michelle McDowd and Natasha Korda (Routledge, Abingdon, 2011), pp.53–68

Beat Kümin and B. Ann Tlusty, 'The World of the Tavern: An Introduction' in *The World of the Tavern: Public Houses in Early Modern Europe*, ed. Beat Kümin and B. Ann Tlusty (Ashgate Publishing, Aldershot and Burlington, 2002), pp.3–11

Thomas W. Lacquer, 'The Queen Caroline Affair: Politics as Art in the Reign of George IV', *Journal of Modern History*, vol.54, no.3 (Sept. 1982), pp.417–66

Jacob Larwood and John Camden, *English Inn Signs* (Chatto & Windus, London, 1951)

Giovanni Paolo Lomazzo, *A Tracte Containing the Artes of Curious Paintinge, Carvinge and Buildinge*, trans. Richard Haydock (Oxford, 1598)

Philip Long and Nicola J. Palmer, eds, *Royal Tourism: Excursions Around Monarchy* (Channel View Publications, Toronto, 2008)

Arthur Marks, 'The Statue of King George III in New York and the Iconology of Regicide', *American Art Journal*, vol.13, no.3, Summer 1981, pp.61–82

Richard Marks and Paul Williamson, eds, *Gothic Art for England 1400–1547* (V&A Publications, London, 2003)

Jonathan Marsden, *Victoria and Albert: Art and Love* (Royal Collection, London, 2010)

Henry McDonald, '"Culture War" Is Sticking Point in Northern Irish Power-Sharing Talks', *Guardian*, 28 June 2017 (https://www.theguard-ian.com/politics/2017/jun/28/culture-war-stick-ing-point-northern-irish-power-sharing-talks)

Angela McShane, 'Subjects and Objects: Material Expressions of Love and Loyalty in Seventeenth-Century England', *Journal of British Studies*, vol.48, no.4, Oct. 2009, pp.871–86

Angela McShane, 'Material Culture and Political Drinking in Seventeenth-Century England' in *Cultures of Intoxication: Past and Present*, supplement 9, ed. Angela McShane and Phil Withington (Oxford University Press, Oxford, 2014), pp.247–76

Kevin Meagher, 'Will Northern Ireland's Culture Wars Kill Power Sharing?', *New Statesman*, 25 Nov. 2014 (https://www.newstatesman.com/politics/devolution/2014/11/will-northern-ire-land-s-culture-wars-kill-power-sharing)

Oliver Millar, *The Tudor, Stuart and Early Georgian Pictures in the Collection of Her Majesty the Queen* (Phaidon, London, 1943)

Richard Morphet, *Meredith Frampton* (exh. cat., Tate Gallery, London, 1982)

Stephen Orgel, 'Prologue: I Am Richard II' in *Representations of Elizabeth I in Early Modern Culture*, ed. Alessandra Petrina and Laura Tosi (Palgrave MacMillan, Hampshire and New York, 2011), pp.11–43

Cele C. Otnes and Pauline Maclaren, *Royal Fever: The British Monarchy in Consumer Culture* (University of California Press, Oakland, 2015)

Jonathan Parry, 'Whig Monarchy, Whig Nation: Crown, Politics and Representativeness 1800–2000' in *The Monarchy and the British Nation 1780 to the Present*, ed. Andrzej Olechnowicz (Cambridge University Press, Cambridge, 2007), pp.47–75

John Peacock, 'The Visual Image of Charles I' in *The Royal Image: Representations of Charles I*, ed. Thomas N. Corns (Cambridge University Press, Cambridge, 1999), pp.176–239

David Piper, 'The Contemporary Portraits of Oliver Cromwell', *Walpole Society*, vol.34, 1952–4, pp.27–41

Murray Pittock, *Material Culture and Sedition, 1688–1760* (Palgrave MacMillan, Basingstoke and New York, 2013)

John Plunkett, *Queen Victoria: First Media Monarch* (Oxford University Press, Oxford, 2003)

Print Sellers Association, *Plates Declared 1847–1891* (Print Sellers Association, London, 1892)

Michael Reed, ed., *The Ipswich Probate Inventories 1583–1631* (Suffolk Records Society, Halesworth, 1981)

Donald M. Reid, 'The Symbolism of Postage Stamps: A Source for the Historian', *Journal of Contemporary History*, vol.19, no.2, April 1984, pp.223–49

Jennifer Scott, *The Royal Portrait: Image and Impact* (Royal Collection, London, 2010)

Tori Smith, '"Almost Pathetic ... But Also Very Glorious": The Consumer Spectacle of the Diamond Jubilee', *Histoire Sociale*, vol.29, no.58, 1996, pp.334–56

William James Smith, 'Letters from Michael Wright', *Burlington Magazine*, vol.95, no.604, July 1953, pp.233–6

Alistair Smart, *Allan Ramsay: A Complete Catalogue of His Paintings*, ed. John Ingamells (Yale University Press, New Haven and London, 1999)

Roy Strong, *Tudor and Jacobean Portraits* (HMSO, London, 1969)

Roy Strong, *Gloriana: The Portraits of Queen Elizabeth I* (Thames & Hudson, London, 1987)

Thomas Talbot, *A Booke Containing the True Portraiture of the Kings of England* (London, 1597)

Alexandra Walsh, 'Domesticating the Reformation: Material Culture, Memory and Confessional Identity in Early Modern England', *Renaissance Quarterly*, no.69, 2016, pp.566–616

Tessa Watt, *Cheap Print and Popular Piety 1550–1640* (Cambridge University Press, Cambridge, 1991)

Y. Whelan, 'The Construction and Destruction of a Colonial Landscape: Dublin Before and After Independence', *Journal of Historical Geography*, vol.28 no.4, 2002, pp.508–33

PICTURE CREDITS

The National Portrait Gallery would like to thank the copyright holders for granting permission to reproduce works illustrated in this book. Every effort has been made to contact the holders of copyright material, and any omissions will be corrected in future editions if the publisher is notified in writing.

All works are © National Portrait Gallery, London, unless otherwise noted. Italics are used for official titles of artworks.

p.2, p.88 King Henry VIII – after Hans Holbein the Younger, probably seventeenth century, based on a work of c.1536. Oil on copper, 279 x 200mm (NPG 157).

p.4 (detail), p.207 Queen Elizabeth II – Dorothy Wilding, hand-coloured by Beatrice Johnson, 1952. Hand-coloured gelatin silver print, 306 x 252mm (NPG x34846).
© William Hustler and Georgina Hustler/ National Portrait Gallery, London
Given by the photographer's sister, Susan Morton, 1976.

p.6, p.127 King Charles I – Gerrit van Honthorst, 1628. Oil on canvas, 762 x 641mm (NPG 4444).
Purchased with help from the Art Fund, 1965.

p.8, p.187 Queen Victoria – Sir George Hayter, 1863, based on a work of 1838. Oil on canvas, 2858 x 1790mm (NPG 1250).
Given by Queen Victoria, 1900.

p.10 Henry, Prince of Wales – Marcus Gheeraerts the Younger, c.1603. Oil on canvas, 1619 x 1168mm (NPG 2562).
Bequeathed by Harold Lee-Dillon, 17th Viscount Dillon, 1933.

p.12 (detail) The Kings and Queens of England: From the Conquest to Queen Victoria – Henry Hering, 1862. Albumen carte-de-visite photomontage, 72 x 55mm (NPG Ax131392).
Given by Algernon Graves, 1916.

p.14 King Henry VI – unknown English artist, c.1540. Oil on panel, 318 x 254mm (NPG 2457).

p.16 Victoria, Empress of Germany and Queen of Prussia, Frederick III, Emperor of Germany and King of Prussia – L. Haase & Co., early 1860s. Albumen carte-de-visite, 79 x 48mm (NPG x132094).
Given by an anonymous donor, 1947.

p.17 King Henry V – unknown artist, late sixteenth or early seventeenth century. Oil on panel, 724 x 410mm (NPG 545).
Transferred from the British Museum, 1879.

p.18 Ruling Monarchs – published by Rotary Photographic Co. Ltd, 1908. Gelatin silver postcard print, 139 x 88mm (NPG x196881).
Given by Terence Pepper, 2014.

p.19 Royal Family of Europe Now at War. A Family Quarrel. – Percy Lewis Pocock for W. & D. Downey, published by Underwood & Underwood, 1914, based on a photograph of 1907. Colour half-tone postcard print, 87 x 136mm (NPG x200036).

p.21 Map of the Commonwealth, 2016. Image courtesy of the Commonwealth Secretariat/Maps-in-Minutes™.

p.22 The Homage-Giving: Westminster Abbey, 9th August, 1902 – John Henry Frederick Bacon, 1903. Oil on canvas, 965 x 1829mm (NPG 6058).
Bequeathed by Miss M.E.B. Samson through the Art Fund, in memory of her father, 1989.

p.22 The Funeral Procession of the Late King Edward VII in Windsor Castle – published by Rotary Photographic Co. Ltd, 20 May 1910. Gelatin silver postcard print, 87 x 139mm (NPG x38524).
Given by Terence Pepper, 1992.

p.23 Princess Anne, Prince Charles, Queen Elizabeth II, Prince Philip, Duke of Edinburgh – Lord Snowdon, 10 October 1957. Gelatin silver print, 286 x 230mm (NPG x32733).
Photograph by Snowdon, Camera Press, London.

p.24 King Richard III – unknown artist, late sixteenth century. Oil on panel, 638 x 470mm (NPG 148).
Given by James Thomson Gibson-Craig, 1862.

p.25 Souvenir of the Royal Wedding, July 6th 1893 – unknown photographer, 1893. Half-tone reproduction, 139 x 101mm (NPG P1700(1c)).
Given by Martin Plaut, 2012.

p.26 The Roiall Progenei of our Most Sacred King James – Benjamin Wright, after unknown artist, published 1619. Line engraving, 394 x 299mm (NPG D1370).

p.28 Inigo Jones – after Sir Anthony van Dyck, c.1632. Oil on canvas, 641 x 533mm (NPG 603).
Given by J. Fuller Russell, 1880.

p.28 Sir Edward Elgar, Bt – Percival Hedley, 1905. Bronze bust, 460 x 350mm (NPG 2219).
Bequeathed by Leo Francis Howard ('Frank') Schuster, 1928.

p.29 George Frideric Handel – Thomas Hudson, 1756. Oil on canvas, 2388 x 1461mm (NPG 3970).
Purchased with help from the Handel Appeal Fund and HM Government, 1968.

pp.30–1 The Family of Henry VIII – British School, c.1545. Oil on canvas, 1445 x 3559mm (RCIN 405796).
Royal Collection Trust/© Her Majesty Queen Elizabeth II 2018

p.32 Prince George of Cambridge, Prince William, Duke of Cambridge, Queen Elizabeth II, Prince Charles – Jason Bell, 23 October 2013. Inkjet print, 525 x 405mm (NPG x138989).
Photograph by Jason Bell, Camera Press, London.

p.33 The Royal Family at Buckingham Palace, 1913 – Sir John Lavery, 1913. Oil on canvas, 3403 x 2718mm (NPG 1745).
Given by William Hugh Spottiswoode, 1913.

p.34 (detail), pp.38–9 Hornby Castle set of kings and queens from William I to Mary I – unknown artist, 1597–1618. Oil on panel, each approximately 500 x 400mm (NPG 4980 (1–16)).

p.36 Offa, King of Mercia – unknown artist, c.796. Silver penny, diameter 16mm (NPG 4152).
Given by Richard Cyril Lockett in memory of the late Richard Cyril Lockett, 1960.

p.40 King Richard II presented to the Virgin and Child by his Patron Saint John the Baptist and Saints Edward and Edmund (The Wilton Diptych) – unknown French or English artist, c.1395. Egg tempera on oak, 530 x 370mm (NG4451).
Bought with a special grant and contributions from Samuel Courtauld, Viscount Rothermere, C.T. Stoop and the Art Fund, 1929.
© The National Gallery, London/Scala, Florence

p.41 King Richard II's coronation portrait – unknown artist, possibly Andrew Beauneveu, c.1390. Oil on panel.
Photo: DeAgostini Picture Library/Scala, Florence

p.42 King Henry VIII – Hans Holbein the Younger, c.1537. Oil on panel, 280 x 200mm (191(1934.39)).
© 2018 Museo Nacional Thyssen-Bornemisza/ Scala, Florence

p.43 King Henry VIII, King Henry VII – Hans Holbein the Younger, 1536–7. Ink and watercolour, 2578 x 1372mm (NPG 4027).
Accepted in lieu of tax by HM Government and allocated to the Gallery, 1957.

p.43 King Edward VI – by a workshop associated with 'Master John', c.1547. Oil on panel, 1556 x 813mm (NPG 5511).

p.44 Queen Elizabeth I (The 'Darnley' portrait) – unknown continental artist, c.1575. Oil on panel, 1130 x 787mm (NPG 2082).

p.45 Queen Elizabeth I – Jan Rutlinger, c.1590. Engraving, 436 x 304mm (1905,0414.45).
© The Trustees of the British Museum

p.46 Charles I in Three Positions – Sir Anthony van Dyck, c.1635–6. Oil on canvas, 844 x 994mm (RCIN 404420).
Royal Collection Trust/© Her Majesty Queen Elizabeth II 2018

p.47 King Charles I – published by G.R. London, 1647. Woodcut, 170 x 102mm (RCIN 601664).
Royal Collection Trust/© Her Majesty Queen Elizabeth II 2018

p.48 Oliver Cromwell – Samuel Cooper, c.1653. Watercolour on vellum. Height 79mm.
By kind permission of The Duke of Buccleuch & Queensberry KT KBE.

p.48 Oliver Cromwell (The Dunbar Medal) – Thomas Simon, 1650. Silver medal, 35 x 28mm (NPG 4365).
Given by the Cromwell Association, 1964.

p.49 King Charles II – John Roettier, 1660. Silver medal, diameter 85mm (NPG 6076).

p.49 King Charles II – John Michael Wright, c.1676. Oil on canvas, 2819 x 2392mm (RCIN 404951).
Royal Collection Trust/© Her Majesty Queen Elizabeth II 2018

p.51 King George III – Allan Ramsay, c.1761–2. Oil on canvas, 2495 x 1632mm (RCIN 405307).
Royal Collection Trust/© Her Majesty Queen Elizabeth II 2018

p.52 Queen Charlotte with her two eldest sons – Johan Joseph Zoffany, c.1765. Oil on canvas, 1122 x 1283mm (RCIN 400146).
Royal Collection Trust/© Her Majesty Queen Elizabeth II 2018

p.53 The Royal Family in 1846 – Franz Xaver Winterhalter, 1846. Oil on canvas, 2505 x 3173mm (RCIN 405413).
Royal Collection Trust/© Her Majesty Queen Elizabeth II 2018

p.53 The Royal Family in 1846 – Samuel Cousins, after Franz Xaver Winterhalter, first published 20 March 1850, republished 1853. Mixed-method engraving, 738 x 889mm (NPG D48098).
Given by Mrs Masterman, 1964.

p.55 Prince Albert, Duke of York (later King George VI) – Meredith Frampton, 1929. Oil on canvas, 1335 x 1187mm (NPG L214).
© National Portrait Gallery, London
Lent by Trustees of Barnardo's, 1997.

pp.56–7 Queen Elizabeth II – Annie Leibovitz, 2007. Colour coupler print, 864 x 1244mm (NPG P1314).
Official Portrait of HRH Queen Elizabeth II.
© 2008 Annie Leibovitz, courtesy of the artist
Given by Annie Leibovitz, 2008.

p.58 Queen Elizabeth II – Pietro Annigoni, c.1954. Tempera, oil and ink on paper on canvas, 1633 x 1133mm.
Portrait by Pietro Annigoni, Camera Press, London.

p.60 The Sex Pistols: God Save the Queen – artwork for 7-inch single sleeve designed in collaboration with Jamie Reid, 1977. Ink on card, 182 x 182mm.
© Sex Pistols Residuals

p.62 The Penny Black stamp, featuring Queen Victoria – engraved by Charles and Frederick Heath, 1840. Ink on paper.
© Royal Mail Group Ltd, courtesy of The Postal Museum
The Penny Black image is a registered trade mark of Royal Mail Group Limited and is used under licence.

p.63 Queen Elizabeth II – commissioned by the Flower Council of Holland for Old Street, London, 2012. Lily stems and petals, 3000 x 2000mm.
© Nigel Davies
Photograph by Nigel Davies

p.63 Queen Elizabeth II – Peter Grugeon, for Camera Press, 1975. Gelatin silver print, 253 x 244mm (NPG x134731).
Photograph by Peter Grugeon, Camera Press, London.

p.64 The Arch of the Dutchmen – William Kip, after Stephen Harrison, published 1604. Line engraving, 375 x 207mm (NPG D18325).

p.65 The Arch of the Italians – William Kip, after Stephen Harrison, published 1604. Line engraving.
Courtesy of Folger Shakespeare Library, Washington DC.

p.66 George I wall painting at the George and Dragon (formerly the George Inn), Chesham, Buckinghamshire – unknown artist, c.1714. Wall painting, 1828 x 2286mm.
© Hawkley Studio

p.66 King's Statue, Weymouth, Dorset – designed by James Hamilton, executed by Coade & Sealy, 1809–10. Coade stone (statue) and Portland stone (pedestal). © geogphotos/Alamy

pp.68–9 *Pulling Down the Statue of George III at Bowling Green, New York, 9 July 1776* – William Walcutt, 1857. Oil on canvas, 1311 x 1956mm. Lafayette College Art Collection, Easton, PA.

p.70 Orange Arch, Lurgan, Co. Armagh – Paul Allen, 2012. Photo © Paul Allen

p.70 Banner depicting Queen Elizabeth II, Bushmills, Co. Antrim – Louise Stewart, July 2017. Digital photograph.

p.72 Queen Elizabeth I – unknown artist, 1585–90. Oil on panel, 953 x 819mm (NPG 2471). Given by wish of Sir Aston Webb, 1930.

p.73 Queen Elizabeth I – unknown artist, late sixteenth century. Woodcut, 500 x 369mm. Image © Ashmolean Museum, University of Oxford

p.73 Fireback – unknown maker, mid seventeenth century. Cast iron and brass, 755 x 90.2 x 27mm. Private collection.

p.74 Dish depicting Charles II and Catherine of Braganza, Brislington Pottery, c.1662. Tin-glazed earthenware with painted decoration, diameter 387mm. Private collection.

p.75 Dish depicting Charles II – London or Brislington, 1672. Tin-glazed earthenware, diameter 323mm. Private collection.

p.76 Charles I – unknown artist, late seventeenth century. Oil on copper with seventeen mica overlays, 79 x 64mm (NPG 6357).

p.78 Jug depicting Queen Caroline – unidentified factory production, probably Staffordshire, c.1820. Earthenware and lustreware, 166 x 192mm (C.52-1997). © The Fitzwilliam Museum, Cambridge

p.78 Loewentheil Album, 1860s–70s. Hand-decorated album with albumen prints, 391 x 324 x 55mm (NPG Album 262). Given by Stephan Loewentheil, 2015.

p.80 Queen Victoria Jubilee Plate – Wallis Gimson & Co., 1887. Earthenware, transfer print and hand colouring, height 243mm. Image © Chronicle/Alamy

p.81 Queen Victoria – unknown artist, 1892–7. Wood and paint, 310 x 140 x 140mm (RCIN 83827). Royal Collection Trust/© Her Majesty Queen Elizabeth II 2018

p.82 Coronation Loving Cup – Charles Noke and Harry Fenton for Royal Doulton, 1953. Coloured and glazed earthenware, 268 x 277mm (NPG D48090).

pp.84–5 (detail), p.103 Queen Elizabeth I (The 'Ditchley' portrait) – Marcus Gheeraerts the Younger, c.1592. Oil on canvas, 2413 x 1524mm (NPG 2561). Bequeathed by Harold Lee-Dillon, 17th Viscount Dillon, 1932.

p.86 King Henry VII – unknown Netherlandish artist, 1505. Oil on panel, 425 x 305mm (NPG 416).

p.87 The Coronation of Henry VIII and Katherine of Aragon – title page from *A ioyfull medytacyon*, written by Stephen Hawes, printed by Wynkyn de Worde, 1509. Woodcut, 175 x 125mm (Sel. 5-55). Reproduced by kind permission of the Syndics of Cambridge University Library.

p.89 Anne Boleyn – unknown English artist, late sixteenth century, based on a work of c.1533–6. Oil on panel, 543 x 416mm (NPG 668).

p.89 King Edward VI – after Hans Holbein the Younger, c.1542. Oil on panel, 438 x 311mm (NPG 1132).

p.90 Queen Mary I – Hans Eworth, 1554. Oil on panel, 216 x 169mm (NPG 4861). Purchased with help from the Art Fund, the Pilgrim Trust, HM Government, Miss Elizabeth Taylor and Richard Burton, 1972.

p.91 Queen Elizabeth I – unknown English artist, c.1600. Oil on panel, 1273 x 997mm (NPG 5175).

p.94 King Henry VIII – unknown Anglo-Netherlandish artist, c.1520. Oil on panel, 508 x 381mm (NPG 4690).

p.95 Katherine of Aragon – unknown Anglo-Netherlandish artist, c.1520. Oil on oak panel, 520 x 420mm (NPG L246). By permission of the Archbishop of Canterbury and the Church Commissioners; on loan to the National Portrait Gallery, London. Lent by Church Commissioners for England, 2011.

p.97 King Edward VI – unknown artist, after William Scrots, c.1546. Oil on panel, 473 x 279mm (NPG 442).

p.99 Lady Jane Grey – unknown artist, c.1590–1600. Oil on panel, 856 x 603mm (NPG 6804). Purchased with help from the proceeds of the 150th anniversary gala, 2006.

p.100 Philip II, King of Spain – after Titian, 1555. Oil on panel, 86 x 64mm (NPG 4175). Given by Edward Peter Jones, 1960.

p.100 Queen Mary I – after Anthonis Mor, 1555. Oil on panel, 86 x 64mm (NPG 4174). Given by Edward Peter Jones, 1960.

p.105 Robert Dudley, 1st Earl of Leicester – unknown Anglo-Netherlandish artist, c.1575. Oil on panel, 1080 x 826mm (NPG 447).

p.105 Robert Devereux, 2nd Earl of Essex – attributed to studio of Nicholas Hilliard, c.1595. Watercolour and bodycolour on vellum, 248 x 203mm (NPG 6241). Accepted in lieu of tax by HM Government and allocated to the Gallery, 1994.

p.106 George Villiers, 1st Duke of Buckingham – attributed to William Larkin, c.1616. Oil on canvas, 2057 x 1194mm (NPG 3840). Given by Benjamin Seymour Guinness, 1952.

p.107 Sarah Churchill (née Jenyns), Duchess of Marlborough – after Sir Godfrey Kneller, c.1702. Oil on canvas, 1054 x 889mm (NPG 3634).

p.107 John Brown, Queen Victoria – George Washington Wilson, 1863. Albumen carte-de-visite, 103 x 62mm (NPG x197188). Given by Terence Pepper, 2014.

p.109 Louise de Kéroualle, Duchess of Portsmouth – Pierre Mignard, 1682. Oil on canvas, 1207 x 953mm (NPG 497).

p.110 Maria Anne Fitzherbert (née Smythe) – Jean Condé, after Richard Cosway, published 1792. Stipple engraving, 330 x 244mm (NPG D2345).

p.111 Dorothy Jordan – John Hoppner, exhibited 1791. Oil on canvas, 749 x 622mm (NPG 7041). Transferred from Tate Gallery, 2011.

p.111 Alice Frederica Keppel (née Edmonstone) – Frederick John Jenkins, after Ellis William Roberts, c.1900–10. Heliogravure, 279 x 203mm (NPG D8115). Purchased with help from the Friends of the National Libraries and the Pilgrim Trust, 1966.

pp.112–13 (detail), pp.134–5 Anne Hyde, Duchess of York, James, Duke of York (later King James II) – Sir Peter Lely, 1660s. Oil on canvas, 1397 x 1920mm (NPG 5077).

p.114 King James I of England and VI of Scotland – Daniel Mytens, 1621. Oil on canvas, 1486 x 1006mm (NPG 109).

p.115 Anne of Denmark – Isaac Oliver, c.1612. Watercolour on vellum, 51 x 41mm (NPG 4010). Purchased with help from the Art Fund, 1957.

p.116 *The execution of King Charles I* – after unknown artist, c.1649. Etching, 292 x 260mm (NPG D1306).

p.116 Henrietta Maria – after Sir Anthony van Dyck, seventeenth century, based on a work of c.1632–5. Oil on canvas, 1092 x 826mm (NPG 227).

p.117 Eleanor ('Nell') Gwyn – Simon Verelst, c.1680. Oil on canvas, 737 x 632mm (NPG 2496). Bequeathed by John Neale, 1931.

p.118 Queen Mary II – attributed to Jan van der Vaart, c.1692–4. Oil on canvas, 1245 x 1003mm (NPG 197).

p.119 King William III – unknown artist, c.1695. Oil on canvas, 2170 x 1750mm (NPG 1026). Given by Henry Yates Thompson, 1896.

p.122 King James I of England and VI of Scotland – after John de Critz the Elder, early seventeenth century, based on a work of c.1606. Oil on panel, 572 x 419mm (NPG 548). Transferred from British Museum, 1879.

p.124 Princess Elizabeth (later Electress Palatine and Queen of Bohemia) – Robert Peake the Elder, c.1610. Oil on canvas, 1713 x 968mm (NPG 6113).

p.124 Henry, Prince of Wales – Robert Peake the Elder, c.1610. Oil on canvas, 1727 x 1137mm (NPG 4515). Purchased with help from the Art Fund, 1966.

p.128 Oliver Cromwell – after Samuel Cooper, based on a work of 1656. Oil on canvas, 756 x 629mm (NPG 514).

p.131 King Charles II – attributed to Thomas Hawker, c.1680. Oil on canvas, 2267 x 1356mm (NPG 4691).

p.133 Barbara Palmer (née Villiers), Duchess of Cleveland, with her son, Charles Fitzroy, as the Virgin and Child – Sir Peter Lely, c.1664. Oil on canvas, 1247 x 1020mm (NPG 6725). Purchased with help from the National Heritage Memorial Fund, through the Art Fund (with a contribution from the Wolfson Foundation), Camelot Group plc, David and Catharine Alexander, David Wilson, E.A. Whitehead, Glyn Hopkin and numerous other supporters of a public appeal, including members of the Chelsea Arts Club, 2005.

p.137 Queen Anne – Sir Godfrey Kneller, c.1690. Oil on canvas, 2337 x 1429mm (NPG 1616).

p.138 Queen Elizabeth I – Nicholas Hilliard, c.1575. Oil on panel, 787 x 610mm (NPG 190).

p.139 King Charles I – Daniel Mytens, 1631. Oil on canvas, 2159 x 1346mm (NPG 1246).

p.139 King George IV – Richard Cosway, c.1780–2. Watercolour on ivory, 98 x 73mm (NPG 5890).

p.140 Princess Victoria of Wales, Queen Alexandra – Queen Alexandra, c.1902. Half-tone reproduction, 106 x 88mm (NPG x137368). Given by Terence Pepper, 2011.

p.141 Princess Margaret – Dorothy Wilding, 1953. Gelatin silver print on tissue and card mount, 445 x 331mm (NPG x34080). © William Hustler and Georgina Hustler/National Portrait Gallery, London Given by the photographer's sister, Susan Morton, 1976.

p.141 Diana, Princess of Wales – Terence Donovan, 1990. Gelatin silver print, 301 x 203mm (NPG P716(13)). © The Terence Donovan Archive Given by the photographer's widow, Diana Donovan, 1998.

p.142 Sir Edward Petre, 3rd Bt, Mary of Modena, Prince James Francis Edward Stuart – attributed to Peter Schenck, c.1688. Mezzotint, 250 x 182mm (NPG D10694). Purchased with help from the Friends of the National Libraries and the Pilgrim Trust, 1966.

p.142 *Anti-saccharrites, – or – John Bull and his family leaving off the use of sugar* – James Gillray, 27 March 1792. Hand-coloured etching, 320 x 409mm (NPG D12446).

p.143 *Dignity!* – attributed to Theodore Lane, published by George Humphrey, 7 June 1821. Etching, 275 x 227mm (NPG D17907b).

p.143 *Handwriting upon the Wall* – John Doyle ('HB'), 26 May 1831. Lithograph, 286 x 415mm (NPG D41066).

p.144 *A Change for the Better* – after John Tenniel, published in *Punch* magazine, 31 July 1869. Wood engraving, 291 x 224mm (NPG D47458).

p.145 Spitting Image, The Royal Family. Photo by ITV/REX/Shutterstock, c.1985.

p.145 *Whose land is it anyway? or Berkshire Gothic* – Steve Bell, published 23 March 2001. Ink and watercolour on paper, 213 x 171mm. © Steve Bell

pp.146–7 (detail), p.165 Maria Anne Fitzherbert (née Smythe) – Sir Joshua Reynolds, *c.*1788. Oil on canvas, 914 x 711mm (NPG L162). By consent of the owners; on loan to the National Portrait Gallery, London; photograph © National Portrait Gallery, London Lent by Tweed Investments Ltd, 1976.

p.149 King George I – replica by Sir Godfrey Kneller, 1716, based on a work of 1714. Oil on canvas, 2470 x 1518mm (NPG 5174).

p.149 King George II – studio of Charles Jervas, *c.*1727. Oil on canvas, 2197 x 1283mm (NPG 368).

p.150 Prince Charles Edward Stuart – Louis Gabriel Blanchet, 1738. Oil on canvas, 1905 x 1410mm (NPG 5517).

p.151 *Temperance enjoying a frugal meal* (Charlotte of Mecklenburg-Strelitz, King George III) – James Gillray, published by Hannah Humphrey, 28 July 1792. Hand-coloured stipple engraving, 362 x 292mm (NPG D12461).

p.151 *A voluptuary under the horrors of digestion* (King George IV) – James Gillray, published by Hannah Humphrey, 2 July 1792. Hand-coloured stipple engraving, 361 x 288mm (NPG D33359).

p.152 King George IV – Sir Thomas Lawrence, *c.*1814. Oil on canvas, 914 x 711mm (NPG 123).

p.152 Caroline of Brunswick – Sir Thomas Lawrence, 1804. Oil on canvas, 1403 x 1118mm (NPG 244).

p.153 King William IV – Sir Martin Archer Shee, *c.*1800. Oil on canvas, 2210 x 1499mm (NPG 2199). Purchased with help from the Art Fund, 1928.

p.156 King George I – studio of Sir Godfrey Kneller, *c.*1714. Oil on canvas, 756 x 635mm (NPG 4223).

pp.158–9 *The Music Party* – Philip Mercier, 1733. Oil on canvas, 451 x 578mm (NPG 1556).

p.160 Charlotte of Mecklenburg-Strelitz – studio of Allan Ramsay, 1761–2. Oil on canvas, 1480 x 1080mm (NPG 224).

p.161 King George III – studio of Allan Ramsay, 1761–2. Oil on canvas, 1473 x 1067mm (NPG 223).

p.162 King George IV – Richard Cosway, 1792. Watercolour on ivory, 70 x 57mm (NPG 5389).

p.167 Princess Charlotte Augusta of Wales, Leopold I, King of the Belgians – William Thomas Fry, after George Dawe, based on a work of 1817. Coloured engraving, 445 x 356mm (NPG 1530).

p.168 Princess Charlotte's wedding dress – Mrs Triaud of Bolton Street, 1816. White silk net embroidered in silver strip with a spotted ground and borders. Photo by Museum of London/Heritage Images/Getty Images.

p.169 HRH The Princess Royal's wedding cake – unknown photographer, 28 January 1858. Albumen print, 202 x 161mm (RCIN 2905602). Royal Collection Trust/© Her Majesty Queen Elizabeth II 2018

p.169 William II, Prince of Orange, Mary Stuart – Anthony van Dyck, 1641. Oil on canvas, 1825 x 1420mm (SK-A-102). Rijksmuseum, Amsterdam.

p.170 Dish to commemorate the marriage of the Duke of York (later James II) to Anne Hyde – Thomas Toft, *c.*1670. Slip-decorated earthenware, diameter 434mm (AN1949.343). Image © Ashmolean Museum/Mary Evans

p.170 *Her Most Gracious Majesty Queen Victoria and His Royal Highness Prince Albert Married February 10th, 1840* – S. Bradshaw, after Francis William ('Frank') Topham, *c.*1840. Stipple engraving, 291 x 216mm (NPG D20923).

p.171 Edward, Prince of Wales (later King Edward VII), Princess Alexandra – John Jabez Edwin Mayall, 18 March 1863. Albumen carte-de-visite, 91 x 60mm (NPG Ax24156). Given by Algernon Graves, 1916.

p.171 Prince Charles, Diana, Princess of Wales – Patrick Lichfield, July 1981. Colour coupler print on card mount, 255 x 255mm (NPG x29864). Photo by Lichfield/Getty Images.

p.173 King George II – Thomas Hudson, 1744. Oil on canvas, 2188 x 1467mm (NPG 670). Given by HM Office of Works, 1883.

p.173 King George V visiting the Red Cross War Hospital, Torquay – Dinham & Sons, September 1915. Gelatin silver print, 360 x 288mm (NPG x136885). Given by Gordon Higham, 2012.

p.174 Prince Edward, Prince of Wales (later King Edward VIII) – Francis Owen ('Frank') Salisbury, 1917. Oil on board, 635 x 505mm (NPG 7006).

p.175 Prince Albert (later King George VI) – Speaight Ltd, 1918. Gelatin silver print, 214 x 164mm (NPG x134718).

p.175 Princess Elizabeth (later Queen Elizabeth II) –Topical Press, 1945. Gelatin silver press print, 155 x 107mm (NPG x139784). Given by Terence Pepper, 2014. © Getty Images

p.176–7 (detail), p.182 John Brown, Queen Victoria – W. & D. Downey, 1868. Albumen print, 140 x 98mm (NPG P22(4)).

p.179 Prince Albert of Saxe-Coburg-Gotha – Franz Xaver Winterhalter, 1867, based on a work of 1859. Oil on canvas, 2413 x 1568mm (NPG 237). Given by Queen Victoria, 1867.

p.180 *Domestic Life of the Royal Family* – unknown artist, *c.*1848. Hand-coloured lithograph, 225 x 295mm (NPG D20924).

p.180 *The Queen and Prince Albert at Home* – unknown artist, published by George Alfred Henry Dean, *c.*1844. Hand-coloured lithograph, 277 x 226mm (NPG D20925).

p.181 *The Secret of England's Greatness (Queen Victoria presenting a Bible in the Audience Chamber at Windsor)* – Thomas Jones Barker, *c.*1863. Oil on canvas, 1676 x 2138mm (NPG 4969).

p.183 King Edward VII – Sir (Samuel) Luke Fildes, 1902–12, based on a work of 1902. Oil on canvas, 2756 x 1803mm (NPG 1691). Given by George V, 1912.

p.189 Queen Victoria – replica by Sir Francis Chantrey, 1841, based on a work of 1839. Marble, height 705mm (NPG 1716). Purchased with help from George Harland Peck, 1913.

p.190 Prince Albert of Saxe-Coburg-Gotha – John Francis, 1844. Plaster, height 794mm (NPG 1736). Given by J.A. Gowland, 1914.

p.192 *Royal mourning group, 1862* – William Bambridge, March 1862. Albumen print, 168 x 130mm (NPG P27).

pp.194–5 *The Landing of HRH The Princess Alexandra at Gravesend, 7th March 1863* – Henry Nelson O'Neil, 1864. Oil on canvas, 1321 x 2134mm (NPG 5487).

p.197 Princess Alexandra – Symonds & Co., 1877. Carbon print, 270 x 355mm (NPG x17460).

p.199 Queen Victoria, Prince Albert of Saxe-Coburg-Gotha – John Jabez Edwin Mayall, February 1861. Albumen carte-de-visite, 85 x 57mm (NPG x26100). Given by Sir Geoffrey Langdon Keynes, 1958.

p.199 Princess Alexandra, Princess Louise, Duchess of Fife – W. & D. Downey, September 1868. Albumen carte-de-visite, 92 x 58mm (NPG x135624)

p.200 Queen Elizabeth II, Prince Charles – Cecil Beaton, September 1950. Gelatin silver print from original negative, 245 x 178mm (NPG x29299). © Victoria and Albert Museum, London Given by Eileen Hose, 1986.

p.200 Queen Elizabeth II – Dorothy Wilding, hand-coloured by Beatrice Johnson, 26 February 1952. Hand-coloured gelatin silver print, 245 x 195mm (NPG x34852). © William Hustler and Georgina Hustler/ National Portrait Gallery, London Given by the photographer's sister, Susan Morton, 1976.

p.201 Diana, Princess of Wales – Mario Testino, 1997. Gelatin silver print, 408 x 515mm (NPG P1015). © Mario Testino

p.201 Catherine, Duchess of Cambridge, with members of GB Women's Hockey Team – Jillian Edelstein, 15 March 2012. Gelatin silver print, 800 x 648mm (NPG P1705). Photograph by Jillian Edelstein, Camera Press, London. Commissioned, 2012.

pp.203–4 (detail), p.219 Queen Elizabeth II – Pietro Annigoni, 1969. Tempera grassa on paper on panel, 1981 x 1778mm (NPG 4706). Given by Sir Hugh Leggatt, 1970.

p.205 King George V and Queen Mary visiting the Red Cross War Hospital, Torquay – Dinham & Sons, September 1915. Gelatin silver print, 232 x 295mm (NPG x136886). Given by Gordon Higham, 2012.

p.206 Queen Elizabeth II – Andy Warhol, 1985. Silkscreen print, 1000 x 800mm (NPG 5882(1)). © 2018 The Andy Warhol Foundation for the Visual Arts, Inc./Licensed by DACS, London

p.208 *Christmas at Windsor Castle, decorating the tree* – Joan Williams, 1969. Colour coupler print, 195 x 245mm (NPG x199582). © Joan Williams Given by Joan Williams, 2015.

p.209 Royal Wedding, Diana, Princess of Wales – Patrick Lichfield, 29 July 1981. Colour coupler print, 250 x 385mm (NPG x29570). Photo by Lichfield/Getty Images

p.209 *The Royal Family: A Centenary Portrait* – John Wonnacott, 2000. Oil on canvas on foamboard, 3665 x 2493mm (NPG 6479). © John Wonnacott/National Portrait Gallery, London Commissioned, 2000.

p.213 Wallis, Duchess of Windsor, Prince Edward, Duke of Windsor (previously King Edward VIII) – Cecil Beaton, 1937. Gelatin silver print, 230 x 168mm (NPG P273). © Victoria and Albert Museum, London

p.214 *Conversation piece at the Royal Lodge – Windsor* – Sir James Gunn, 1950. Oil on canvas, 1511 x 1003mm (NPG 3778). Commissioned, 1950.

p.217 Queen Elizabeth II, Prince Philip, Duke of Edinburgh – Cecil Beaton, 2 June 1953. Colour coupler print, 484 x 397mm (NPG P1458). © Victoria and Albert Museum, London Given by Mr Ford Hill and the American Friends of the National Portrait Gallery (London) Foundation, Inc., 2015.

p.220 Prince Charles – Bryan Organ, 1980. Acrylic on canvas, 1778 x 1782mm (NPG 5365). Commissioned, 1980.

p.221 Diana, Princess of Wales – Bryan Organ, 1981. Acrylic on canvas, 1778 x 1270mm (NPG 5408). Commissioned, 1981.

p.222 Prince William, (later Duke of Cambridge), Prince Harry (later Duke of Sussex) – Nicola Jane ('Nicky') Philipps, 2009. Oil on canvas, 1374 x 1475mm (NPG 6876). Commissioned, 2009.

p.225 Catherine, Duchess of Cambridge – Paul Emsley, 2012. Oil on canvas, 1152 x 965mm (NPG 6956). Commissioned and given by Sir Hugh Leggatt in memory of Sir Denis Mahon through the Art Fund, 2012.

pp.226–7 Queen Elizabeth II and Prince Philip, Duke of Edinburgh – Thomas Struth, 7 April 2011. Colour coupler print, 1633 x 2062mm (NPG P1665). © Thomas Struth, 2011 Commissioned, 2011.

INDEX

Published in Great Britain by
National Portrait Gallery Publications,
St Martin's Place, London WC2H 0HE

Published to accompany the exhibition *Tudors to Windsors*

The Museum of Fine Arts, Houston, Texas, USA
7 October 2018–3 February 2019

Bendigo Art Gallery, Australia
16 March–14 July 2019

This exhibition is organised by the National Portrait Gallery, London,
in collaboration with the Museum of Fine Arts, Houston, and Bendigo
Art Gallery.

Every purchase supports the National Portrait Gallery, London.
For a complete catalogue of current publications, please write to the
National Portrait Gallery at the address above, or visit our website at
www.npg.org.uk/publications

ISBN 978 1 85514 756 0

A catalogue record for this book is available from the British Library.

10 9 8 7 6 5 4 3 2 1

Printed and bound in Italy

Managing Editor: Christopher Tinker
Project Editor: Sarah Reece
Designer: Will Webb
Picture Researcher: Mark Lynch
Production Manager: Ruth Müller-Wirth
Proofreader: Patricia Burgess

FRONT COVER
Clockwise from top left:
King Henry VIII (fig.67); Princess
Elizabeth (later Electress Palatine
and Queen of Bohemia) (fig.96);
Queen Elizabeth II (fig.163); Queen
Elizabeth I (fig.78); Diana, Princess
of Wales (fig.160); King Charles II
(fig.100)

FRONT FLAP
King George III (fig.128)

BACK COVER
Clockwise from top left:
Queen Victoria (fig.150); Prince
William (later Duke of Cambridge),
Prince Harry (later Duke of Sussex)
(fig.174); *Conversation piece at the
Royal Lodge, Windsor* (fig.169); King
George IV (fig.122)

BACK FLAP
Charlotte of Mecklenburg-Strelitz
(fig.127)